A collection in the making

BRITISH ART
AND DESIGN
00-1960

VICTORIA
ALBERT
MUSEUM

Originally published by the V&A in 1983 for the opening of
the gallery of British Art and Design 1900-1960
Second edition 1984

© Victoria and Albert Museum 1983

ISBN 0 905209 57 5

Designed by Paul Sharp
Set in Monotype Dante and
printed by Robert Stockwell Limited
London SE1

Cover Illustration
'Mindslave' by Leon Underwood (1890-1977)
1934. Marble. Given by Garth Underwood
A. 1-1981

THE FRIENDS OF THE VICTORIA AND ALBERT MUSEUM

The Friends of the V & A receive the following privileges:
Free and immediate entry to all exhibitions with a guest or husband/wife and children under 16
Free evening Private Views of major exhibitions and new developments within the Museum
Quarterly mailings of Museum literature and News Letters
The opportunity to participate in trips abroad with Keepers from the Departments
Discounts in the Craft Shop and on exhibition catalogues
Friends: £15 annually
Friends: (Concessionary) £10 annually for pensioners and full-time Museum staff
Corporate friends: £100 annually
Receive all the privileges offered to Friends, plus a fully transferable Membership Card
Benefactors: £1000 donation, which may be directed to the Department of the donor's choice

Corporate Friends
Alan Hutchison Publishing Company Ltd
Albert Amor Limited
The Antique Porcelain Company Limited
Artists Cards Ltd
Ashtead DFAS
Asprey & Company
Bankers Trust Company
Blairman & Sons Limited
BP
Cobra & Bellamy
Colnaghi & Co
Coutts & Co Bankers
Cyril Humphris
Doncaster Institute of Higher Education
Goldsmiths' Company
Hotspur Limited
John Keil
Kennedy Brookes plc
Ian Logan Limited
London & Provincial Antique Dealers' Association Limited
Madame Tomo Kikuchi (Gallery Kandori)
Madame Tussaud's Limited
Marks & Spencer plc
Mendip DFAS
Barbara Minto Limited
W. H. Patterson Fine Arts Limited
S. Pearson & Son
Phillips Auctioneers
Pickering & Chatto
R T Z Services Limited
Société Générale
South Molton Antiques Limited
Spink & Son Limited
The Fine Art Society Limited
The Wellcome Foundation Limited
Winifred Williams

Benefactor friends
Sir Duncan Oppenheim
Mr Garth Nicholas

FOREWORD

It may strike the public as ironic or moronic that it has taken the V&A until 1983 to update its presentation of British art beyond the year 1900. Ten years ago, even if we had done it the result would have been thin and unbalanced. Ten years on, the fact that we can essay it at all reflects a monumental shift in the thrust of the Museum's collecting policy. That impulse, the one to collect and exhibit today *now*, lost for so long, must never again disappear. And the galleries which will take the visitor on from 1960 are already designated.

The planning of the gallery and its organisation has been shared between the Department of Furniture and the Exhibitions Section of the Museum Services Department, the main load being taken by Clive Wainwright in the Furniture Department and Garth Hall in the Exhibitions Section, under Simon Jervis and Michael Darby respectively. The gallery has been designed by Christopher Firmstone, working to the tightest of deadlines.

I am grateful to Carol Hogben for his stimulating introduction to this picture book, and to our colleagues in the various departments for their captions.

Finally I must acknowledge the generous grant from the Baring Foundation through the Associates of the V&A which has rendered the project feasible.

Roy Strong
DIRECTOR
VICTORIA AND ALBERT MUSEUM

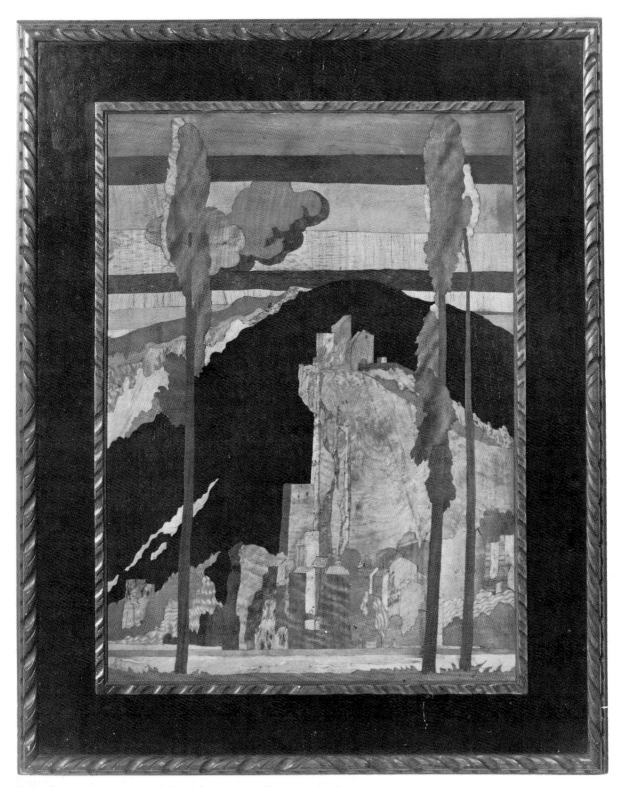

Sir Frank Brangwyn (1867-1956) *Italian Town*, c. 1920. Panel: Marquetry of various woods. Circ. 360-1976

INTRODUCTION
by Carol Hogben

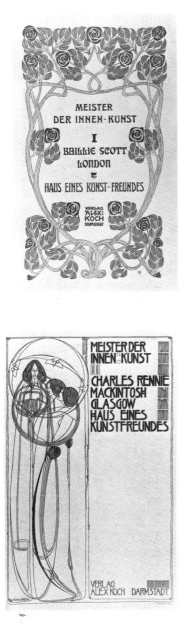

Titlepages, 1901, 1902
From *Baillie Scott: London* (Volume I) and *Charles Rennie Mackintosh: Glasgow* (Volume II), *Haus Eines Kunst-Freundes* by Hermann Muthesius.
L. 200 & 794-1902

This book is meant to show the kinds of things that one pretty special Museum has collected, to exemplify the arts in its own country, for the first sixty years of the present century. It is based on a display that it has just installed, but that fits into a pre-existing scheme. For many years it has had two finely-tempered runs of 'permanent' displays, where the various arts are shown in combination, and laid out to a time continuum. Of these, one run is British, and until lately stopped at 1900. The other is non-British, European.

This scheme allows one century, one generation, one decade even, to be broadly compared with the preceding period, and the marks of change progressively observed. So each part in a run links to the last. But it also lets the visitor reflect on traits of national schools, comparing for example the British with the French. So each run is linked also to the other, which can affect the choice of works put in.

Now when one speaks of change in this context, it is not so much a question of changing object-types, though new ones do appear from time to time. Rather to the contrary, there is if anything a bias towards tracing continuities. We find ourselves still looking at tables and chairs, carpets, curtains, cups. But what they are actually made of; how they are made; their colouring, shape, proportions, surface feel; the imagery or patterns applied (if any), skills required, these change of course; and above all the whole philosophy implied as to what is beautiful, what fits the real conditions of the times, these constantly evolve as artists, designers, craftsmen – and their clients – reach new views. In short they trace what most of us call style.

And when one speaks of objects 'exemplifying' the decorative arts of a country at a time, it is not in the sense of their being typical, everyday, popular, best-selling things of just those years. To the contrary, most are rather what stood out as different, offering something new and challenging. What proves their claim to have significance, indeed, only becomes clear after a while, when ideas change; when what stood out as new becomes a norm, widely received, and maybe widely copied. In the same way, what emerges to have been significant in international terms, is proved when those ideas are plainly taken up in other lands.

Held and displayed in a national museum these things quite properly, in time, are taken for the standards of our visual invention, the standards of care we attach to execution, and the pith of character we would choose to identify as British, entirely without regard to what our markets sold.

There need be no mystery how individual creative artists get picked to represent the national first team. Both peers and experts act as talent scouts. But it is perhaps worth noticing at what point a seal of popular confirmation gets attached. Indeed, it is worth asking where anyone ever got the idea, in the first place, that what we call the decorative arts have anything in common? Did it ever make sense to suppose that designing a poster was a similar process to, say, throwing a pot? Or is tackling the design of, say, a heater pretty much like weaving a tapestry?

The answers are closely tied to the origins of this Museum. For the lines of what the V&A collects are the effective rule-book as to what the decorative (industrial or applied) arts in the present day comprise. The way the lines have run in actual fact may best be judged from the picture pages here, where notes on each appear beside the plates. The aim of the present introduction, therefore, is to offer a somewhat broader, longer view on questions that already have been touched.

How and why does a Museum collect such things, and what does it try to prove by

their display? What was the distinguishing character of British decorative arts at large during the years 1900 to 1960? How did it compare with the period before? How did it compare with that of neighbouring countries, both at the time and before?

If all that should give plenty on which to chew, one might say this first. One does not get a good view of a hill, when standing half way down its further slope. And it can be best to climb another hill, some distance back, to judge its shape in full.

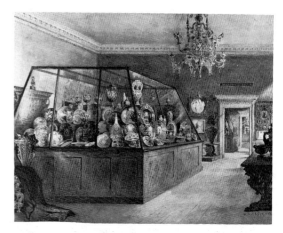

William Linnaeus Casey (1835-1870)
Museum of Ornamental Art,
Marlborough House: Second Room, 1857.
Watercolour, A.L. 7280

'Designing is the Foundation of Painting, Sculpture, Architecture, &c.; and in proportion as Designing is encouraged and improved, these must of consequence improve with it. And all the Train of inferior Arts which depend upon Designing – all the ornaments of Building, Gardens, nay of Furniture, Dress and Equipage, where the Justness of the Outline, and the Fancy of the Pattern, give the neatness and Elegance to the Work – will daily receive their share of [this] Improvement.

'That this is not merely a Romantic Notion, will appear from the remarkable Preference which is given to the *French* in everything of this sort they send over to us. Our own Furniture, our own Silks, our own Manufactures are as useful as theirs; but not so elegant, not so well fancied, nor our patterns so well Designed. Is it not evident then, that the improvements in Designing have there insensibly crept into all the inferior Arts where Taste and Fancy have any Concern? And is it not reasonable to expect the same Improvements here, when we have the same Encouragement?'

These words were written in 1735 by the painter William Hogarth in a letter to a member of Parliament. The particular 'Encouragement' he was seeking was a law to protect an artist's copyright. But he was soon campaigning, with his fellow professional artists, for another advantage the French had over us. They had had a national academy to promote standards in art since 1643. The British would not achieve its counterpart, in the Royal Academy, till 1768. And this was how it always seemed to go. The French opened their Louvre in 1793, when the revolution seized the royal collections and turned them into a national art museum. It had instant treasures that successive kings had piled, going right back to the time of François Ier, in the sixteenth century. Napoleon would add more from his war spoils. The British did not get their National Gallery until 1838, with a batch of pictures bought by Parliament. They would not get their Museum of Ornamental Manufactures (alias V&A), until 1852.

The revolution had similarly kept all the other aids which royal patronage had formed for its own needs – the porcelain factory at Sèvres, the tapestry workshops of Gobelins and Beauvais, the Mobilier and Imprimerie Nationale for furniture-making, printing and engraving. The British had just nothing of this kind.

A hundred years after Hogarth put his case, the House of Commons set up a Select Committee with three tasks. To examine the state of art in this and other countries as manifested in their different manufactures. To see how a knowledge of the arts and the principles of design might best be spread among the people. And to find the best ways of advancing the higher branches of art at the same time. The Committee sat through 1835 and 1836 taking copious evidence and making two reports. There has not been in our history, before or since, a survey of the arts that was either so wide-ranging in the inquiries made, or so far-reaching in the consequences spurred.

Just about every expert witness called before it carried the same tale, almost in Hogarth's words. From the highest branches of design down to the lowest, the Arts got no encouragement at all in this country, compared to others. The French (it was always the French) had museums, galleries, libraries and exhibitions freely accessible to all; and popular with it. They enjoyed them as a matter of natural habit. They had eighty public schools of design, throughout the land. The Prussians had them too, not just in the capital but in provincial towns. Bavaria had thirty-

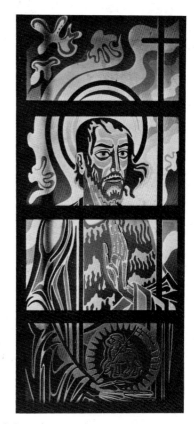

Francis Spear (1902-1979)
St John the Baptist, c. 1938 (Detail)
Panel of flashed and acid-etched glass. Given by Francis Spear. C. 33-1980

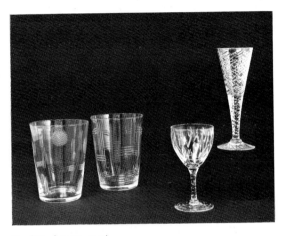

Paul Nash (1889-1946)
Group of drinking glasses, c. 1934.
Made by Stuart and Sons, Stourbridge.
Circ. 132-139-1961

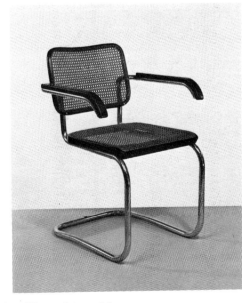

Marcel Breuer (1902-1981)
Armchair, 1928. Made by PEL (Practical Equipment Ltd)
and Thonet, 1933. Ebonised bent wood, chromium-plated
metal. W. 36-1983

three such schools. Yet here in Britain we had not a single one; not in London, nor in any of our great industrial cities.

We had not one public library, no freely open galleries, or art museums. It was only recently that a National Gallery had even been commenced. When it came to letting people see their own cathedrals, Westminster Abbey and St Paul's, an admission charge was levied at the door, excluding the poor, and further levies made for parts inside. Over there, as one witness observed, 'French churches had in them beautiful paintings, admirable sculpture, fine music, in a word all the arts are made subservient to religious services.' Here, from the Reformation, and even more from the Commonwealth, our churches had been fairly bare of art.

There was no teaching of art in British universities or local schools. We had nothing like the Books on Art published by other governments for the help of their workmen. We had no equivalent to the German *Kunstverein* to popularise the patronage of living artists.

But to round off all this dreary catalogue it was seen that the government went beyond neglect. It gave active discouragement, by taxing e.g. paper, glass and bricks. The paper tax hit publications on the arts, the use of drawing paper for designs, even the employment of card in Jacquard looms. The glass tax meant buildings were less comely from restraints on windows; it hit the art of stained glass, and the manufacture of any coloured decorative glass. The duty on bricks and rules on size and form meant Britain alone of all brick-using countries was denied the architectural enrichment of ornamental modelling.

These conditions did not prevent fine work being done, but they did make it inherently more expensive. We did have painters and sculptors with the skills of drawing the figure. We did have architects with a wide experience of decoration. What we did not have was any reservoir of trained designers in the ornamental arts. *The great advantage which foreign manufacturing artists possess over those of Great Britain consists in the greater extension of art throughout the mass of society abroad. Art is comparatively dear in England. In France it is cheap, because it is generally diffused.* In England a wealthy manufacturer has no difficulty in procuring superior designs. Our affluent silversmiths have called to their aid the genius of Flaxman and of Stothard. But the manufacturer of cheap plate and inferior jewellery cannot procure designs equal to those of France without incurring an expense disproportioned to the value of the articles.

Where a French capitalist would employ three or four artists to his exclusive use, in England a single artist would be found supplying eight to ten manufacturers. The branches that most needed the assistance of artists were the gold and silversmiths, manufacturers of ornamental furniture, glass, china, metal, and house decoration generally (everything in short that one finds in the V&A). For superior designs they would go outside their trade to painters, sculptors, and architects, but the cost of doing so was an inhibition, and there were few others on whom they could rely. One witness being asked if our designs in gold and silver were not lately improved said 'they were very considerably improved within the last 25 years, and *from the employment of painters, sculptors and architects'*.

Asked whether foreign or British china had more accurately drawn forms he said 'Foreign. In this country *works of the best forms are those copied from foreign articles*.' So what about furniture? Was sufficient intelligence in art being exhibited in that area here? 'I think not, unless designed by the architect himself. If he will not give his attention to it, the taste of the furniture is not good in this country . . .'

Reading these comments now, from our latterday, it could be remarked that things have little changed. Certainly during the period 1900-60 we continued to turn to architects, painters and sculptors (perhaps less so since 1960) as our best hope of improving modern design in industry. Our best furniture would still be produced where architects gave their attention to it, although large areas, like tubular chromed steel, would simply be adapted straight from Germany.

Just occasionally the reports refer to styles, but it seemed to be their assumption that these things drifted by, one fashion after another, with no one signifying more than any other. They envied those universal source books on Empire decorations

issued in France by Percier and Fontaine. And in introducing their conclusions they said it was basically from ignorance and want of instruction that in furniture our workmen adopted the designs of the era of Louis XV, 'a style inferior in taste and easy of execution'. But the want was at its clearest in 'the fancy trade; more especially in the silk trade; and most of all, probably, in the ribbon trade'.

Believing its case was made by the evidence heard, the Committee could refer to the economic aspects as if they were not what mattered most. 'For this merely economical reason', it said, 'were there no higher motive, it equally imports us to encourage art in its loftier attributes; since *cultivation of the more exalted branches of design tends to advance the humblest pursuits of industry*'.

Funnily enough, this observation also, seated as it is in the language of its time, is still true now as it was then. During the 1920s, let us say, the British might hate Picasso, and prefer Augustus John, but they were forced to admit (or boast) our fine arts led the rear and not the van. In the 1930s Paul Nash would prove, at least to our own foks at home, that we could in fact be modern if we tried. While since the war the world's attention paid to Henry Moore, Ben Nicholson, Graham Sutherland and Francis Bacon has helped the whole of industry to see our national image as visually out front and not behind.

No doubt it was only their polite way of making sure the argument would tell, but upon this simple statement the Committee coolly went on to propose that just about everything we lacked should now be undertaken. Where encouragement had wanted it should be given. We must have schools of design and proper art instruction. We must build museums, art galleries, libraries; hold exhibitions, not just in London but through the country. We must procure collections of the finest artefacts. '*Everything, in short, which exhibits in combination the efforts of the artist and the workman, should be sought for in the formation of such institutions. They should also contain the most approved modern specimens, foreign as well as domestic, which our extensive commerce would readily convey to us from the most distant quarters of the globe.*' Here indeed, like Paxton's dream of a Crystal Palace doodled on blotting-paper, was a perfect thumbnail vision for a future V & A.

And so on and so on. All was to be reversed, our disadvantages removed as quickly as they could. Even where no recommendation was spelt out, the points were taken. Those taxes disappeared. Our churches would groan with art, stained glass, and decorations of all kinds; our homes burst out in windows, festooned in modelled brick; forests would be cut down to pour out books.

What seems barely credible today is that such a total cultural revolution (for it did all happen) could all have been sparked at bottom by our sheer continued national inability to match the French silk ribbons. There was never the least doubt in the Committee's mind that we led the world in matters of production. It was just this business of the fancy trade in which we lagged. But there it was bad. 'For if the manufacturing exports of France be examined' said one witness, '[wherever art and] taste can be introduced into manufacture, the superiority of France is remarkable and undoubted. Of the silk manufactures of France, five sixths of her whole production are exported; with those of England probably not more than one eighth or one tenth are sent to foreign countries.'

Another, from a big shop in Pall Mall, gave a still closer picture. 'Speaking of 'plain' goods, I should think our sales are probably quite two thirds English and one third French. [Of] figured and fancy silks I should say that better than one half were French, and the quantity of French sold consists of the articles of the best quality and the richest designs; the more commonplace ones are of English fabric . . . [The finer fancy goods are] almost exclusively French, but as the lower descriptions are in more daily consumption it brings up the quantity of English to be nearly proportionate.'

From a firm that specialised in tempting the well-to-do with large stocks of imported fancy goods, this vivid answer should not be pressed far. Its interest for us lies both in what was said and how it was taken. It affected its hearers, as it was meant to do, as one more goad. Yet those facts showed that two thirds of the plain goods sold were British. Offered the choice between English plain and foreign

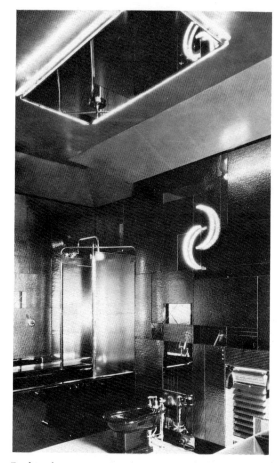

Paul Nash (1889-1946)
Designed in 1932, the bathroom was commissioned by Edward James, a wealthy poet and collector of surrealist art, upon his marriage to the Viennese dancer Tilly Losch – for whom he would also acquire as a present a complete ballet company under Balanchine. The bathroom walls were lined with $\frac{1}{4}$ inch thick stippled cathedral glass, treated with 'alloy' silvering producing a deep metallic purple colour, while the roughened surface made condensation almost invisible; for relief, some of the panels were peach plate mirror. The room had a tilting ceiling mirror, and a chromed steel ladder as a practice barre for Miss Losch. A re-creation of the bathroom (which no longer exists) was made for the joint V&A/Arts Council *Thirties* Exhibition in 1979, and is now in the Museum Collection. Many of the original elements, such as the mirror, shower-screen, electric fire and bidet, have since been presented to the Museum by the Edward James Foundation.

Ben Nicholson, OM (1894-1982)
Untitled gouache, 1936. P. 2-1961

Wyndham Lewis (1884-1957)
The Audition, c. 1912. Pen, ink, wash and brown chalk.
E. 3782-1919

fancy, twice as many people (even in a top of the market shop) preferred to buy the plain. In the witness's mind, 'plain' meant lower, cruder, worse, because cheaper; there was less money in it. The thought that plain and simple, like small, might one day come to be recognised as beautiful occurred to no one. Nor did they care that more of what was sold was of this kind.

One hundred more years further on again, in the 1930s, the bareness of ordinary Georgian houses with their pathetically standard bricks and limited windows would once again be revived as the very model of a decent style. A critic like Anthony Bertram, writing in his book *Design* (1938) would use 'unostentatious' as the highest word of praise, alongside 'planned' (i.e. regulated) and 'orderly'; whereas, the most splendid triumphs of Victorian ornament would be rubbished by Wyndham Lewis as '*passéist filth*'. But back in the 1830s we were headed all-out determined to catch up with the French at their own game.

Now there was one other thing of which the Committee took a note. Every few years, at irregular intervals going back to 1789, the French had held a national exhibition of the products of their industry. It had started as a simple three-night stand in the Champ de Mars, but soon transferred to the Louvre and grew into a highly organised event of almost overwhelming proportions. New arrangements in 1819 even required each manufacturing exhibitor to deposit samples and records for a future historical archive. In that year an English journal was quoted as enthusing '*Imagine 28 rooms in the most magnificent palace in Europe, filled with everything that taste and luxury can make perfect, everything that genius can create, everything that talent can execute. It is an absolute triumph for France, more glorious than all those she has ever achieved. In this country, the arts march with giant steps towards perfection.*'

The whole affair projected and pushed forward the state of the art. It was competitive in spirit to the nth degree, and absolutely conceived to inspire the most vigorous rivalries. Prizes, medals, diplomas, *croix d'honneur*, sometimes even titles to aristocracy, were showered on those who outshone others. There was an understandable bias towards the luxury trades, to the point that the government had to remind itself severely that there must also be a place for common goods, answering the needs of the poor, to excite designers' zeal for their well-being.

In time the British had a go at doing the same, calling theirs The National Repository. With the King as Patron it was held in the Royal Mews at Charing Cross, as an annual event from 1828. Its rules invited three classes of goods, the first two bent on isolating novel principles and ingenious constructions. The third was also focused on invention, but made room for '*such objects as are highly finished or distinguished by exquisite taste; likewise every description of elaborate ornamental workmanship such as would not find a place in an exhibition of the fine arts*'.

One can glimpse here, and in the quote above, the roots of why the decorative arts would get regarded as a single scene. For shows like these, heaping all the luxury trades together under one roof, had immeasurably more impact than isolated parts would ever have. Not just presenting the state of several congruent arts, it was rather, *en masse,* as if civilisation itself was being portrayed, in rampant growth. The British Repository was, however, of the most humble possible scope compared to the French. The 1829 event drew no more than 350 exhibited objects, where the Paris show of 1834 had 2,400 exhibiting firms.

All this must throw considerable light on the conditions under which the British came to conceive the Great Exhibition of 1851, the first ever planned on a global or 'universal' scale. There was no way we would ever catch up with the French unless we could confront and if possible outflank them on the ground they had already established as theirs. It had obviously got to be something on a scale that could eclipse their purely national triumphs. But what, or how?

Well, there was one fairly intimate area where we did have a clear edge. And, indeed, one of the particular reasons why our industry tended to focus on simple things was that much of our exports were directed to a simple colonial empire, parts of which, like Canada, or zones of India, we had prised from the French over the past 100 years by might of arms. Our ace, then, would be to demonstrate to the world the very proof of that 'extensive commerce that should readily convey

to us the most approved modern specimens from the most distant quarters of the globe'. Sheer mind-blowing internationalism, with British shipping trading to and fro, that would be the image that would win. We need not put ourselves across as the makers of everything, so long as it was all stock in our trade.

In point of fact the decision to go international was taken quite casually, and at the last moment, only months before it would open. It had of course phenomenal success, although short-lived. Over six million visitors, 14,000 exhibitors (nearly half foreign), a healthy profit – who could ask more? New York would copy it in 1853, and Paris too, in 1855. London fixed a return match in 1862, the French responding in 1867, and then again in 1878 and 1889.

A whole new medium of international intercourse would seem to have been born. Each time the formula was encased in one embracing grand cohering palace, bringing the world symbolically together, and each time, in those early years it drew an audience of similar colossal scale. However, it was nothing to the scale of things to come, and yet, after its first two efforts, Britain herself was never again to host a global show on the lines she had invented.

Thackeray had described the opening in 1851 as 'the grandest and most cheerful, the brightest and most splendid show that eyes had ever looked on since the creation of the world'. So how was it possible our people, once this much engaged, should presently have failed to build on the triumph they had won? The answer just has to be that the French in fact would soon seize back their ground. Paris 1889 was followed by Paris 1900 (*to which over 39 million visitors would come*), Paris 1925, and Paris 1937. The French understood how to orchestrate the motions of fashion and of style. Their industries formed a tight front rank of national honour. The protestant British, absorbed in the struggles of their individual conscience, could not marshal themselves in the same effective way.

By 1900, too, the medium itself changed. Instead of the one grand palace, uniting the world, it split into a jungle of separate pavilions vying against each other: and from 1925 it dropped the heavy industries bit and just concentrated on the domestic decorative arts.

There was no official British appearance in Paris 1900, and our showing there in 1925 was half-hearted in the extreme. The French Government's own official report commented that in point of physical scale our participation was worthy of our economic importance. But from the artistic point of view, it did not offer the revelations expected from a country which had been the birthplace of the revolution against ugliness and pastiche, and in which the marvellous example, from the 19th century, of our Ruskins, our William Morris's and Walter Cranes had revitalised the art of their age. Was it, it asked, that these prophets had not produced disciples, or was it rather that Ruskin's theories, counter to the arrival of a machine economy, had had a retarding effect? At all events, it pronounced, the decorative arts in the British section did not show any profound originality.

The British Government's own report frankly described the overall impression of their exhibits as dull, aloof, lacking in the spirit of adventure, albeit of excellent craftsmanship and finish. The question was what these qualities truly implied. Did they reflect 'sanity, restraint, and continuity of tradition which are signs of health and power? [Or was it rather] a degree of rigidity and ossification and an enfeeblement of the power of reacting to external stimulus which are well-known marks of impaired health and organic decay? . . . is the British reluctance to break with past practice a sign of the vigorous persistence of living tradition, or . . . the mere clinging of a parasitic plant which has lost the power of independent growth and life?' These were all grave issues that agonised Sir Hubert Llewellyn Smith, the chairman of committee, in summarising its report.

The government's pavilion in Paris 1937, by Oliver Hill, was certainly a great improvement, and the language of exhibition design as an art form all its own would at least seem to have been thoroughly learnt. 'For Britain', said the *Architectural Review*, '1937 marks the overcoming of her habit of conservatism . . . The official innovation of a united national exhibit has justified itself.' But it absolutely flayed its failure to project a nation of any purpose. We seemed to have

no idea of where we wanted to get, that might have any relevance to anyone else. And if our pavilion was at last in modern dress, its message was not.

'Beside the principal entrance,' said the same magazine's editorial, 'is a hunting scene, the riders of the stuffed horses dressed, we are told, in pink coats arranged with the advice of a real Master of Foxhounds, and on the other side an autumn woodland scene, with tweed-clad figures on shooting sticks, bearing (*in English!*) the prominent legend, '*Shooting. Pheasant, partridge grouse and innumerable other game birds abound in Great Britain where the sport of shooting is a social institution.*' With the exception of a shop window displaying coronation robes this is the only exhibition of our national life and habits.

'It is, however, not the unrepresentativeness of this that calls for comment. Indeed, it is arguable that this emphasis on sport, wealth and 'le weekend', giving a picture of England so startlingly different from the picture offered in other national pavilions and so comfortably like the foreigner's traditional idea of eccentric England, is a piece of particularly subtle, if perverse, exhibition technique . . .

'The British Government knows well enough the importance of prestige. The pavilion of a nation is that nation in miniature. In a few hours at the Paris Exhibition one can tour Europe and the Americas, admiring the customs and scenery of Switzerland, the highly organised public services of Sweden, the colossal new canal systems of Russia, the ambitious town-planning projects of Denmark and Holland, *and the cups and saucers of the United Kingdom of Great Britain and Northern Ireland.*'

As a matter of detail, in one of the backgrounds to a display of commercial goods, there was a gigantic photographic blow-up of the Prime Minister seen fishing. When one considers that the moment was at the height of the Spanish Civil War, and that Britain was committed to rearming for a second war with Germany, it simply passed belief.

I would like, however, to cast back along this arc of the great international exhibitions in order to make a cardinal point for their bearing on the V&A collections. In form, they ought to have offered the supreme showcase for a study of each country's decorative arts viewed as a sum, one with another; the ideal shopping place for a museum, and a key point at which a seal of national esteem could be attached. And in the beginning that is just how they were seen.

The fact that Parliament spent all of £5,000 at the Great Exhibition on buying in furniture, metalwork, pottery and woven fabrics, of the most swagger kind, to form the future core of the museum is often told. And it is used to prove that the collection of 'the most approved examples' of modern work had always been a main goal from the start. Yet actually that line was not kept up. In 1855 almost as much, £3,500, was spent in Paris on comparable material, and £4,000 odd in the London repeat of 1862. A larger sum still, was lashed out in Paris 1867, when we could not resist the Castellani collection of some 450 pieces of 'modern' jewellery in sundry antique manners. Some run of the mill items were taken in from Norway, Turkey, India and Japan, while over £6,250 was spent on just four pieces, three of them English. All these were competitive tours de force, of just the type the French themselves loved best, while for the fourth item, a cabinet by Fourdinois, on its own, a staggering price of £2,750 was paid.

After that, however, the rot set in. It was as if we had at last once more perceived that in these repeated tournaments to show new styles we were not born winners; that fancy trades were really not our line. The balder truth may be that Henry Cole retired. In Paris 1878, we bought about 80 miscellaneous pots and pieces of glass for around £800 – including 12 examples by W. Zsolnay of Hungary for a mere £7 the lot. At the Paris show of 1889 – to which 32,500,000 visitors trooped – we outlaid just £90 total on 28 pots, four of them small examples by Emile Gallé, 20 of them 'modern Persian' adaptations from antiques.

Finally – and as it turned out that is the right word – in 1900 (39,000,000 visitors) the Museum sent its team of experts to Paris armed with authority to spend up to £500. They looked at everything, absorbing the New Art, studied the various

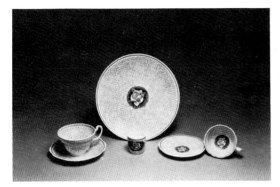

Graham Sutherland, OM (1902-1980)
Part of a tea set, *Green Daisy or Green Spot,* c. 1934
Made by E. Brain and Company under the direction of
Thomas Acland Fennemore (1902-1959)
Circ. 483 & a-1948, 1183 & a-1967

juries' prize awards, and came away having spent barely half the sum allowed on various bits of pottery and glass, a couple of textiles, and some door furniture. So feeble a response could only be excused if the authorities had meanwhile found some better shopping ground for modern work. But they had not. On this particular occasion a private individual, Sir George Donaldson, was so impressed by the New Art in Europe (to the origins of which, as he pointed out, Britain had made so conspicuous a contribution), that he bought a large collection of the furniture, by such masters as Majorelle, Gallé, Gaillard, and Bagués, at a personal cost of several thousand pounds, and gave it to the Museum. He actually had to beg to make the gesture, and when the things in due course went on show there were piercing howls of protest – not just from aggrieved artists like Walter Crane (who was outraged that the display had involved the removal of William Morris tapestries) but from members of the Council to the Board of Education like Sir William Richmond and T. G. Jackson.

The Board had committed itself to accept and show – even travel – the gift; but it was so embarrassed by the public fuss that the collection was bundled off to Bethnal Green, and a printed notice, on the lines of a government health warning, was prepared for those intending to borrow the show. It explained how the gift had been received, but then went on . . . "Much of the modern Continental furniture however exhibits a style which is not consistent with the teaching of Art Schools in the United Kingdom. It is therefore necessary that students inspecting the examples in this collection should be guided, in forming an opinion as to their merits and obvious faults, by instructors who have given attention to such subjects as Historic Ornament, Principles of Ornament, and Architecture".

The immediate effect of the row was to switch off the tap, altogether, of buying any contemporary furniture. It was expensive anyway; it was large, and thus conspicuous. Of all the arts collected, it was by definition the most useful, the most clearly connected, through architecture, to the real fabric of our living style. It was better not to buy any at all, than risk free thought upsetting student minds.

The Museum did get more space with its new building added in 1909, but its growth was then more pointed to the past. Even after the Second World War, when its galleries were being rearranged to set out a chronological sequence, the tale they told was stopped at 1830. The whole Victorian dream, and our own times equally, were kept well out of sight, as if they might confuse the public taste. It did in fact continue to collect the smaller arts like pottery and glass, textiles, prints and drawings etc.: and it held a number of temporary exhibitions of modern work. But these were not put in the main standing displays.

It was not until it faced its own centenary, in 1952, that the Museum would set about those missing 100 years. It chose, as its best form of celebration, to mount a major exhibition of British decorative arts from the Victorian period onwards. And it has been by a continuation of the research begun for that particular project that the Museum came to acquire, in increasing numbers from 1950 on, all the larger objects that are pictured here. They were not thus bought as an instant accolade from current output, at the time of making. Rather they were pursued in retrospect, spurred by the suggestions of contemporary comment and aided by the judgments, with hindsight, of historians.

For this same Museum, which had commissioned complete roomfuls from Morris & Co. in the 1860s, and covered its walls with the murals of leading painters, would not buy a single three-dimensional example of the work, during their lifetimes, of Charles Rennie Mackintosh, M. H. Baillie Scott, C. F. A. Voysey, C. R. Ashbee, Ernest Gimson, or any other of the early 20th century giants (as we now see them) in its own country.

There is however another strand to that collision over New Art Furniture which deserves to be picked out and looked at more.

The original plan for the V&A in bud was a museum linked to the new School of Design at Somerset House. Its collections should show to the students, to manufacturers, and the public, 'the practical application of the principles of design in the graceful arrangement of forms and the harmonious combination of colours'. These

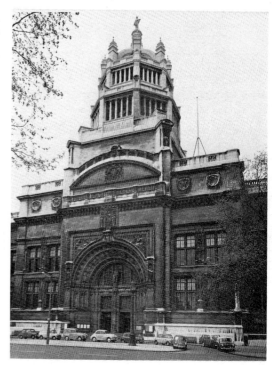

Main Entrance and the central tower of the Victoria and Albert Museum. Sir Aston Webb modified his 1891 plans and building started in 1899. The extension was completed and opened in 1909.

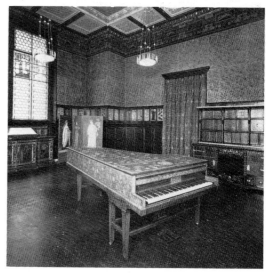

William Morris Room
In 1866 the firm of Morris, Marshall, Faulkner and Company were commissioned by the V&A's first Director, Sir Henry Cole, to decorate the West Dining Room of the Museum. The scheme was created by Morris, assisted by Phillip Webb, and included stained-glass windows and painted panels representing the months of the year, which were designed by Sir Edward Burne-Jones.

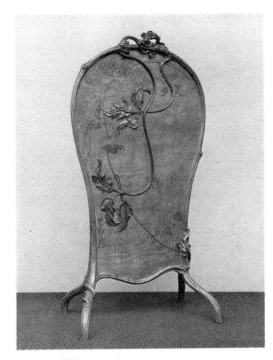

Emile Gallé (1846-1904)
Screen of Ash with applied floral decoration in oak,
zebrawood and sabicue and marquetry of amboyna and
walnut. French: 1900.
George Donaldson Gift.
1985-1900
Exhibited in the Paris Exhibition in 1900.

words indeed defined its entire goal – all you could ever want to know about art but might be afraid to ask. Rules as to what it should acquire were framed by Cole in *1863*. The decorative art of all periods and all countries was to be completely represented *at the level of the best work, so as fully to illustrate human taste and ingenuity*. It need not take much if an age or country showed low taste: where art was excellent and could help modern manufactures improve, it might take more.

At that time, apart from the Museum, South Kensington governed all schools of design. In the same year it uttered detailed General Principles of Instruction in the Decorative Arts, formulated by Richard Redgrave, RA. They occupied three pages of close print, and the first overriding rules were given as these. 'The decorative arts arise from, and should properly be attendant upon, architecture. Architecture should be the material expression of the wants, the faculties and the sentiments, of the age in which it is created. . . . Ornament should arise out of and be subservient to construction. The true office of ornament is the decoration of utility. Ornament, therefore, ought always to be secondary to utility. True ornament does not consist in the mere imitation of natural objects . . .'

All the rules enunciated were astonishingly specific, and founded upon deep practical experience. Some anticipate that functionalist approach that was, through the Bauhaus, to characterise the modern movement in the twentieth century. E.g. (in three-dimensional work) '*The form should be most carefully adapted to use,* being studied . . . for capacity, strength, mobility, etc. . . . All projecting parts should have careful consideration to render them as little liable to injury as is *consistent with their purpose*'. The phrases could have been compressed still further, to 'form follows function', and 'fitness for purpose'. In essence however they were a kit of tools equipping students to historicise with taste.

We can now appreciate the real dilemma of the Board in 1900. It had had to accept the Donaldson gift because its rules said the collections should be comprehensive. But they were no less bound by this other set of rules, which fixed the very base of their art teaching. It was obvious that in this chap Gallé's work the ornament did not arise out of, nor was it subservient to, construction. It was not secondary to the utility of his things, and, damn it all, they imitated natural objects straight. One simply could not go on teaching the rules as they were given if fellows like this Gallé were set up and admired.

Yet it was not as simple as that. It would soon happen that for every true art worker in Britain the Old Testament commandments would be followed by the New, to be found in the many Gospels according to John Ruskin, and the truly inspiring Acts of William Morris. One hates to trot these old war horses out, but one cannot not. It is plain fact; they did inspire so many.

It was Ruskin who had taught himself that the key to the whole kingdom of art was to begin by using a pencil, and to study, without prejudice, exactly what one saw. And it was Ruskin whose sermon from the Crown of Wild Olives (and elsewhere) was able to convey that the fundamental critique of art must rest in moral values. Finally it was Ruskin who would harp on the virtues of the mediaeval guilds, and even form his own Guild of St George. Translated into many languages, and running through countless editions, all these gospels passed abroad with a unique resonance. The eye first, and intuition . . .

Yet it was Morris who was perhaps the true fisher of artists and of men; Morris with the energy of seven (if not twelve) who pursued beauty without ever letting up, the original do-it-yourself man, poet and reviver, through perpetual experiment, always seeking elusive perfection, of so many lost arts. It was Morris who would help to found the Arts & Crafts Exhibition Society where all creators in the several fields could feel the strength of their work when put together. It was Morris whose political concerns placed art in the largest perspective of social progress, appealing quite beyond mere national bounds. And it was Morris whose own experience was proof that love of nature and joy in working with one's hands were roots of art. Hands with eye, and love, and exploration . . .

In this, Morris' own example with his tapestries, textiles, and wallpapers in which there was so much informal direct drawing from nature, was itself in flat

contradiction of South Kensington rules. And certainly the whole drive of his life had been never to accept rules spelt by others, always rather tease out questions for himself from basic scratch after studying great monuments from the past. As to Ruskin's judgment of them, he would write *'The Professorship of Sir Henry Cole at Kensington has corrupted the system of art teaching all over England into a state of abortion and falsehood from which it will take twenty years to recover'.*

Now here we may find an ironical connection. The origin of Ashbee's Guild of Handicrafts lay in classes for skilled tradesmen at Toynbee Hall, where he would hold readings and discussions of Ruskin's work. He told the story in 1901 in *An Endeavour Towards the Teachings of John Ruskin and William Morris.* In it he wrote, 'What those of us who read our Ruskin found when we tried to apply his ideas to practical education was not encouraging. We found apprenticeship defunct, the time-honoured manner by which a youth learned his craft, destroyed by sub-division of labour and mechanical production, we found the teaching function and the workshop function everywhere divorced, which for the proper study of industrial art should be united, and instead of their union we saw only the flaccid and mechanical South Kensington system by which paper designers were not exactly educated, but incubated in the 'Government Grant' hot houses. We found the application of the principles of art to materials nowhere taught – those principles, the understanding of which is the glory of every great aesthetic period, and gives to the workman the subtle sense of true craftsmanship'.

In the small private school which he had led more than 700 students had passed through (many to teach in turn), and 'To have had William Morris, Sir William Richmond and Mr. T. G. Jackson down to talk, or a practical demonstration from . . . Mr Walter Crane, had the highest educational value in the training of the Guild's young craftsmen'.

We see from this that the storm over Donaldson's New Art was not mere mouthing from 'Disgusted, Tunbridge Wells'. It was the cry of all the conjoined Morris men. Moreover it was a cry to the general effect that the real Holy Grail was on our side of the Channel; that this French stuff was basically meretricious sensuality; that we British could say our true national tradition of design was founded on disciplined, ethical values of social decency. We did not have to listen any longer to other people (like the French) telling us all the time what was really modern, really smart, perfectly chic.

In point of fact the judgment of history on a later view would say that the British reservation over Art Nouveau in its wilder French excesses, far from being a silly parochial squawk was absolutely right. And indeed one may add that it was Morris, of all British artists, whom the French wished to see, and to whom conse-crate a retrospective exhibition in their Louvre in 1912.

It is proper to speak of the British Arts and Crafts endeavours as more than just the sporadic appearance of a few disconnected individual talents. They amount to a movement of ideas which was recognised at once in other countries. Within the first sixty years of this century it has to be discerned as the only such general movement, such general direction of efforts in work and thought, to come out of Britain and be offered to the world.

In order to justify this (inescapable) statement, one has to be reading those ideas in far broader terms than could be taken from Morris' personal model. It is strictly a statement about *post*-Morris Arts and Crafts. For Morris himself had a deep knowledge of and absorption in international decorative traditions. After him, there was a clearer determination to look for more ordinary, truly national roots, at least closer (if not close) to common man, and it was quite prepared to leave off ornament altogether and just show plain, virtuous, well-made simple form. One would be thinking, for example, of Mackintosh's light fittings based on squares; of the robust 'country' solid wood furniture and blacksmiths' iron of Gimson, Barnsley and Waals, inherited from tithe-barns and ship-building; of the quill-pen uncials of Edward Johnston, or the clean page of Cobden-Sanderson's Doves Press. [*Pages 11, 12 and 96.*]

One would have to recognise the fundamental hold these ideas gained over the

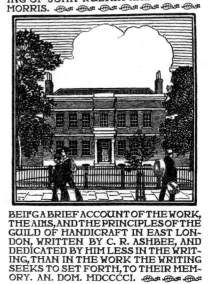

Frontispiece to 'An Endeavour . . .' by C. R. Ashbee, 1901. The woodcut block is by George Thomson, and the essay was the first book printed at the Essex House Press in the new type designed by Ashbee, in an edition limited to 350 copies.

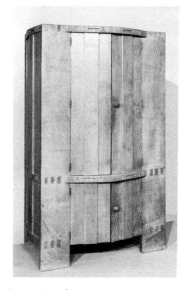

Ernest Barnsley (1863-1926)
Wardrobe, 1902. W. 39-1977
This piece was designed by Barnsley for Upper Dorval, his own house at Sapperton near Daneway, Gloucestershire.

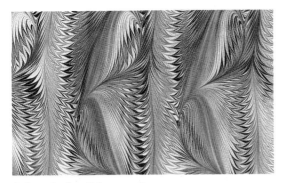

Sydney Cockerell (born 1906)
Marbled endpapers, c. 1938. Made by Douglas Cockerell and Son. E. 3439-1938.

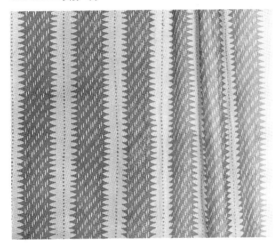

Phyllis Barron (1890-1964) and Dorothy Larcher (1884-1952) *Pointed-pip*, 1930s. Furnishing fabric: hand block-printed linen. Circ. 301-1938

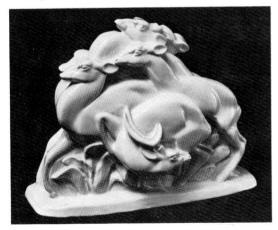

John Skeaping (1901-1980)
Axis deer, 1927, Made by Josiah Wedgwood and Sons. Moulded earthenware.
Given by John Skeaping. C. 426-1934

upper echelons of our education system through the writings of such men as W. R. Lethaby, or Lewis Day, or Roger Fry, or Herbert Read. One must note their correspondence to the idealised plans of Ebenezer Howard for Garden Cities. One has to see them as having imbued not only the private do-gooding pressure groups like the D.I.A. but all the official bodies they prompted into being, like the British Institute of Industrial Arts, the Council for Art & Industry – leading to the Council of Industrial Design; not only a number of our leading manufacturers, publishers, printers, or store heads, but in the end a significant skein of customers on whom such artists have to depend for patronage.

People sometimes identify 'Arts and Crafts' a little too closely, if vaguely, in the back of their minds with the Guild of Handicrafts, since it was Ashbee who took the principles to their furthest social point. For that reason, it is too easily supposed that the whole scene virtually collapsed when the Cotswold experiment went bankrupt in 1908 – still full of the joys of country work, but unable from there to reach sufficient buyers – and thus proved the ideas were empty, just not viable. Yet in fact the general inspiration would stay strong, and wide, for many years further. [*Page* 17.]

This ampler reading of the movement, then, would embrace many of those later creators active through the 1920s and 1930s, and even well beyond; like Bernard Leach and Michael Cardew, divining the lost secrets of English slipware; Katharine Pleydell-Bouverie working through ash glazes; Eric Gill cutting new type-faces with such masterly finesse and barely controlled passion; Sydney Cockerell rediscovering the dazzling world of marbled papers, besides making fine bindings; Ethel Mairet, Elizabeth Peacock, or Marianne Straub making endless experiments with vegetable dyes, and weaving structures; Phyllis Barron, Dorothy Larcher or Enid Marx bringing hand-block textile printing up to date. Rebecca Crompton opening so many eyes to the use of embroidery as a medium of adventurous expression; Edward Bawden, John Farleigh, Eric Ravilious re-exploring old chapbooks and broad sheets for a new popular vitality of engraved image; the painted furniture of Duncan Grant and Vanessa Bell, just as much as the industrialised version of Cotswold in Ambrose Heal and Gordon Russell or the second generation work of Edward Barnsley; John Skeaping carving animals in wood, Richard Garbe sculpting in ivory; Henry Wilson, Omar Ramsden, or Robert Gooden each sustaining and extending silver crafts; Harold Curwen, St. John Hornby, Robert Gibbings, running their presses with such absolute distinction. [*Pages* 55, 116, 131, 190 *and* 205.]

When one has gone this far, to have drawn an inclusive defining line around such talents is to see clearly that the 'movement' is much larger than this season's or any seasons' flavour, a question of readied modes or passing styles. There is no reason for us to expect that more than one such tide would rise over a couple of generations. It has moreover the special validation of being attached to a sense of standing values – as basic as truth to materials, simplicity of concept and mien, generosity with work-time applied because of pleasure in it, honesty of construction, openness of eye to nature's beauties, responsibility for self-judgment, devotion to a workshop ideal of training others – that cannot be lightly dismissed or treated as irrelevant. It can even be given, in its origins, a root to a clearly distinctive British School of painting in the Pre-Raphaelites. As all such, it may be that much easier to identify this band with our national character, and think that they come nearest to our soul whatever our own surface inclinations.

Yet against this, firstly, the attachment to arts and crafts may in fact only describe one aspect of those talents, who were individually more complex. And secondly, this scene is not all good, not, at least, as good as it envisioned. In his autobiography Eric Gill would write of the Arts and Crafts Exhibition Society events as having deservedly high fame and great prestige. 'And the standard of works shown was, accepting their detachment from the common life of our times, a very high one. In furniture and textiles, in pottery and, after Edward Johnston's appearance, in lettering and writing, no better work was being done anywhere in the industrial world – for it was being done in the industrial world

even though it was not being done by the industrial method. But what was the result? . . . In the first place, the sale of the things made was, quite inevitably, almost exclusively, among the rich middle and upper classes. You can't possibly make good tables and chairs and pots in price competition with industrial mass-production; and any argument . . . that one good thing made 'to last' is better than a dozen unenduring and unendurable things made cheaply in the factory, had no effect whatever on the poor. [The result was they] made only 'luxury' and luxurious articles such as only the rich could want. [There then] came into existence all the Liberty and Heal tradition of supplying by factory methods goods which, to the ordinary refined inhabitant of the suburbs looked just like the genuine arts and crafts. Thus industrialism got a nice new lease of life among the pseudo-educated, . . . and were able to do what it is death to them not to be able to do – make the world look better than it is. And that was the main result of the Arts and Crafts Exhibition Society – to supply beautiful hand-made things to the rich, and imitation ditto to the not so rich. But as for wrecking commercial industrialism, and resuscitating a human world – not a hint of it . . . the movement was a failure.' [*Page* 107.]

To be fair, this judgment was from 1909, and Gill himself went on to adapt with everyone else to broader changes in society. But it will also be seen, in any case, that the seine net we were drawing just now was at best sectional. It did not bring in, by any means, all the main creative talents of this time.

It could not embrace those interior designers who practised, often with great flair, those revivals of past tastes such as the Neo-Georgian or Neo-Regency styles which were intended to match architecture in these manners. It had no relevance whatever to the large areas of graphic arts as in photography, posters, packaging, or advertising arts where we have excelled.

And yet more importantly still, it made no bracket for the real *avant-garde,* which on principle wanted no part in the past, and longed to build a quite new art, in new forms, by new methods, from new stuffs. To confront this area, and finger our seine net cord, one would have to admit that it is harder to draw such a line around easily so many 100 per cent true innovators in Britain as one could with the arts and crafts traditionalists. Wyndham Lewis' short-lived Vorticist group of painters, with Gaudier Brzeska as (even shorter-lived) resident sculptor, is always described as Britain's only original fine art movement of the twentieth century. But despite Lewis' fiercely expressed assertions, it is difficult to view its achievements as other than a pale mirror to French Cubism and Italian Futurism. In almost all other movements that would rise here and there in the international firmament, one would have to jibe that they always in practice rose *there* and were reflected *here* by the adhesion of a few local followers. Against this, there were individual artists, to name only Ben Nicholson, Henry Moore, and Graham Sutherland, who could be claimed to have painted their way out of their British corner into world reverence, without owning an ism to their skins.

Among architects within the European modern movement we had many who kept good pace with the front runners, without themselves *setting* the international pace when compared with such visitors from overseas (who worked in Britain for some while) as Gropius, Mendelsohn, Chermayeff or Lubetkin. It was rather in our postwar schools' building programme, and new towns' development planning that major local authority teams would win fresh international attention; while the New Brutalism of the 1950s, grouped around Peter and Alison Smithson, represented a sort of Modern Movement, Phase Two. [*Pages* 199 *and* 200.]

As to the decorative arts, one might cite the glass furniture of Denham MacLaren as quite outstanding in any company; yet he stands out very much as an exceptional individual who worked as a loner, and withdrew from design altogether after a few years only. And the same would be true of Gerald Summers and his daringly simple laminated wood furniture. Or there is the isolated case of Jack Pritchard's Plymax cabinet, with its thin bonded metal walls, and absolute negation of any decorative qualities beyond simple proportions and the choice of

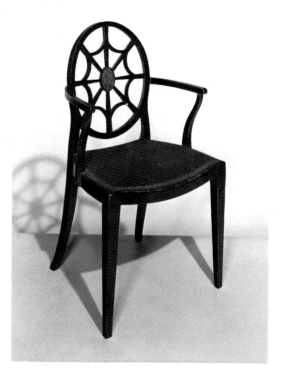

Sir Edwin Lutyens (1869-1944)
Arm-chair, 1905. Ebonised and painted beech. Given by *Country Life*. W. 6-1944
This chair, one of a set of 21, was designed by Lutyens for the Board Room at the *Country Life* magazine offices.

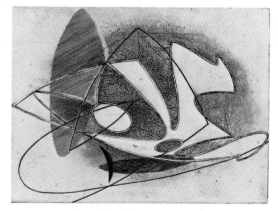

Stanley William Hayter (born 1901)
'Viol de Lucrece', 1934. Engraving and soft ground etching. Circ. 101-1939. Hayter's experiments have considerably influenced attitudes to printmaking in the mid 20th century. After graduating in chemistry Hayter set up an informal printmaking studio in Paris in 1927. It has attracted such 'students' as Picasso, Miró, Dali and Ernst.

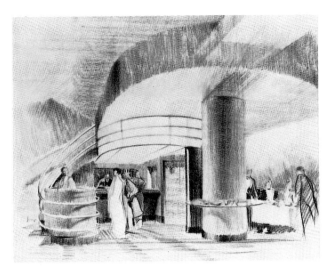

Raymond McGrath (1903-1977)
Design for Fischer's Restaurant and Long Bar, New Bond Street, London, 1932 (perspective view of cashier's desk and cloaks counter). Pencil, crayon and gouache on tracing paper. Circ. 565-1974

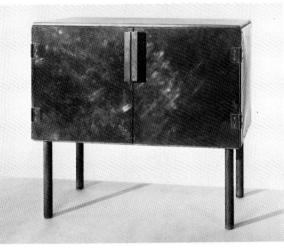

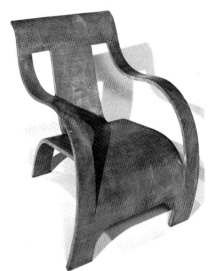

Jack Pritchard (born 1899)
Cabinet, 1929. 'Plymax' metal-faced plywood. Made by Crossley and Brown Ltd. Circ. 507-1967

Gerald Summers
Arm-chair, 1934. Made by Simple Furniture Ltd, London. W. 26-1978

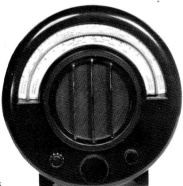

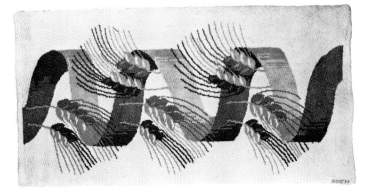

Wells Coates
(1895-1958)
Wireless set 'Ekco AD65', 1934. Made by E. K. Cole Ltd of Southend-on-Sea. Bequeathed by David Rush. W. 23-1981

Marion Dorn (1899-1964)
Rug, 1934-5. Made by the Wilton Royal Carpet Factory Ltd. Circ. 480-1974

a new material – as austere a solution as ever Gropius might have sought. Yet the fact is we produced no innovators in furniture of the calibre of Mies Van der Rohe, Gerrit Rietveld, Le Corbusier, or Alvar Aalto. [*Pages 126 and 128.*]

There were of course the exciting bakelite wireless cabinets made by Ekco and taken to an instant extreme in the designs of such architects as Wells Coates or Serge Chermayeff. There were the rugs and textiles of our long-staying American visitors Marion Dorn and that supreme poster artist Edward McKnight Kauffer. There was the matchless pottery and glass Keith Murray would design in the 1930s when he could not get enough jobs as an architect. One could point to Christian Barman's fan heater, or electric iron, for H.M.V. We had the ubiquitous and visionary painter Paul Nash who would take up any industrial challenge and try his hand at almost everything. [*Pages 71, 150, 154 and 157.*]

But to characterise these together as a movement of any depth, or try to make them look a rising tide, would convince few. Nor is the number of creative talents the only measure; for talents to shine there have also to be clients. And in this field it might be true to say that real supporting clients for the *avant garde* were just as rich, if fewer, than Gill mocked over Arts and Crafts.

The sting in his remarks was that what the rich have owned was irrelevant to ordinary people – as it must be in their everyday lives. The only really significant creations, he implied, would be mass-produced utilities that benefited all, could be owned by all, and should probably be boringly familiar to all. In the century of H. G. Wells's Common Man, distinguished by the Russian revolution, would it not follow that the modern works picked here to prove our culture must be significant in just that way? It is certainly a line of thought to which some responses will be found in this selection; posters for example are a true street, truly popular art; so in a differing sense is Johnston's sans serif type for London Transport. And there is at least one token of purely commercial design aimed at business clients and touching the consumer only as its working operator. The mix moreover does contain some items up at the end of our period which received (like David Mellor's cutlery, Neal French's tableware, or Audrey Levey's wallpaper) a Design of the Year Award from the Council of Industrial Design. Instituted in 1957, the Awards have been a highly successful way of encouraging the public's appraisal of ordinary consumer products, and focusing attention on the best. [*Pages 216 and 219.*]

On the other hand, the Museum itself represents an ultimate form of public ownership, where everyone is free to enjoy the contemplation of unique things that were, perhaps, once used by kings, but have now become a shared social possession. And if rich people paid the original costs, it cannot matter now when we have all inherited. One might in fact easily have imagined that 'such objects as are highly finished or distinguished by exquisite taste; likewise every description of elaborate ornamental workmanship . . .' were no longer made in modern times. However, Robert Goodden's silver tea-service is splendid proof that it goes on, and steals our admiration just as much. [*Page 182.*]

Should we have thought that in an increasingly secular age we could not expect to find objects made by artists in God's honour? We will see things like Gill's Bible, Sydney Cockerell's binding, Francis Spear's stained glass, or Sutherland's tapestry trial which remind that rituals have not at all died out; on the contrary, under challenge, their vigour is more sharp.

Conversely, in an increasingly technological society, might not the visitor expect to see everywhere signs of those liberating miracles by which this period has sprung clear from all past time? If not satellites, optical fibres, moonsuits, then at least what electricity has brought into our living rooms? It is a zone that could perhaps stand beefing up in the collection. There are some token light fittings included; a number of radios, and occasional television sets. What one does notice, however, especially about these objects is the extent to which familiar currency may blind us to what march they represent. So that one does not perceive the radio as a net for radio waves, and layers and layers of impulses worldwide carrying non-stop communications, productions, creations. It is just another

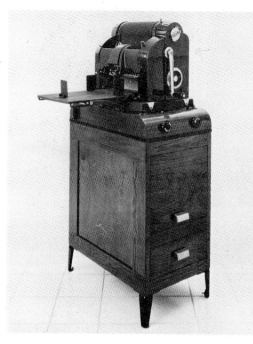

Raymond Loewy (born 1893)
Duplicator, 1929. Made by Gestetner Ltd. Given by Gestetner International Ltd. W. 47-1981

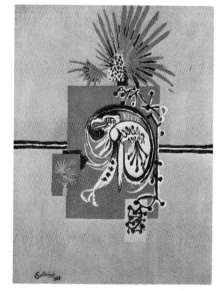

Graham Sutherland, OM (1903-1980)
'Red, Green and Black' Tapestry, 1958. Circ. 400-1962
Based upon a section of the original design for the Coventry Cathedral *Christ in Majesty* tapestry and woven by the Edinburgh Tapestry Company Ltd at Dovecot Studios. The Company tendered for the commission by the cathedral's architect Sir Basil Spence, and made a number of trial pieces, but the contract went to Pinton Freres at Felletin.

Eric Gill (1882-1940)
Cast-iron fire back. M. 5-1983

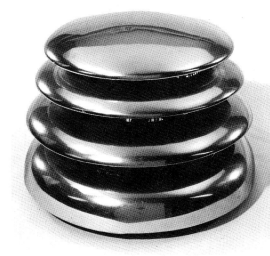

Christian Barman, R.D.I. (1898-1980)
Electric fan heater, 1934. Made by H.M.V. (His Master's Voice). W. 71-1978

receptacle with knobs on, a cabinet like so many already in the Museum.

One good way to get a little over this is to imagine just any of these items set down amongst the Victoriana of the previous galleries, and see how *really* different each might then appear. But even in the space of this display, it is perhaps possible to gulp the gulf in time by putting side by side two heaters that we see; Eric Gill's own cast-iron fireback, made for his home hearth by age-old means; and Christian Barman's electric space-heater, in chromium-plated steel, using a fan to blow the warmed air, and mollusc-shaped deflectors to distribute it. Around the same date, the one unique, the other mass-produced, the two stand surely a whole age apart.

I suppose I have made clear that arts and crafts, on a broad interpretation, plus our own version of the modern movement, appear the two main tides running through the whole span of these sixty years. But what was happening up at the end of that span, nearest to now? Ought one to be pointing the finger to the first signs of the real next direction, if there was one, after that?

I feel at least some mention should be made of Britain's response to Paris 1937. 1951 would come up as our big chance to have a re-run celebration of the original 1851 Great Exhibition. We took it. But this time we would not have any of those foreigners running about, not on our side of the counter. This time it would be just about Britain, a Festival of Britain, show what we could do in a more developed, much more ambitious way, than was scraped together in 1946, at the V&A, as 'Britain Can Make It'. It would do what the old French National Exhibitions had done, and ignite national pride with no confusion.

All our architects were charged to build pavilions and do decorative schemes, if not on the South Bank itself then round the country. Every painter, every sculptor, every designer, every craftsman of any note, was given the opportunity to do something big, and no restraints. Every industrialist equally. And the organisers even thought to orchestrate a novel fashion style. It would be nothing that battened on to modish fine art styles, or jazzed up any exotic man-made taste. They set up a Festival Pattern Group to coordinate – along with their groups on typography and everything – and found their source of inspiration in geology, crystals to be precise, perceived by modern means through microscopes. How thrilled Ruskin would have been to see: Nature! Abstract! New! Fantastic!

A lot of flat pattern areas like printed textiles, wallpapers and plastic laminate design were certainly heavily affected, and given a new confidence in invention that would last. They could go amoebic and dotty now all over. The Festival also let large numbers get used to metal furniture, like the chairs by Ernest Race.

Writing in 1924 upon the success of our Empire Exhibition at Wembley (the British family version of the world) Sir Lawrence Weaver said 'It is the business of great exhibitions to give opportunity to the innovator, to accustom the timid to new ideas, to provide at least a platform and at best a continuing vogue for inventions of real desert'. (Weaver was building up to a puff for reinforced concrete.) With the passing of a few years of the 1950s, one might agree the metal furniture would emerge a tested invention of real desert that gained a continuing vogue, but the crystals would sink back as one more fashion. Leslie Martin's Festival Hall remains the finest memorial of all. But, new tide? Hardly.

What one can say on the other hand is the education picture changed, and so did our international orientations. Design training was brought to a higher academic level, and pushed to mesh more closely inside industry. There was less stress on individual creation, more on raising industry at large. The real inter-national exchange of decorative goods, up to 1950, had been tightly limited by economic walls. But as the economics slowly warmed, and then relaxed, we became very much more aware, for example, at first hand of Scandinavian, Italian, and American, design. Our traditional insularity began to melt away, and targets became more cosmopolitan. It was less of an issue to rediscover national motifs; more a pointing of energy to swim in the larger world.

Robin Day's furniture designs first won worldwide attention when shown and given first prize in an international competition at the Museum of Modern Art, New York. Not only would they go on to deck, e.g. the Royal Festival Hall, and

receive an exceptional number of Design of the Year awards, but to gain (as we would say for Britain) a gold medal at the Milan Triennale 1951, plus two silvers in 1954. His polyprop chair of 1963 would eventually sell *more than eleven million units in over forty countries*. It would need a subtle mind to see them at first glance as quintessentially British. Plain, simple, ordered, economical, clearly they are. But above all they are rational, studied down to the last detail in terms of production process. So is that British, also? Not everyone would have said so in the past. They belong in a world of multinational companies and global patent rights.

Or take the Smithsons' designs for the House of the Future in 1956. Their study base at that time followed from Georgian Bath; from Corbusier's Unité block built in Marseilles; fascination for Dutch De Stijl furniture round the end of the First World War; the 1920s housing of Oud, and Gropius; the spatial concepts of traditional Japanese gardens and architectural forms, and the consumer fantasies of postwar American magazine advertising. Roll it all together, and you have the peculiarly British (?) phenomenon, New Brutalism; or, should we not rather say, a British reading of international consumers' crystal balls? [*Pages* 199 *and* 200.]

In these advances by the humblest pursuits of our industry, a belated encouragement for art in its loftier attributes would play a marked part. It was not until 1946 that the Arts Council of Great Britain was to be formed by a Royal Charter, with the aim of increasing public access to the arts. Alongside this was a significant move at the Tate Gallery. The Tate, holding the national collections of British and modern foreign art, was built entirely by private donations just prior to 1900, and was badly bombed during the Second World War. It was not until 1946 that it would receive one penny by way of purchase grant from the government; so that it was wholly dependent on gifts, bequests, and trusts. Even, indeed, as late as 1960, at the end of the period in this book, the grant was still pathetically small – a few thousand pounds per annum total. The surprise can only be that the standard of its collections was as high as it achieved. But it was not until the major exhibitions programmes of the Arts Council got into gear in the 1950s, and the Tate's collections gradually blossomed, that the public in general would have any real experience of modern international art. Thus, to say that attitudes before this had been insular or parochial was merely a matter of geographical fact, compounded perhaps by an uneasy and incestuous feeling of a special relationship to a dissolving empire of old descendant dominions.

For it was too easily the undertie of the Glasgow or Wembley Empire Exhibitions that if they did not always go for us in Paris, at least our conservative instincts would be properly appreciated in New Delhi, Durban, Saskatchewan, Adelaide, or Canterbury (N.Z.). The official report on Paris 1925 had had to say 'The wave of what is known as "Modern Art" has swept across Europe in the last twenty years, almost unbeknown to the majority of English people . . .' As to the Arts Council's major exhibitions programmes, it may be remembered that these were in their early days peripatetic. One of its first real crackers, indeed, was the Picasso and Matisse show of their war years' work, held at the V&A, in 1945/46. But the Tate's show of The New American Painting in 1958, and the Brussels Expo of that same year, would be important levers in the shift of our established orientations.

The preachings of the Council of Industrial Design (formed 1946), through the publication of its magazine *Design* and the opening of its Design Centre in London, were clearly a significant stimulus in fostering rising standards. So too was the educational pressure of the Society of Industrial Artists and Designers, the network of the Design and Industries Association, and the bursary competitions of the Royal Society of Arts. Yet a leadership in calling for higher academic levels came from the Royal College of Art, insisting designers must sway management boards, or we would get nowhere.

So one by one, and very very gradually in their effects, the disadvantages which the 1836 Committee noticed we suffered were all of them sponged away. But I am going to suggest that one last step (one final excuse) had been still missing. We still had really nowhere where the public, and the student, could get a museum's-eye view of the course of modern design.

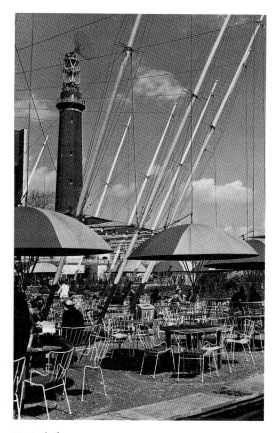

Festival of Britain, 1951, South Bank Exhibition. *Café* outside the Lion and Unicorn Pavilion; Architects R. D. Russell, RDI, and R. Y. Goodden, RDI, with the Shot Tower in the background. Metal chairs with moulded plywood seat, Ernest Race, Ltd. [*Design Council Archive*]

Milner Gray (born 1899)
Design for S.I.A. journal heading (not used), c. 1937

Cole had kicked off in the nineteenth century with the right ideas. But his vision of how a museum should relate to the improvement of modern manufactures was distorted by the show-stopping exhibition pieces of the French National and Universal Exhibitions. Such objects might carry everything there was to say about elaborate workmanship, and impute an ever-expanding capacity of skills. But they were also totally unnatural, really no one's taste. Where Cole would seem to be offering foreign fancy, the British preferred their own domestic plain. So violent a switch, of course, would lend their very meaning to the simplifications of our arts and crafts. In place of hot-house over-ornament, we would bring out our informal country-living style, 'genuine', 'honest', 'four-square', solid oak and chisel, hammer and iron stuff. In place of exhibition pieces, impossibly refined, demonstrating the highest historicist sophistication, we would put more transparently expressive images of enduring national character up to the fore, as bearing our pride.

But then, what after that? Cap that? Follow that act? Would it ever be enough, with those native veritable virtues, just to go on enduring?

Sullivan, Voysey, Loos, Gropius, all foresaw that after needless ornament had been swept away, at least for a while, one might reach a new situation when different spiritual hungers would call to be answered. That day has certainly come, and we perceive ourselves in a 'post-Modern' world. What the pre-Moderns possibly did not foresee was just how far it might fall out a global village.

So does it any more make sense to be thinking of a 'national tradition' and 'national character' to our design, as though these origins still mattered when practically the galaxy drives Japanese, or beams up Texas? There is every temptation to think exactly that, yet who in their hearts would dare say no, it does not matter? People have to believe they are still individuals. People do still need to picture who they are. We want to place respect for what our society can do; to dole out an approval measured by what we ourselves approve. And we still need, all the time, to develop our belief, recheck that measure.

Here it is what only museums can do. It does not have to be twenty-eight rooms in the most magnificent palace in Europe, filled with every modern thing that taste and luxury can make perfect. It does not have to be a sort of permanent Asprey's. It is not where our industrialists are going to come regularly scouring to pick up clever production tips, or quiffs of style. The function of conveying the very latest consumer technology goes on in Earls Court, Olympia, Birmingham, or, come to that, Harrods. But only museums can set present-day creations in an unbroken line of comparisons with the past, or lay out what our people admire against the best of the world. Only they can properly confer that particular dignity of self-respect. For a tradition is not a sum of everything we were used to having in our own homes; to make; to do; to imagine. It is a sum of those things as a people we admire in public places; take pleasure in; see to express some feelings we have had ourselves on what could make the world a better place in time to come. And a museum is where we should look to find such things, around which historians may try defining words, and we perhaps may glimpse, as in two mirrors, a slightly surprising side-view of our own nose.

What we have lacked, in short, as a country, till right now, is just such a display in a national museum as this book samples. About the things in it, everyone should make up their own minds, for that is the very process of historical resonance. It is there for the visitor or reader to pick out his own likes, tease why some items may not please, prompt memories, puzzle out intentions.

And what we will now only, last of all, still lack, is a second run of foreign counterparts, from this same time. But the Museum is working on it . . .

Photograph 'Lincoln Cathedral, Stairway in S.W. turret'
By Frederick H. Evans (1852-1943)
c. 1900
Photogravure
Given by the photographer
Ph. 595-1900

Frederick H. Evans began photography because of his interest in cell
structures and he became well known for his micro-photographs
before turning to the Gothic monuments of England and France,
which are the principal subject of his subtle platinum prints and
photogravures. His photographs of architecture reveal structure,
materials and ambient light and remain among the finest ever made.
Evans belongs in the tradition of fine photographic printing of the
late 19th century; the unadorned modernity of his 'straight' approach
ensures that he is still a contemporary.

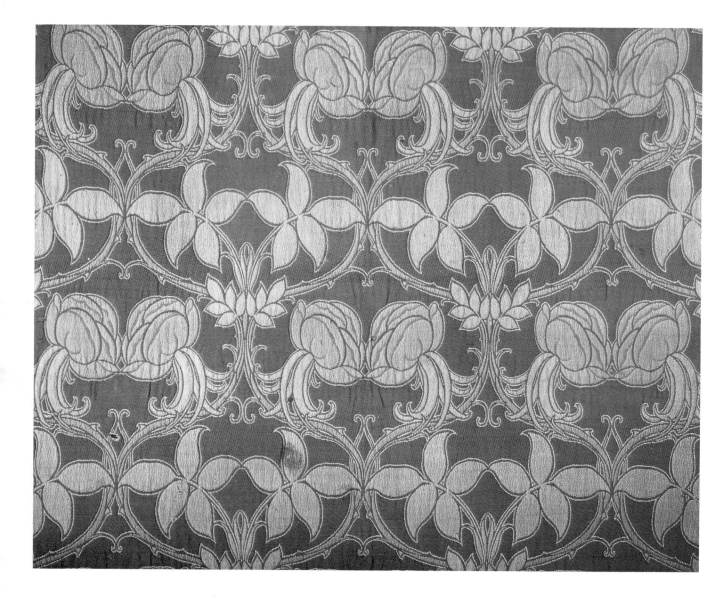

Furnishing fabric 'Tudor'
Designed by Lindsay P. Butterfield (1869-1948)
Made by Alexander Morton & Co
c. 1901
Woven wool and cotton double cloth (reversible)
Given by Miss Mary Harrison
T. 92-1973

Alexander Morton & Co made frequent use of the double cloth technique for soft furnishings throughout the 1890s and early 1900s, when it was seen to greatest advantage in the subtly coloured, flowing designs of C. F. A. Voysey and Lindsay P. Butterfield. Light yet warm as well as durable, over the years this type of fabric proved its worth and was still in production (with suitably up-dated designs) in the 1920s.

Interior Designs Mackay Hugh Baillie Scott (1865-1945) *top*
Charles Rennie Mackintosh (1868-1928) *bottom*
For the Music Room in the House of an Art Lover
1901
L. 200 & 794-1902

Plates from *Baillie Scott, London, Haus Eines Kunst-Freundes* and *Charles Rennie Mackintosh, Glasgow, Haus Eines Kunst-Freundes*; volumes I and II in the series *Meister der Innen-Kunst*, by Hermann Muthesius. Text, London; published by Alexander Koch, Darmstadt. The design of an art-lover's house was the set subject of an international architectural competition proposed by Koch in the German magazine *Innen-Dekoration* (Interior Design), in which Baillie Scott and Mackintosh were judged first and second respectively.

Hermann Muthesius (1861-1927), as superintendent of the Prussian Board of Trade for Schools of Arts and Crafts, was a moving spirit in the foundation, in 1907, of the Deutscher Werkbund. From 1896 to 1903 he had been attached to the German Embassy in London for research on English housing, and sent back extensive reports on the British Arts and Crafts movement. He wrote up Ashbee's Guild and School of Handicrafts in the magazine *Dekorative Kunst* in 1898, and in 1900 published The Arts and Crafts Movement in England (*Der Kunstgewerbliche Dilettantismus*) with especial reference to the London Home Arts and Industries Association, which held annual exhibitions at the Royal Albert Hall. In the same year he published two folio volumes on English contemporary architecture, followed shortly by another on English church architecture, and three volumes on English houses (*Das Englische Haus,* 1904-5). He contributed the English section in R. Graul's *Die Krisis im Kunstgewerbe,* and generally played a key role in translating the doctrines of British arts and crafts into the guiding principles for German industry, pointing forward to the modern movement in architecture in which he himself would take professional part.

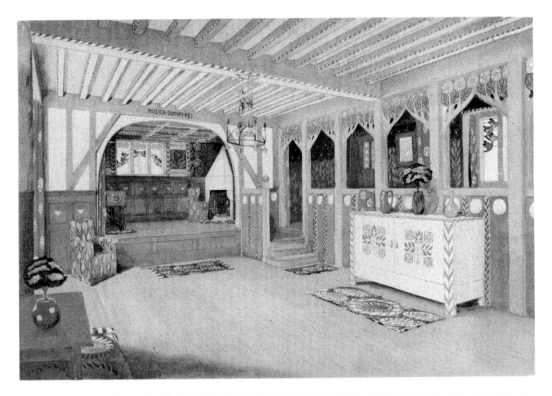

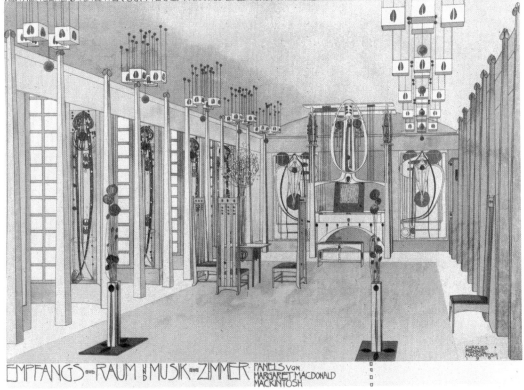

IDEEN WETTBEWERB FÜR EIN HERRSCHAFTLICHES WOHNHAUS EINES KUNST-FREUNDES

EMPFANGS ... RAUM UND MUSIK ... ZIMMER. PANELS VON MARGARET MACDONALD MACKINTOSH

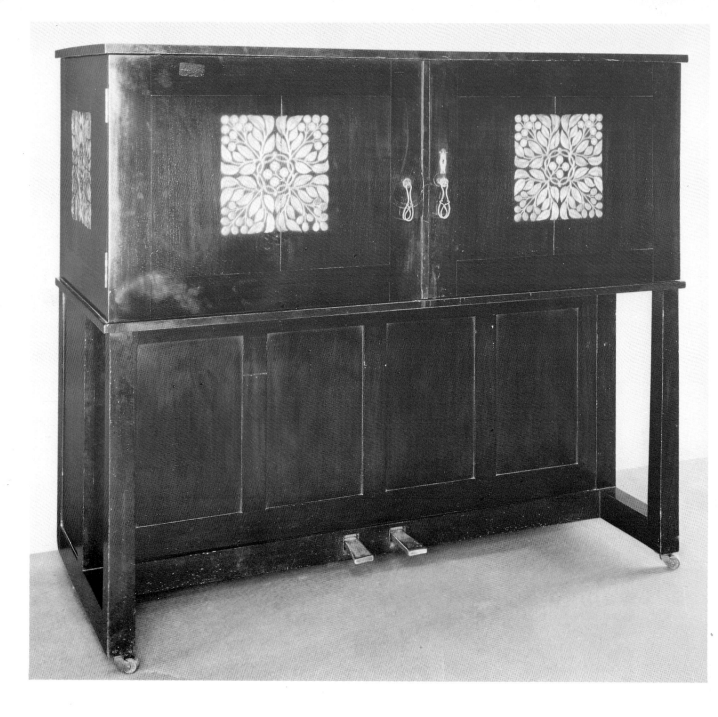

Piano 'The Manxman'
Designed by Mackay Hugh Baillie Scott (1865-1945)
Made by Broadwood and Sons, London
1902
Ebonised wood decorated with mother-of-pearl
and various veneers
W. 15-1976

This piano was made for the exhibition of British decorative art which took place in Budapest from September to November 1902. The 'Manxman' form had been used by Baillie Scott since 1896. This is perhaps the most elaborate surviving example of Baillie Scott's furniture and the only piece in the collection of the Museum. He was as well known in the Austro-Hungarian Empire as Mackintosh, their work having been widely published, and it was with Mackintosh that he showed at Budapest. This exhibition gave Hungarian designers an opportunity to see examples of British decorative arts in the flesh. The cover of its catalogue was designed by George Walton.

Ceiling light Designed by W. A. S. Benson (1854-1924)
Made by Benson & Co
c. 1902
W. 38 cm
Copper and brass
M. 16-1979

Benson, in 1878 (during his last year at Oxford), became articled to the architect Basil Champneys, remaining with him until 1880. At this time he shared lodgings with the painter and etcher Heywood Sumner, who introduced him to Burne-Jones, who in turn introduced him to William Morris. Benson became a close associate of Morris, who encouraged him to establish a small workshop for the production of turned metalwork, which he did in 1880. However, unlike Morris, Benson fully accepted the implications of mechanical production and designed exclusively for it. He prospered. Shortly after starting, a factory was built in Hammersmith and in 1887 a shop was opened in Bond Street with the façade designed by Benson. On his retirement in 1920, the firm went into liquidation.

Cabinet on Stand	Designed by Ernest Gimson (1864-1919)
	Made at the Daneway House Workshops, Gloucestershire
	1902
	Walnut with gilt gesso panels, the stand ebony
	W. 27-1977

The Daneway Workshops were established at Daneway House in 1902 by Gimson and Ernest Barnsley, and this piece was probably one of the earliest made there. The gesso panels were modelled by Gimson himself. A design by Gimson for a very similar cabinet is in the Cheltenham Museum and Art Gallery. The sophistication of the design contrasts with much of the output of the Daneway Workshops at this period. A more typical example of Daneway furniture is the Barnsley cabinet (W.39-1977) illustrated on *Page* 16. The panels of walnut, the gesso panels and the oriental character of the stand all look forwards to the 1920s rather than back to the arts and crafts movement of the late nineteenth century. It demonstrates how mistaken it is to categorise even a designer like Gimson, so closely involved with the craft movement, too narrowly.

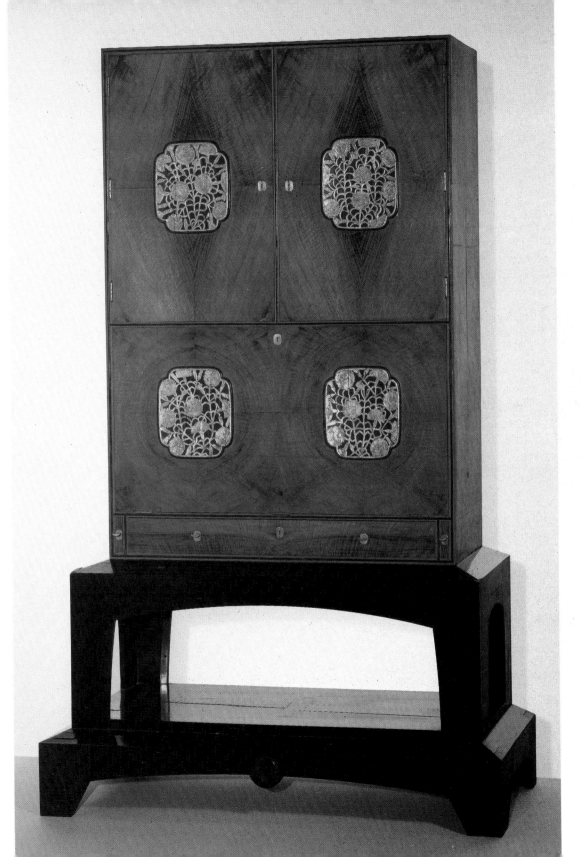

Bookbinding Thomas James Cobden-Sanderson (1840-1922)
Doves Press Bindery
1903
Blue morocco, gold tooled
On *Pericles & Aspasia* by W. S. Landor
Presented by Mr and Mrs Cobden-Sanderson
L. 1583-1922

Thomas Sanderson adopted the first barrel of his name on marrying Anne, the daughter of Richard Cobden, in 1882. At the same time he gave up a Bar career in order to work with his hands as a bookbinder. A prominent member of the Arts & Crafts Exhibition Society formed by Walter Crane, William Morris and others in 1888, he would deliver to it the first lecture, 'On Art & Life', arranged in the wake of Morris's death in 1896. In it he expressed his debt to the master for the concept of joy through work.

With Emery Walker he set up his own Doves Press in 1900, adding it to the Bindery in Hammersmith Terrace just yards away from Kelmscott House. The second publication of the press, in February 1901 – and later to be translated and reprinted in many languages – was Cobden-Sanderson's own essay tract 'The Ideal Book or Book Beautiful, on Calligraphy, Printing and Illustration and on the Book Beautiful as a Whole'. It set out a reasoned philosophy, however, that differed totally from the gothic Kelmscott approach.

'The whole duty of typography', it said for example, 'is to communicate to the imagination, without loss by the way, the thought or image intended to be communicated by the Author'. It is a philosophy demanding the highest degree of control by the designer, and Doves Press pages, in their immaculate clarity, appeal to the reader rather than the collector; in this they anticipate the principles of functionalism. The only concession allowed to ornament was limited to refined calligraphic initials, supplied by Edward Johnston.

In 1902 he embarked on his most ambitious work, an edition of *The Bible* which came out in five volumes over the next two years. He regarded the Bible as the supreme masterpiece of English literature, and he wanted to give it to his fellow-countrymen 'not ornamentally, for a collector's toy, but severely, plainly, monumentally, for a nation's masterpiece, for a nation's guidance, consolation and hope'.

The Doves type-face, designed for its exclusive use by Cobden-Sanderson and Emery Walker, was based on a renaissance fount employed by Nicholas Jenson. In 1909 however, the partners quarrelled, and out of a black determination Cobden-Sanderson destroyed the matrices for ever, by dribbling them, night after night, into the Thames.

Cigarette box Designed by Archibald Knox (1864-1933)
 Made by W. H. Haseler, Birmingham
 For Liberty & Co (Cymric) Ltd
 1903-04
 Mark: maker's mark of Liberty & Co (Cymric) Ltd;
 Birmingham hallmarks for 1903
 Silver, on a wooden carcass, set with opal matrix
 L. 21.6 cm
 M. 15-1970

Apparently a stock design by Knox for the Liberty Cymric range of silverwork, this box was originally owned by Arthur Lasenby Liberty (1843-1917), the founder of the Regent Street firm. Like most of the Cymric range from 1900 until 1927, the box was made by Liberty's associates, W. H. Haseler of Birmingham.

The box was sold by Liberty's after the Second World War to Mrs Denise Wren, a former pupil of Knox. The Museum bought it from her in 1970.

THE CALENDAR, WITH THE TABLE OF LESSONS

JULY HATH — XXXI DAYS

		MORNING PRAYER		EVENING PRAYER		
		I. Lesson	II. Lesson	I. Lesson	II. Lesson	
1	g	Job 3	Acts 9 v 23	Job 4	1 John 4 v 7	Visit. of V. Mary
2	A	— 5	— 10 to v 24	— 6	— 5	
3	b	— 7	— 10 v 24	— 9	2 John	Tr. of S. Martin
4	c	— 11	—	— 11	3 John	
5	d	— 12	— 12	— 13	Jude	
6	e	— 14	— 13 to v 26	— 16	Matthew 1 v 18	
7	f	— 17	— 13 v 26	— 19	— 2	
8	g	— 21	— 14	— 22 v 12 to v 29	— 3	
9	A	— 23	— 15 to v 30	— 24	— 4 to v 23	
10	b	— 25 & 26	— 15 v 30 to 16 v 16	— 27	— 4 v 23 to 5 v 13	
11	c	— 28	— 16 v 16	— 29 & 30 v 1	— 5 v 13 to v 33	
12	d	— 30 v 12 to v 27	— 17 to v 16	— 31 v 13	— 5 v 33	
13	e	— 32	— 17 v 16	— 33 to v 39	— 6 to v 19	
14	f	— 38 v 39 & 39	— 18 to v 24	— 40	— 6 v 19 to v 7	
15	g	— 41	— 18 v 24 to 19 v 21	— 42	— 7 v 7	Swithun, Bishop
16	A	Proverbs 1 to v 20	— 19 v 21	Proverbs 1 v 20	— 8 to v 13	
17	b	— 2	— 20 to v 17	— 3 to v 27	— 8 v 13	
18	c	— 3 v 27 to 4 v 20	— 20 v 17	— 4 v 20 to 5 v 15	— 9 to v 18	
19	d	— 5 v 15	— 21 to v 17	— 6 to v 20	— 9 v 18	
20	e	— 7	— 21 v 17 to v 37	— 8	— 10 to v 24	Marg. V. & M.
21	f	— 9	— 21 v 37 to 22 v 23	— 10 v 16	— 10 v 24	
22	g	— 11 to v 15	— 22 v 23 to 23 v 12	— 11 v 15	— 11	S. Mary Magd.
23	A	— 12 v 10	— 23 v 12	— 13	— 12 to v 22	
24	b	— 14 v 9 to v 28	— 24	— 14 v 28 to 15 v 18	— 12 v 22	Fast
25	c	2 Kings 1 to v 16	Luke 9 v 51 to v 57	Jer. 26 v 8 to v 16	— 13 to v 24	S. James Apostle S. Anne
26	d	Proverbs 15 v 18	Acts 25	Proverbs 16 to v 20	— 13 v 24 to v 53	
27	e	— 16 v 31 to 17 v 18	— 26	— 18 v 10	— 13 v 53 to 14 v 13	
28	f	— 19 v 13	— 27	— 20 to v 23	— 14 v 13	
29	g	— 21 to v 17	— 28 to v 17	— 22 to v 17	— 15 to v 21	
30	A	— 23 v 10	— 28 v 17	— 24 v 21	— 15 v 21	
31	b	— 25	Romans 1	— 26 to v 21	— 16 to v 24	

THE CALENDAR, WITH THE TABLE OF LESSONS

AUGUST HATH — XXXI DAYS

		MORNING PRAYER		EVENING PRAYER		
		I. Lesson	II. Lesson	I. Lesson	II. Lesson	
1	c	Proverbs 27 to v 23	Romans 2 to v 17	Proverbs 28 to v 15	Matt. 16 v 24 to 17 v 14	Lammas Day
2	d	— 30 to v 18	— 2 v 17	— 31 v 10	— 17 v 14	
3	e	Eccles. 1	— 3	Eccles. 2 to v 12	— 18 to v 21	
4	f	— 3	— 4	— 4	— 18 v 21 to 19 v 3	
5	g	— 5	— 5	— 6	— 19 v 3 to v 20	
6	A	— 7	— 6	— 8	— 19 v 27 to 20 v 17	Transfig.
7	b	— 9	— 7	— 11	— 20 v 17	Name of Jesus
8	c	— 12	— 8 to v 18	Jeremiah 1	— 21 to v 23	
9	d	Jeremiah 2 to v 14	— 8 v 18	— 5 to v 19	— 21 v 23	
10	e	— 5 v 19	— 9 to v 19	— 6 to v 22	— 22 to v 15	S. Lawrence, M.
11	f	— 7 to v 17	— 9 v 19	— 8 v 4	— 22 v 15 to v 41	
12	g	— 9 to v 17	— 10	— 13 v 8 to v 24	— 22 v 41 to 23 v 13	
13	A	— 15	— 11 to v 25	— 17 to v 25	— 23 v 13	
14	b	— 18 to v 18	— 11 v 25	— 19	— 24 to v 29	
15	c	— 21	— 12	— 22 to v 13	— 24 v 29	
16	d	— 22 v 13	— 13	— 23 to v 16	— 25 to v 31	
17	e	— 24	— 14 & 15 to v 8	— 25 to v 15	— 25 v 31	
18	f	— 26	— 15 v 8	— 28	— 26 to v 31	
19	g	— 29 v 4 to v 20	— 16	— 30	— 26 v 31 to v 57	
20	A	— 31 to v 14	1 Cor. 1 to v 26	— 31 v 15 to v 38	— 26 v 57	
21	b	— 33 to v 14	— 1 v 26 & 2	— 33 v 14	— 27 to v 27	
22	c	— 35	— 3	— 36 to v 14	— 27 v 27 to v 57	
23	d	— 36 v 14	— 4 to v 18	— 38 to v 14	— 27 v 57	Fast
24	e	Gen. 28 v 10 to v 18	— 4 v 18 & 5	Deuteron. 18 v 17	— 28	S. Bartholomew Ap.
25	f	Jeremiah 38 v 14	— 6	Jeremiah 39	Mark 1 to v 21	
26	g	— 50 v 21	— 7 to v 25	— 51 v 54	— 1 v 21	
27	A	Ezekiel 1 to v 15	— 7 v 25	Ezekiel 1 v 15	— 2 to v 23	
28	b	— 2	— 8	— 3 to v 15	— 2 v 23 to 3 v 13	S. Augustin, B.
29	c	— 3 v 15	— 9	— 8	— 3 v 13	Beheading of S. John Baptist
30	d	— 9	— 10 & 11 v 1	— 11 v 14	— 4 to v 35	
31	e	— 12 v 17	— 11 v 2 to v 17	— 13 to v 17	— 4 v 35 to 5 v 21	

The Prayer Book of
King Edward VII

Charles Robert Ashbee (1863-1942)
Guild of Handicraft Press
1903
L. 1781-1903

The book was begun at Essex House, Bow, in 1901 and finished at Essex House, Chipping Campden, Gloucestershire in 1903. The wood-cut designs and type (Great Primer and Endeavour) throughout were by C. R. Ashbee. A total edition of 400 copies was printed on hand-made paper bearing the watermark of the press, plus ten copies on vellum of which the first was specially pulled for His Majesty the King. The binding, with carved oak boards and wrought-iron clasps, was carried out in part at the Guild's own bindery and in part by Messrs Eyre & Spottiswoode.

The press was started by Ashbee in 1898, after the death of William Morris and the demise of his Kelmscott Press. It moved to Gloucestershire in 1902, and from 1908, when the Guild had run into difficulties, it was mainly conducted by A. K. Coomaraswamy.

Safe-cabinet Designed by Sir Edwin Lutyens (1869-1944)
1903-1904
Oak
Loan

This massive cabinet, made to house a safe, was designed for Marsh-court, Stockbridge, Hampshire, a house designed by Lutyens for Herbert Johnson in 1901-4. It is an interestingly complex design which nods in the direction of Gimson and Barnsley, but also uses Baroque forms. The revealed construction of the doors looks back to Pugin's *True Principles*, whereas the Baroque elements recall the fashionable Edwardian Baroque interiors being created at this period throughout Britain. Structural honesty extends to the very size and constructional detail of the cabinet, totally appropriate to supporting a heavy metal safe.

Cabinet Probably designed by G. Montague Ellwood (1875-?)
Made by J. S. Henry Ltd, Old Street, London, whose label it
bears
1903-1905
Mahogany
W. 26-1976

The firm of Henry manufactured a wide range of furniture in the
early years of this century, employing several designers, including
Ellwood. His work was published widely for instance in *The Studio*.
This cabinet is a sophisticated example of English Art Nouveau
design. Comparatively little furniture made in this country can be
described unequivocally as Art Noveau, although English designers
of textiles, wallpapers, metalwork and ceramics often worked in a
style close to Continental Art Nouveau.

Fireplace Designed by Charles Rennie Mackintosh (1868-1928)
For the Willow Tea Rooms, Sauchiehall Street, Glasgow
c. 1904
Iron with white and blue tile surround
H. 138 cm
Circ. 244-1963

C. R. Mackintosh joined the Glasgow School of Art in 1885 and qualified four years later when he joined the firm of Honeyman and Keppie. In 1894 Mackintosh, with a group of fellow students, organised an exhibition of furniture, metalwork and embroidery. This led to an invitation, the following year, for the group to exhibit at the exhibition 'L'Oeuvre Artistique' in Liège. Their work made a significant impression, and thereafter Mackintosh, his wife, Margaret Macdonald, with Herbert and Frances McNair, exhibited as a group with the Vienna Secession, the Glasgow exhibition of 1901, the Turin exhibition of 1902 and in Budapest, Dresden, Munich, Venice and Moscow.

In 1897 Mackintosh won the competition for the new Glasgow School of Art building. In the same year he designed the first of a series of Glasgow tea rooms for Miss Cranston. Between 1903 and 1904, he did the Willow Street tea rooms for which this fireplace forms part of the furnishings. Its geometric interior and spatial experiments forecast the preoccupations of later architects of the 20th century.

Other commissions include Hill House, Helensburgh, for the publisher Walter Blackie in 1902, the Scottish Pavilion for the Turin Exhibition in 1902 and the interior and furniture of a house at Northampton for W. J. Bassett Lowke in 1916. In 1919 he was commissioned by W. Foxton to design printed textiles and in 1920, for reasons of ill health and increasing financial difficulty, he gave up his practice.

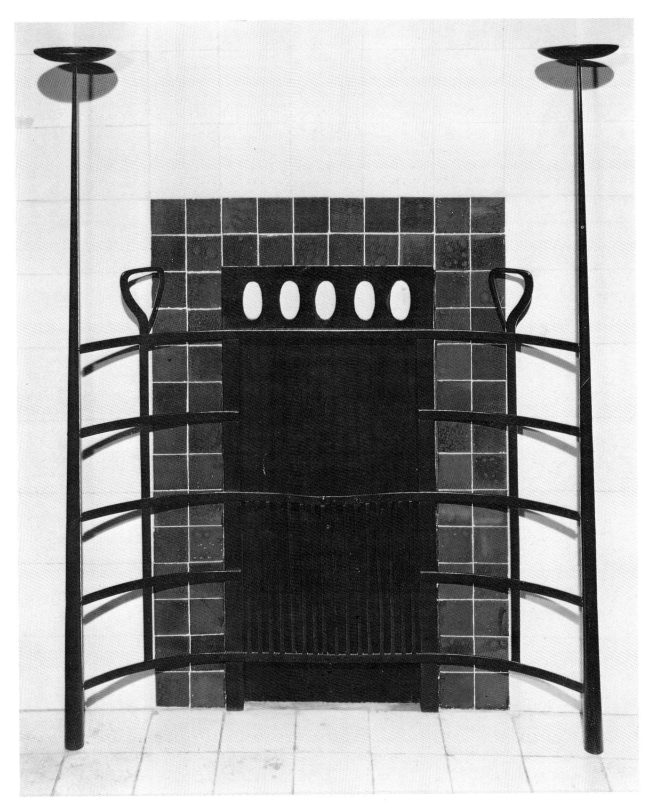

23

Table Designed by C. F. A. Voysey (1857-1941) in 1903
Made by F. C. Nielsen, London, whose label it bears
1905-6
Oak
W. 19-1981

Voysey's design for this table is in the R.I.B.A. Drawings Collection.
It is inscribed 'Mrs. Burke, Knotty Green, Nr Beaconsfield Bucks'.
The Burke house Hollymount was built to Voysey's design in 1905-
1906. Like most of Voysey's furniture this table is in oak and was
originally natural white, unstained and unpolished, its present
stained and polished finish being later. It is constructed without glue
or screws, being jointed and pegged, another common Voysey
feature. The design is singular, more reminiscent of a gyroscope than
a piece of furniture, and close to the divide between eccentricity and
innovation.

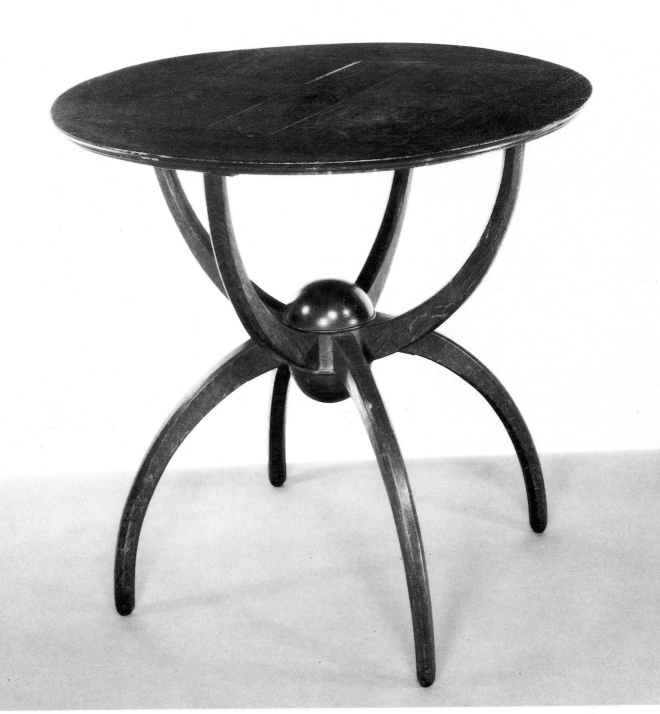

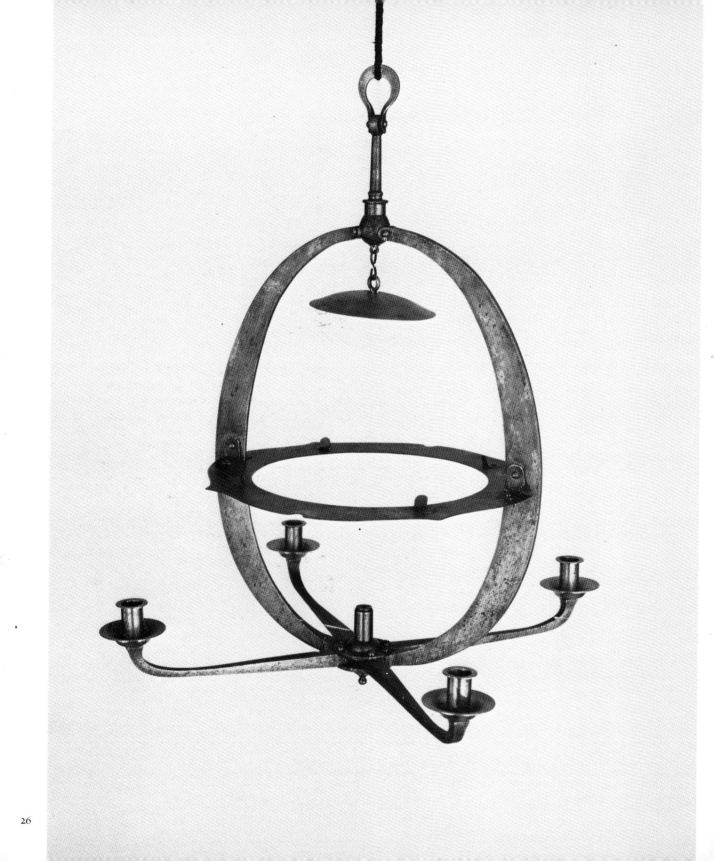

Chandelier Designed by George Walton (1867-1933)
For The White House, Shiplake, Oxfordshire
c. 1908
Polished iron and copper
H. 66 cm
Circ. 125-1959

George Walton practised as an architect and designer. His training was gained through attendance at evening classes at the Glasgow School of Art. In 1888 he established himself in Glasgow under the title of 'George Walton and Company, Ecclesiastical and House Decorators', and proceeded to decorate and furnish a number of houses in the Glasgow area. He first exhibited in 1890 and in Budapest in 1902.

In 1897 he moved to London, and in 1898 opened a subsidiary shop in York. He designed shop fronts for Kodaks in capital cities throughout Europe and for their five London branches between 1897 and 1902. His private commissions include The Leys, Elstree, in 1901 and The White House, Shiplake, 1907-10.

He is usually considered a member of the Glasgow School despite his main work being done outside Scotland and that he was practising before Mackintosh, whose reputation, subsequently, has tended to eclipse his own.

Jug Made by Reginald Wells (1877-1951)
 Coldrum Pottery, Elystan Street, Chelsea
 1909
 Red earthenware with turned grooving, white slip decoration
 and the words COLDRUM CHELSEA 1909
 H. 21.5 cm
 C. 82-1981

Until the emergence of this highly important documentary jug it was
thought that Reginald Wells began working in Chelsea in 1910. He
first learned to pot at Coldrum near Wrotham in Kent and in this
early piece demonstrates his newly acquired skills. Some of his
importance as a studio potter lies in his anticipating Bernard Leach's
're-discovery' of the traditional slipware technique and production
of it in this country some eleven years later, at St Ives.

In addition to working in slipware, Wells concentrated on glazes
in the Chinese style which he produced as 'Soon' pottery. In this, he
provides an interesting counterpoint to W. Howson Taylor (Ruskin
Pottery) and a forerunner to the glaze achievements of Charles and
Nell Vyse.

Originally, Wells trained as a sculptor at the Royal College of Art
and in addition to vases and jugs he made stoneware figures in a
purely sculptural style, such as the Mother and Child also in the
Museum's collection.

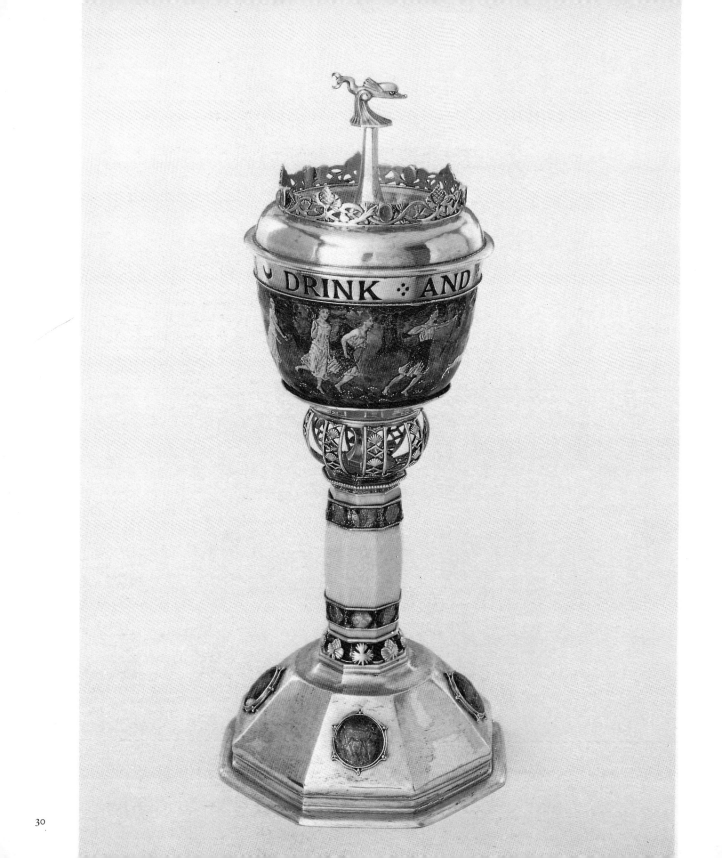

Loving cup Designed and made by Harold Stabler (1872-1945)
c. 1909
Silver, set with painted enamels, moonstones and ivory
Inscribed: DRINK AND FEAR NOT YOUR MAN
H. 16 cm
Given by Miss M. McLeish
Circ. 501-1956

Harold Stabler, originally trained as a woodworker and stone-carver, took up metalworking at the Keswick School of Industrial Art and eventually became head of the Sir John Cass School of Art, also teaching at the Royal College of Art, 1912-1926. An outstanding designer and silversmith, he was also distinguished in the field of ceramics. A founder of the Design and Industry Association, 1937.

Poster 'Skegness is *so* bracing'. Advertising the London and North
Eastern Railway Co Ltd
By John Hassall, RI, RWA (1886-1948), 1908
1909
Signed *J Hassall*
Colour lithograph
Given by the artist
E. 1326-1931

The simplicity of image, colour and humour, so unusual in British railway posters at this time helped to make this 'arguably the most famous railway poster of all time and one which proved so popular that it continued to be used by the Great Northern and later the London and North Eastern Railway right up to the end of the 1930s, and was even reissued in 1968 by the way of an anniversary celebration . . . The municipal authorities in Skegness erected statues of the jolly fisherman, incorporated him into the mayoral chain of office and on Hassall's death in 1948 sent a wreath . . . in the form of a leaping figure . . .' (J. T. Shackleton, *The Golden Age of the Railway Poster*, 1976).

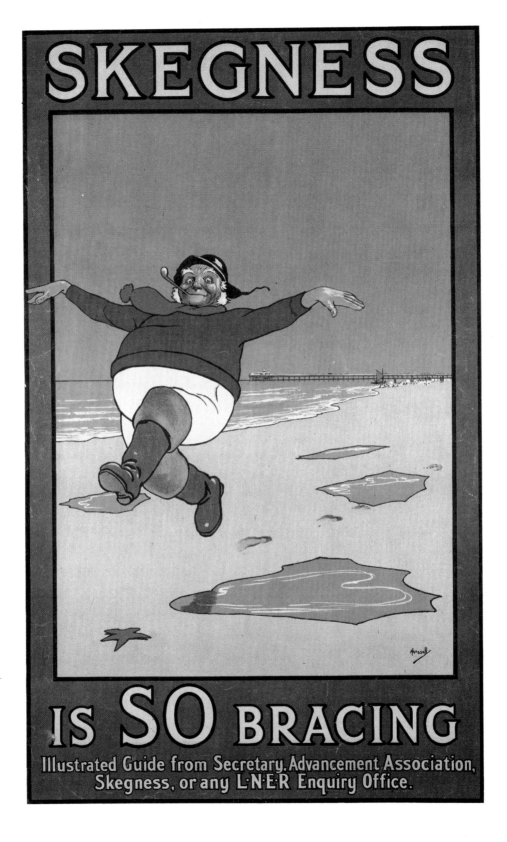

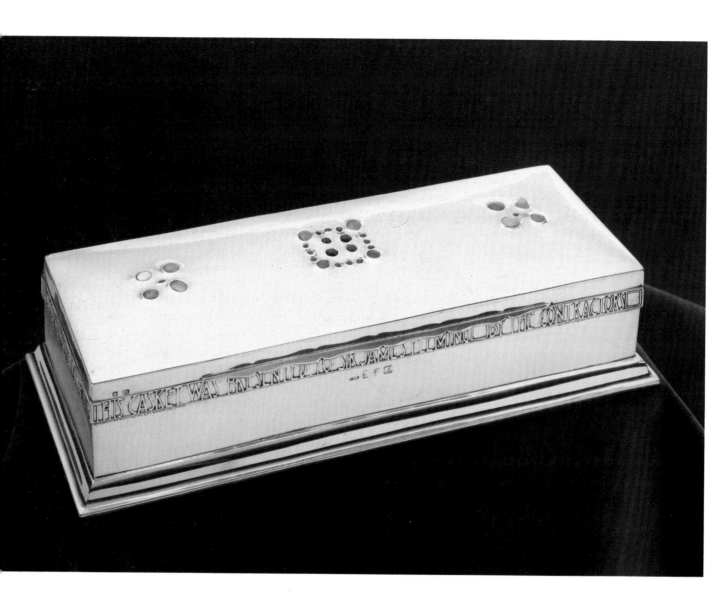

Presentation casket Designed by Charles Rennie Mackintosh (1868-1928)
Made by WAD, Glasgow (the craftsman is traditionally said to
be P. Wylie Davidson)
1909
Mark: WAD; Glasgow hallmarks for 1909; signed, C. MACKIN-
TOSH. DESIGNER
Inscribed: 'THIS CASKET WAS PRESENTED TO SIR JAMES FLEMING BY
THE CONTRACTORS ON THE OCCASION OF THE OPENING OF THE
SECOND PORTION OF THE GLASGOW SCHOOL OF ART/FIFTEENTH DAY
OF DECEMBER NINETEEN HUNDRED AND NINE A.D.'
Silver set with lapis lazuli and varieties of chalcedony
L. 32.2 cm, D. 12.8 cm
M. 29 & a-1975

Sir James Fleming, Chairman of the Governors of the Glasgow School
of Art, opened the new wing of the school, erected to Mackintosh's
design.

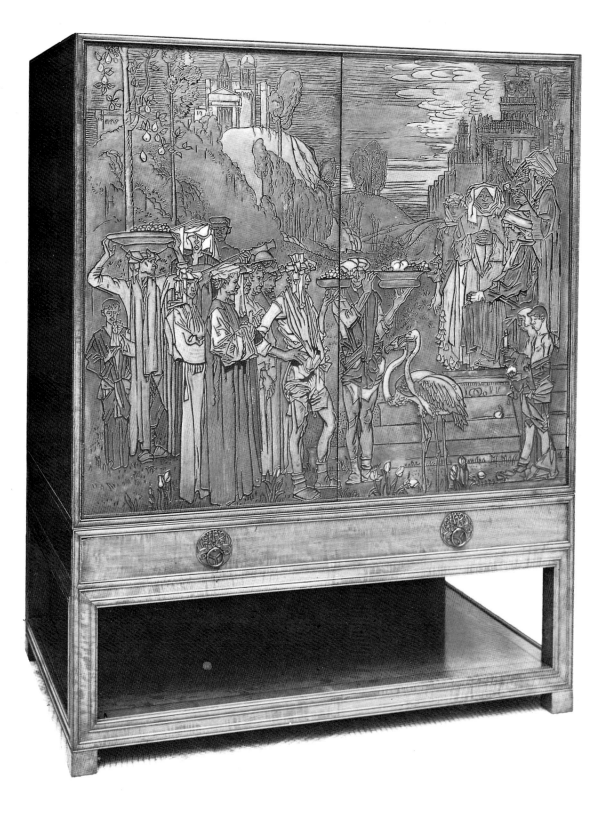

Cabinet Designed by Sir Frank Brangwyn (1867-1956)
Made by Paul Turpin of Berners Street, London
1910
Cherry decorated with coloured gesso imitating incised oriental lacquer
Given by Sir Frank Brangwyn
W. 40-1932

This print cabinet was designed by Brangwyn for his own use. It is illustrated in the *Studio Year Book of Decorative Art* 1914. Brangwyn was first and foremost a painter and engraver, but he also designed widely for the decorative arts. A considerable number of pieces of furniture were made to his design. The Museum also has in its collection textiles and ceramics by Brangwyn all of which display his wide knowledge of historical sources. China and Japan provide the inspiration for the lacquer-like panels and metalwork of this cabinet, although the scene illustrated on the gesso panel is close to contemporary paintings by Brangwyn.

Painting 'The Draughtsman and his Model'
By Sir William Orpen, KBE, RA, RI (1878-1931)
1910
Pencil and watercolour
Bequeathed by Alfred W. Rich
P. 179-1929

First shown at the New English Art Club in 1910, the drawing figured subsequently in most of the important exhibitions of modern British art before the First World War. Orpen was by birth and early education a Dubliner whose ease and urbanity fitted him for the career of a successful London portrait painter in the first quarter of the century. This drawing, on the other hand, catches accurately much of the self-conscious bohemianism of the Slade-Bloomsbury groups, spending the long hot pre-war summers reading, writing and painting in the open air.

Dish Designed and painted by Gordon Mitchell Forsyth (1879-1953)
Made by Pilkington's Royal Lancastrian Pottery, Clifton
Junction, Manchester
1910 (not necessarily decorated in this year)
Mark: impressed monogram PL and bees, date mark for 1910;
painted, the artist's rebus and four scythes
Cream coloured earthenware decorated on the front in lustred
black and orange with a freely painted peacock and around the
rim with a border of celtic knots and tracery
The reverse lettered: VICTORIA ET PER VICTORIAM VITA
Diam. 48.5 cm
Given by the Directors of Pilkington's Tile and Pottery Co, in
1964
Circ. 32-1964

After a travelling scholarship to Italy, Gordon M. Forsyth was,
briefly, Art Director at Minton, Hollins & Co., before taking up a
similar post at Pilkington's in 1905-1906 where he stayed until about
1915. He became Principal of the City of Stoke-on-Trent Schools of
Art and Superintendent of Art Institution, City of Stoke-on-Trent.
Apart from his own work, he achieved equal importance for the
influence and support he gave to the artists and generations of
students who worked under him and he is still remembered with
affection and respect in Stoke-on-Trent today. As a painter he was a
medallist at the Franco-British, Brussels, Turin, Venice and Paris
exhibitions during the early years of the century.

At Pilkington's he specialised in lustred decoration and was res-
ponsible for a number of impressive decorative designs as well as for
welding into a highly successful team the pottery's various artists,
such as Richard Joyce, W. S. Mycock and Gwladys Rodgers.
Europäisches Keramik des Jugendstils, Düsseldorf, 1974, no. 158

Vase and cover Designed, glazed and fired under the direction of William Howson Taylor (1876-1935)
Made at the Ruskin Pottery, Oldbury Road, West Smethwick
1910 (the shape; the vase was not necessarily glazed in the same year)
Mark: impressed RUSKIN POTTERY 1910
Stoneware, baluster shape with domed lid covered with a high temperature *flambé* glaze
H. 35
Given by Mrs Robert Ferneyhough
Formerly in W. Howson Taylor's private collection
Circ. 32 & a-1978

The Ruskin Pottery was established in 1898 at Smethwick by Edward Richard Taylor and his son William Howson Taylor. The name Ruskin was adopted in admiration of John Ruskin a few years later although official permission was not granted by the Ruskin family until 1909, the year before this vase and cover were made.

It was William Howson Taylor, the son, who worked to develop the impressive range of true, high temperature *flambé* glazes, one of the few British potters to experiment with these highly difficult, demanding and yet supremely rewarding effects.

Taylor kept many of his best pieces in his own private collection and eventually these passed to his friend Robert Ferneyhough, admirer and, after Taylor's death, champion and custodian of his life's work. In 1975 the Museum mounted a travelling exhibition of loans from the Ferneyhough Collection and on the death of Robert Ferneyhough in 1977 this superb example was given to the Museum by his wife.

A true *flambé* glaze, such as this by Howson Taylor is fired at extremely high temperatures (up to 1,500° C or higher) and, at a critical point, the amount of oxygen in the kiln is reduced, creating a dramatic effect in the metal oxide-based glaze. Depending on the chemical composition of the glaze, and combined with the temperature and the amount of oxygen allowed in the kiln, the colour range may be anything from greens and blues through pinks and purples to the richest red. Further combinations of oxygen, temperature and chemicals produce even more extraordinary effects in the gathering and volatilization of the glaze, all these changes giving rise to the technical description of 'transmutation glazes'.

Howson Taylor was recognised and admired by his contemporaries as major figure. Before the 1914-1918 War the Pottery won Grand Prizes in six major international exhibitions. It continued to win respect and admiration throughout its existence and until its official closure in 1933. Howson Taylor continued to glaze and fire pieces until the summer of 1935.

44

Bookbinding Douglas Bennett Cockerell (1870-1945)
c. 1910
Red and green morocco, with gold tooling, tooled leather
doublures and buckram end-papers
On the Holy Bible, John Baskerville, Cambridge
Presented to the Museum by W. H. Smith & Son
L. 1340-1957

Douglas Cockerell took over the management of the bookbinding
workshops for W. H. Smith & Son between 1904 and 1915, and the
present binding is signed inside the lower cover WHS within a
lozenge. It was lent by the company to the British Institute of
Industrial Art – formed in 1920 but disbanded in 1934 – and shown
with their collection of work by modern British artists at the Bethnal
Green Museum and elsewhere.

Cockerell began work in 1893 as an apprentice at the Doves Bindery
under T. J. Cobden-Sanderson. In 1898 he set up on his own in Soho.
After the period spent with W. H. Smith, and a stint of work for the
Imperial War Graves Commission, he started a workshop in Letch-
worth with his son Sydney Morris Cockerell. His influence was
important both as a binder and teacher. He was an instructor at the
Central School of Arts and Crafts between 1897 and 1935, and lectured
also at the Royal College of Art. His most important commission was
the rebinding for the British Museum of the Codex Sinaiticus after
its acquisition in 1934. His own work *Bookbinding and the Care of Books*
first appeared in 1901 and has been since reprinted in five further
editions.

Rose bowl Designed by Omar Ramsden (1873-1939)
Made by Omar Ramsden and Alwyn Carr
1912-13
Mark: maker's mark of Omar Ramsden and Alwyn Carr;
London hallmarks for 1912-13; signed, 'OMAR - RAMSDEN - ET -
ALWYN - CARR - ME - FECERUNT'
Inscribed: 'THE ANCIENT ZODIAC PICTURES STILL THE NEVER
ENDING SONG OF HUMAN LIVES, WHICH LEAF, BUD AND BLOSSOMS AS
THE FLOWERS, THE SUNSHINE, SHADOW, PLEASURE, PAIN AND
WRONG, ARE BUT THE UNITS OF THE QUICKLY PASSING HOURS'
Silver, pierced and embossed with the signs of the Zodiac
Diam. 30 cm
Given by Mrs M. Campbell-Voullaire
M. 285-1975

One of a group of pieces commissioned from Ramsden & Carr by the
donor's grandmother, Mrs Mary Eliza Laidlaw, who patronised
several members of the Arts and Crafts Movement. Ramsden and
Carr studied at Sheffield and at the Royal College of Art, London.
The partnership ended in 1918.

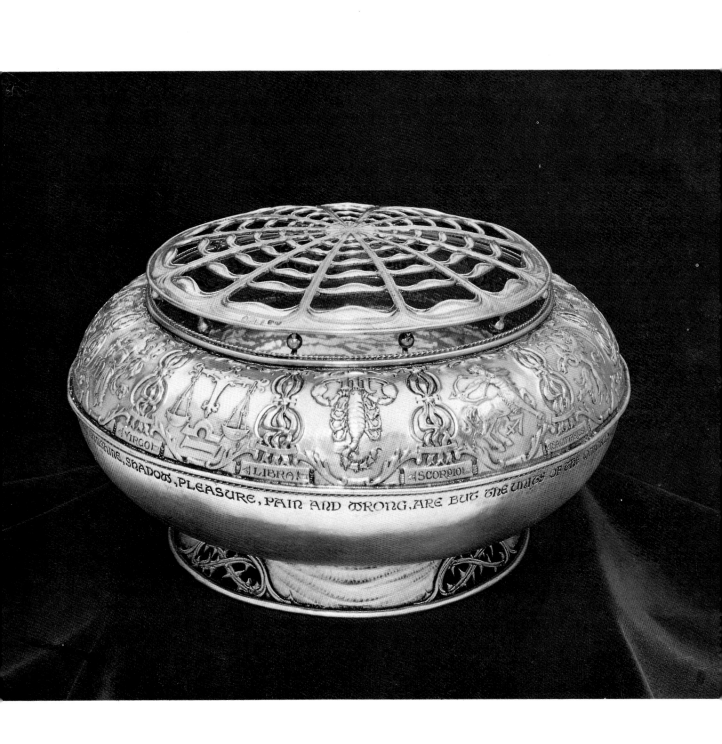

47

Study of a seated figure Henri Gaudier-Brzeska (1891-1915)
1912-15
Bronze
Given by Dr Neville Goodman, CB
A. 23-1971

Henri Gaudier, son of a carpenter and wood carver, visited England in 1906 and 1908 before settling in London in 1911. Shortly before this he met Sophie Brzeska and had added her name to his own. Before returning to France to join the French army in 1914 he became a central figure in the London Art world and was associated with both the Omega Workshops and the Vorticist Group. He was killed in action at Neuville-Saint-Vaast. This small bronze, although not mentioned in any of the artist's lists or notes of own works, is close in style to other examples made by him between 1912 and 1914.

Richard Aldington, in his review of *Blast* in *The Egoist* of July 1914, gave an account of Brzeska, which, if not accurate, at least pleased Henri immensely, so that he adopted it as a true portrait.

'Mr. Gaudier-Brzeska is really a wild unkempt barbarian, with a love for form and a very clear knowledge of the comparative history of sculpture. He is the sort of person who would dye his statues in the gore of goats, if he thought it would give them a more virile appearance.

'His *Vortex* is extremely good reading, even if you don't understand; though I see no reason why any reasonably intelligent person should not understand it. He thinks in form – abstract form – instead of in things and ideas. He is perhaps the most promising artist we have. If he ever becomes civilized he will lack creation.'

(Quoted by Horace Brodsky, *Henri Gaudier-Brzeska, 1891-1915,* London, 1933.)

50

Furnishing fabric 'Amenophis'
Designed by Omega Workshops Ltd
(probably Roger Fry (1866-1934))
Made by Maromme Printworks, Rouen
1913
Printed linen
Misc. 2(40)-1934

The various fabrics (printed and woven textiles, carpets and embroideries) designed and sold by Roger Fry's Omega Workshops revolutionised British textile design. Influenced by contemporary painting the fabrics established a fashion for abstract and geometric pattern. The linens were printed in Rouen by a method which, according to the firm's catalogue, maintained the 'freedom and spontaneity of the original drawing'. They set new decorative guidelines which were adopted by the textile industry after 1918.

Sir Thomas Malory's
Morte D'Arthur

C. H. St John Hornby (1867-1946)
Ashendene Press, Chelsea
1913
L. 294-1916

This edition of Malory's classic was three years in production at the Ashendene Press. The text follows that of Caxton, printed in 1485. It contains twenty-nine woodcut illustrations by Charles and Margaret Gere. A total of 125 copies only was printed for sale, on specially watermarked hand-made paper produced by Messrs J. Batchelor & Sons, plus six copies on vellum (of which this is one) in special bindings designed by Douglas Cockerell and carried out by W. H. Smith & Son (of which Hornby was to become a director).

The press was started by Hornby in a garden-house at his father's place, Ashendene in Herts, in 1895, and transferred to Shelley House, Chelsea, in 1900. Over the span of 40 years, working as an amateur for pleasure in his spare time he was to produce forty major editions of the most exacting standards, the last to appear being a catalogue raisonné in 1935. The initials, printed alternately in blue and red, were designed for the work by Graily Hewitt. An Albion Royal hand press was used for all the printing. The type-face Subiaco was adapted from the first type used by Sweynheym & Pannartz in 1465, and specially cut for the exclusive use of the press by Sydney Cockerell and Emery Walker.

HOW GALAHAD WAS BROUGHTE TO THE
KNYGHTS OF THE ROUNDE TABLE & WAS
SETTE THERE IN THE SIEGE PERYLLOUS.

LE MORTE D'ARTHUR. ❡INCIPIT LIBER PRIMUS. ❡CAPITULUM I.
❡Fyrst how Utherpendragon sente for the duke of Cornewayl and Igrayne his wyf,
and of their departyng sodeynly ageyn.

IT BEFEL IN THE DAYES OF UTHER PENDRAGON WHEN
HE WAS KYNGE OF ALL ENGLOND, AND SO REYNED
THAT THERE WAS A MYGHTY DUKE IN CORNEWAILL
THAT HELDE WARRE AGEYNST HYM LONGE TYME.
AND THE DUKE WAS CALLED THE DUKE OF TYNTAGIL
AND SO BY MEANES KYNGE UTHER SEND FOR THIS
DUK, CHARGYNG HYM TO BRYNGE HIS WYF WITH HYM, FOR SHE
was called a fair lady, and a passynge wyse, & her name was called Igrayne.
❡So when the duke & his wyf were comyn unto the kynge by the meanes of grete lordes they
were accorded bothe, the kynge lyked and loved this lady wel, and he made them grete chere
oute of mesure, and desyred to have lyen by her. But she was a passyng good woman, and
wold not assente unto the kynge. And thenne she told the duke her husband and said : I
suppose that we were sente for that I shold be dishonoured. Wherfor husband I counceille
yow that we departe from hens sodeynly that we maye ryde all nyghte unto oure owne castell,
and in lyke wyse as she saide so they departed, that neyther the kynge nor none of his coun-
ceill were ware of their departyng. Also soone as kyng Uther knewe of theire departyng soo
sodenly, he was wonderly wrothe. Thenne he called to hym his pryvy counceille, and told
them of the sodeyne departyng of the duke and his wyf. ❡Thenne they avysed the kynge to
send for the duke and his wyf by a grete charge. And yf he wille not come at your somons,
thenne may ye do your best, thenne have ye cause to make myghty werre upon hym. Soo that
was done and the messagers hadde their ansuers. And that was thys shortly, that neyther
he nor his wyf wold not come at hym. ❡Thenne was the kyng wonderly wroth. And thenne
the kyng sente hym playne word ageyne, & badde hym be redy and stuffe hym & garnysshe
hym, for within xl dayes he wold fetche hym oute of the byggest castell that he hath.

WHANNE the duke hadde thys warnynge, anone he wente & furnysshed and
garnysshed two stronge Castels of his of the whiche the one hyght Tyntagil, &
the other castel hyght Terrabyl. So his wyf Dame Igrayne he putte in the castell
of Tyntagil. And hym self he putte in the castel of Terrabyl the whiche had
many yssues and posternes oute. Thenne in all haste came Uther with a grete hoost, & leyd
a syege aboute the castel of Terrabil. And ther he pyght many pauelyons, & there was grete
warre made on bothe partyes, and moche peple slayne. Thenne for pure angre and for
grete love of fayr Igrayne the kyng Uther felle seke. So came to the kynge Uther Syre Ulfius
a noble knyght, and asked the kynge why he was seke. I shall telle the, said the kynge : I am
seke for angre and for love of fayre Igrayne that I may not be hool. Wel my lord, said Syre
Ulfius, I shal seke Merlyn, and he shalle do yow remedy that youre herte shal be pleasyd.
So Ulfius departed, and by adventure he mette Merlyn in a beggars aray, and ther Merlyn
asked Ulfius whome he soughte, and he said he had lytyl ado to telle hym. Well, saide Mer-
lyn, I knowe whome thou sekest, for thou sekest Merlyn ; therfore seke no ferther, for I am
he, and yf kynge Uther wille wel rewarde me, and be sworne unto me to fulfille my desyre,
that shall be his honour and profite more than myn, for I shalle cause hym to have alle his
desyre. Alle this wyll I vndertake, said Ulfius, that ther shalle be nothyng resonable, but
thow shalt have thy desyre. Well, said Merlyn, he shall have his entente and desyre. And
therfore, saide Merlyn, ryde on your wey, for I wille not be long behynde.

C I

1

53

Screen Painted by Vanessa Bell (1879-1961)
 For the Omega Workshops
 1913-14
 Gouache on paper laid down upon canvas
 Circ. 165-1964

The subject 'Bathers in a landscape' is based upon a painting 'Summer Camp' painted by Bell in August 1913. This screen is more a piece of painted furniture – as described in the caption to the Lewis box (*Page* 58) – than many Omega works. The figures reflect Vanessa Bell's knowledge of cubism, and their fragmented geometry is well adapted to a folding screen.

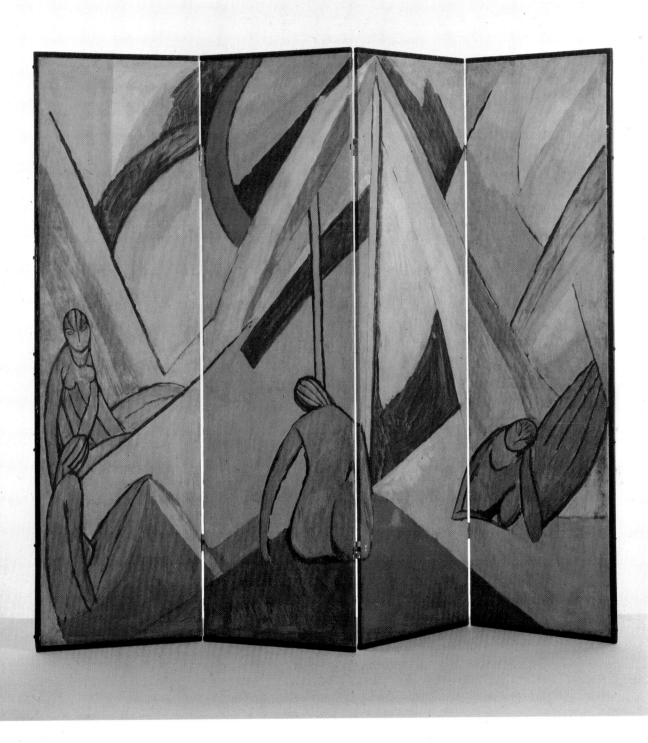

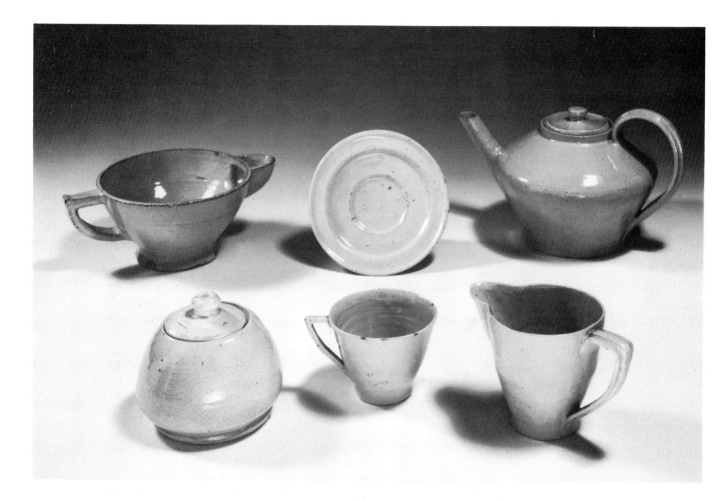

Part of a tableware set

Designed and made by Roger Fry (1866-1934)
Poole, Dorset
c. 1913-14
Mark on the teapot: impressed, the Omega symbol
Earthenware with a thick, white tin glaze
Margaret Bulley Bequest (part)
Misc. 2 (55 & A, B, C, G)-1934, Circ. 173-1964

The Omega Workshops were begun in 1913 by Roger Fry, art critic, painter, lecturer and artists' champion, to provide employment and a limited income for the young, avant-garde artists among his friends.

The Workshops made and decorated a whole range of domestic furnishings etc., including pottery. Roger Fry himself learnt to throw pottery on a wheel and, by 1914, he had made an arrangement to work at the Carter & Co pottery in Poole, using their materials. For Fry, the highest and most admirable quality was the involvement of the potter himself as evidenced in the roughness and marks left by the hand process. In his case these were more than usually evident due to his imperfect technique. Nevertheless he would not allow any cleaning up or turning to remove the excess clay but instead had moulds faithfully made which not only put the Omega pottery into limited commercial production, but repeated the irregularities.

The importance of these pieces lies not simply in their part in the Omega Workshops history but also for their foreshadowing the more angular and positive shapes taken up by the British modern movement in the 1920s, some ten years later.

The Margaret Bulley Collection was first shown as 'illustrating certain modern tendencies in European industrial art' in a complementary display to the exhibition *British Industrial Art for the Slender Purse,* British Institute of Industrial Art, V&A, North Court, 1929. The pottery is not individually described in the catalogue but it is probable that part of this group was included. The collection came as a bequest to the Museum in 1934.

Box Painted by Wyndham Lewis (1884-1957)
 1914
 Painted soft wood
 Signed inside the lid
 W. 37-1983

Painted by Lewis after he had left the Omega Workshops and set up
The Rebel Art Centre early in 1914. Quite apart from a personality
clash with Roger Fry, Lewis felt that the painters who worked for
Omega were working in an old-fashioned style. They tended to
decorate their pieces of furniture with nudes or flowers whereas
Lewis favoured an abstract style more akin to advanced continental
paintings. The Omega pieces are often furniture which has been
painted, rather than painted furniture. 'Painted furniture' is produced
when painting is carefully conceived to fit the piece which it decorates
rather than applied arbitrarily to an existing piece. With this box
Lewis has carefully conceived his design to respect the cubic shape of
the box. The Rebel Art Centre was closed when the war started and
seems to have produced no large-scale furniture, or at least none that
is known to survive.

'Blast' War Number, July 1915
Wyndham Lewis (1884-1957)
1915
Magazine cover; published by John Lane
L. 1491-1937

Only two issues of 'Blast, The Review of the Great English Vortex'
ever appeared, the first being launched in June 1914, when it was said
that it would come out quarterly, priced 2/6. It was edited, and in
large part written and illustrated, by Wyndham Lewis, who put
copies on sale at his short-lived Rebel Art Centre. The present second
issue was produced to coincide with an exhibition of the Vorticist
Group at the Dore Galleries, Bond Street, in July 1915, with sculp-
tures by Gaudier-Brzeska, and paintings by Lewis, Dismorr, Etchells,
Kramer, Roberts, Sanders, and Wadsworth. The first issue contained
Vorticist manifestos that were printed with a futurist abandon in
wild-scaled type. The second boasted of subscribers in the Khyber
Pass, as well as Santa Fe, and announced that the first stone in the
world-wide reformation of taste had been securely laid.

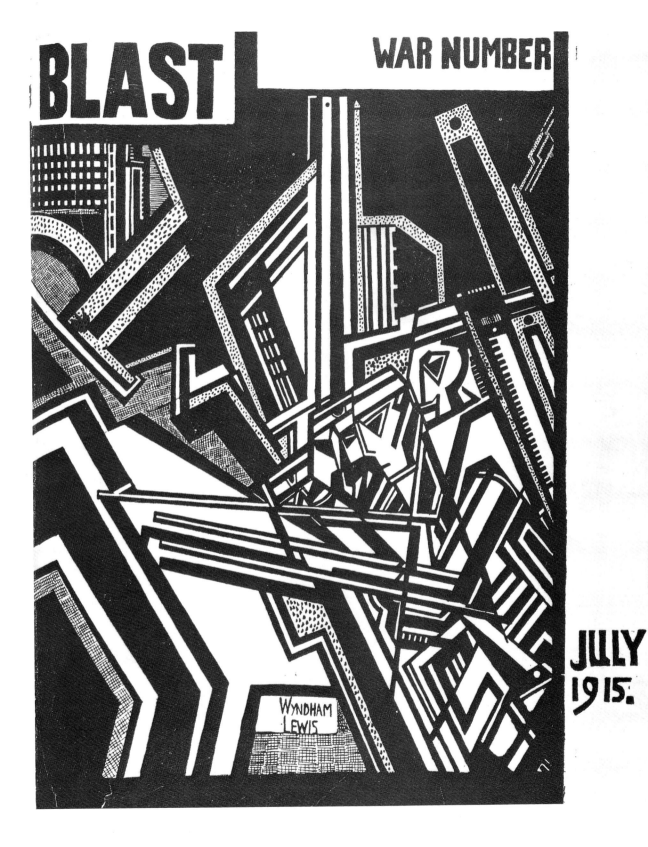

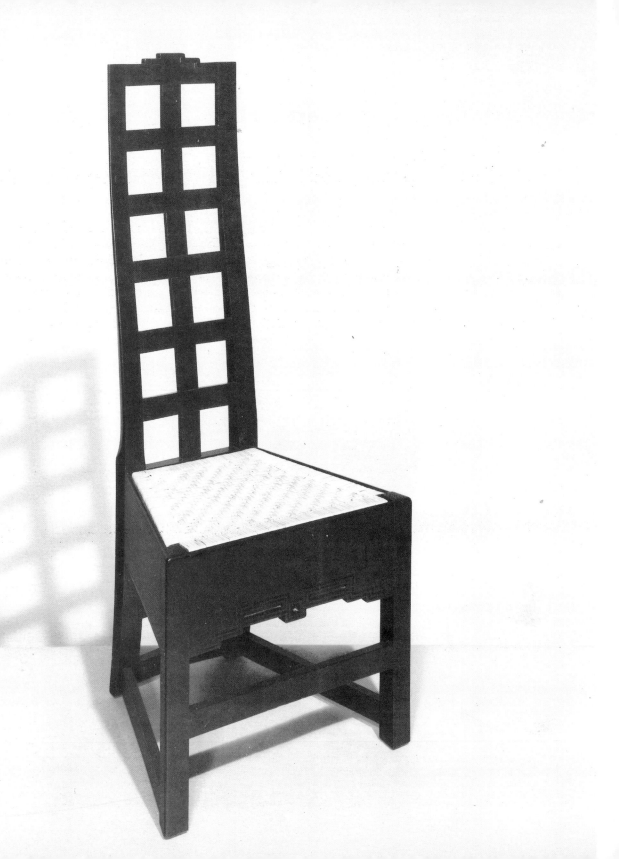

62

Chair Designed by Charles Rennie Mackintosh (1868-1928)
1916
Painted wood, repainted 1970
W. 7-1970

Commissioned by J. Bassett Lowke for his house, 78 Derngate, Northampton. Here in one of his last furniture designs Mackintosh demonstrates that he had lost none of that brilliance which he showed in his earlier Scottish works. Several pieces from this house are in the V&A's Collection. They are quite different in character from his earlier work, and demonstrate that his style was still developing in 1916, influenced, in detail, by Chinese prototypes.

Print 'Camouflaged ships in dry dock: Liverpool'
By Edward Wadsworth, ARA (1889-1949)
1918
Signed and dated in pencil *Edward Wadsworth 1918*
Woodcut on Japan paper
E. 4141-1920

Wadsworth was a prominent member of the Vorticist group, whose peculiar blend of Futurism and Cubism formed the basis of a radical art movement in Britain which was virtually destroyed by the war. Wadsworth had studied engineering in Munich in 1906 before becoming a painter and had always been interested in marine subjects. During the war he served in the Royal Navy Volunteer Reserve until he was invalided out in 1917. Then he was employed designing Dazzle camouflage for ships in Bristol and Liverpool. A newspaper report after the end of the war 'gave him credit for having designed the largest painting in the world by being responsible for camouflaging the Aquitania' (Mark Glazebrook, *Edward Wadsworth*, Colnaghi, 1974).

Dress fabric Designed by Charles Rennie Mackintosh (1868-1928)
 Made by William Foxton
 1918
 Printed silk
 Given by Miss Minnie McLeish
 T. 43-1953

Charles Rennie Mackintosh completed numerous textile designs from
about 1915 to the early 1920s, some of which were sold to Seftons as
well as Foxtons. Many of the designs are in the Mackintosh Collection
at the Hunterian Art Gallery, Glasgow University, but unfortunately
very few of the fabrics have survived.

Harpy Eagle — Designed by Harold Stabler (1872-1945), 1916
Possibly made by Carter, Stabler & Adams, Poole, Dorset
c. 1918-20
Buff coloured stoneware in the form of an eagle perched on a rock
H. 66 cm
Given by the artist to the British Institute of Industrial Art in 1926 and acquired by the Museum on the closure of the B.I.I.A. in 1934
Circ. 425-1934

Harold and Phoebe Stabler had their own pottery at their home, 34 Upper Mall, Hammersmith, in which they made a number of pieces. These are normally marked with their own backstamp of a design based on Hammersmith Bridge with their initials. Harold Stabler's first recorded contact with Charles Carter was in 1918, but not until 1921 was the partnership formed with John Adams, into Carter, Stabler and Adams, the pottery works. It is possible, even probable, that Stabler anticipated his official standing by working at Poole, with either the smaller pottery or the tileworks, which continued separately under the name of Carter & Co and for which he provided many designs throughout the next decade.

Although the Harpy Eagle does not bear the Hammersmith stamp, neither does it have the usual Poole glazes. Nevertheless, the Pottery does own an inferior but surviving example of this figure which makes it likely that the Eagle was fired at Poole but glazed by Stabler. From 1921 C.S.A. sold the figure for many years through its garden statuary catalogues. The Harpy Eagle seems to have been a favourite Stabler theme.

Arts and Crafts Exhibition Society, Royal Academy, 1916, 'Harpy Eagle in lead' and in enamel, nos. 118, 194 n.

British Institute of Industrial Art Exhibition, V&A 1922, no. 529.

Possibly, *International Exhibition,* Paris, 1925, Garden Statuary section, cat. p. 81 (as 'Mrs Stabler, Eagle').

British Industrial Art for the Slender Purse, B.I.I.A., V&A 1929, accompanying exhibition of the *Permanent Collection.*

The Poole Potteries, V&A, 1978, no. 218.

Poster Soaring to Success! Daily Herald – The Early Bird. Advertising the re-launching of the Labour party newspaper, 31 March 1919
By Edward McKnight Kauffer, Hon RDI (1890-1954), 1916
Printed by T. B. Lawrence Ltd, 1 Arundel Street, London WC2
1919
Colour lithograph
Given by Ogilvy Benson and Mather Ltd
E. 35-1973

Kauffer was American but lived and worked in Britain from 1914 to 1940. The woodcut from which the poster design was derived was made in 1916. It was modified and published as an unlettered design in *Colour,* in January 1917, from where it was purchased and re-sold to Francis Meynell who used it for his *Daily Herald* Campaign in 1919. The design is also Kauffer's homage to Vorticism and has links with Futurism: 'Balla painted a series of pictures based on his observation of the flight of swifts, in Rome in . . . 1913 . . . A comparison of Balla's interpretation with Kauffer's shows the essential difference in aims between Futurism and Vorticism as clearly as it shows the underlying similarities. Balla's observations were reinforced by a study of E. J. Marey's photographic analysis of birds in flight. Kauffer . . . used a Japanese model, [probably] a flight of small birds printed predominantly in green, yellow and grey by Suiseki published in Japan in 1820 . . .' (Mark Haworth-Booth, *Edward McKnight Kauffer,* 1979).

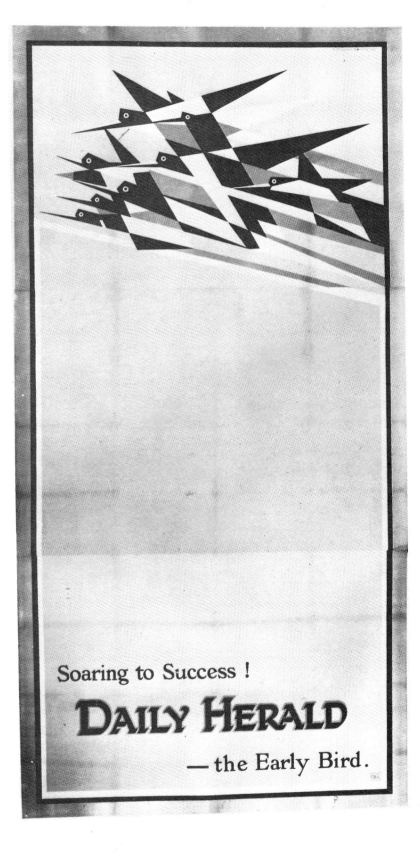

Soaring to Success !

DAILY HERALD

— the Early Bird.

St. Sebastian Eric Gill (1882-1940)
1919-20
Portland Stone
Given by Rev Canon John Gray in memory of
Mr A. Raffalovich
A. 10-1934

Although most famous, perhaps, for his calligraphic and other printed work, Eric Gill also carried out many sculptural commissions. The best known are probably the Stations of the Cross which he carved between 1913-18 for Westminster Cathedral, decorative sculpture for the exterior of Broadcasting House and similar work for the League of Nations Building in Geneva in 1936. His sculpture is characterised by the same crispness and flatness so evident in his typographic work. Although he was made a Royal Designer for Industry in 1936, throughout his life Gill was much involved with hand as opposed to industrial production. After conversion to Roman Catholicism in 1913, he took part in the formation of the Guild of St Joseph and St Dominic, a semi-religious community of craftsmen; in 1920 he was a founder member of the Society of Wood Engravers; and in 1928 he set up his own printing press at Speen in Buckinghamshire.

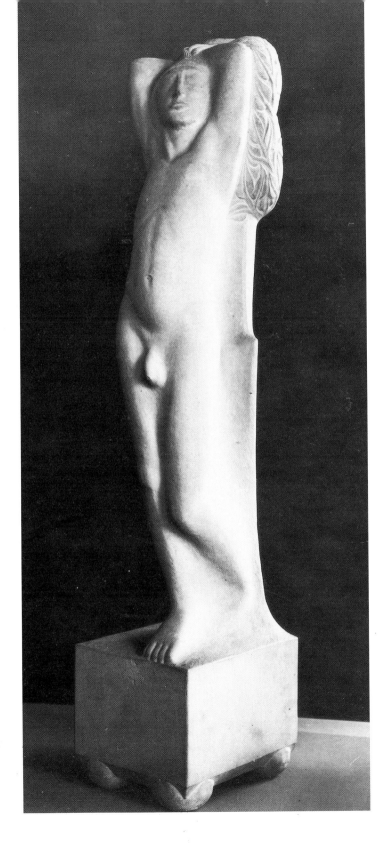

73

Vase Designed and decorated by Alfred Hoare Powell (1865-1960)
 Made by Josiah Wedgwood & Sons, Etruria
 1920
 Mark: impressed WEDGWOOD; painted, the artist's monogram
 Cream coloured earthenware painted in colours with a land-
 scape including trees, cottages and distant hills
 H. 72 cm
 Bought for the Museum from Alfred Powell by a body of
 subscribers and the National Art Collection Fund in 1938
 Possibly made for Sir Hugh Bell, Rounton, Yorkshire
 C. 134-1938

Alfred H. Powell trained at the Slade School of Art and then went
into the offices of the architect J. D. Sedding where he stayed until
1892. His friendship with Ernest Gimson and the Barnsley brothers
put him firmly into the English, rural, arts and crafts based philosophy
and he and his wife Louise regularly exhibited with the Arts and
Crafts Exhibition Society. Powell approached Wedgwood in 1903
and their close association lasted until 1930 although the Powells
continued to visit regularly throughout the 1930s and to buy blanks
for decoration which were then fired at the factory. Their influence
was also continued by painters and designers such as Millicent Taplin
(1902-1980) who had trained under them.

The Lavender Seller and
The Balloon Woman

Designed and made by Charles Vyse (1882-1971)
Cheyne Row, Chelsea
1920-21
Mark: painted, the artist's monogram, 1920 (the Lavender Seller) and 1921 (the Balloon Woman)
Cream coloured earthenware, moulded
Two figures: one of a woman holding a basket of lavender and offering one bunch; the other of a woman holding an armful of balloons
Both painted in enamel colours
H. (Lavender Seller) 22 cm
Given by the artist to the British Institute of Industrial Art in 1920 and acquired by the Museum on the closure of the B.I.I.A. in 1934
C. 428 & 432-1934

Charles and Nell Vyse were part of a colony of potters of all types, from Reginald Wells to Gwendolen Parnell, who settled in Chelsea. Figure-making was a particular speciality of the area although in the Vyses' case, they also made pots decorated purely with very beautiful and impressive glazes based on the Chinese Jun Song, celadon and other wares. The Vyses began figure-making in 1920 with the introduction of these two, the first of a series of somewhat idealised, picturesque English working and country characters.

Charles Vyse exhibited regularly in B.I.I.A. exhibitions which, from 1922, were held in London, in the North Court of the Victoria and Albert Museum.

The Bull Designed by Harold and Phoebe Stabler (1872-1945), (?-1955),
1914
Made by Carter, Stabler & Adams, Poole, Dorset
1921-1924
Mark: impressed CARTER STABLER ADAMS POOLE ENGLAND,
incised HAROLD & PHOEBE STABLER 1914
Buff coloured stoneware in the form of a bull ridden by two
children garlanded with flowers and seated on tasselled and
draped harnessing
H. 33.5 cm
C. 113-1977

By 1921, Harold Stabler was already a well-established teacher,
enameller, jeweller, silversmith and designer and a founder member
of the Design and Industries Association. His wife, Phoebe, not only
partnered her husband in some of his design work but was a prolific
and enterprising designer on her own behalf selling similar, some-
times even the same, designs to Carter, Stabler & Adams, Ashtead,
Doulton and Worcester.

This cast of The Bull was formerly in the collection of Sir Edward
and Lady Maufe. Edward Maufe was the architect of Cyril (son of
Charles) and Truda Carter's house 'Yaffle Hill'; Lady Maufe was on
the Board of Directors of Heals, one of C.S.A.'s chief customers.

Furnishing fabric Designed by Gregory Brown (1887-1948)
Made by William Foxton
1922
Printed linen
Acquired by the Museum on the closure of the British Institute
of Industrial Art
T. 325-1934

William Foxton played the role of an enlightened manufacturer
uniting art and industry – a notion he fully exploited in his advertising
campaigns. He produced some of the most exciting fabrics of the
1920s. This arched design reveals the '20s predilection for black and
the liberating effect of abstract art. It was exhibited at the Inter-
national Exhibition, Paris 1925, and illustrated three years earlier in
Design in Modern Industry – the Design and Industries Association
Year Book.

'Cube Teapot' Made by Napper & Davenport, Birmingham
1922
Mark: maker's mark of Napper & Davenport; Birmingham
hallmarks for 1922
Inscribed: 'ROBERT JOHNSON'S PATENTS. GT. BRITAIN 110951/U.S.A.
1380066-21. NAPPER & DAVENPORT/BIRMINGHAM/ENGLAND. SERIAL
NO. L. 31'
Silver; wooden finial and handle
13 cm square, approximately
M. 934-1983

An early example of a design incorporating a spout and handle
within a cube which in ceramic became widely popular in the late
1920s and 1930s. The V & A has two ceramic examples, one of which is
stamped: CUBE TEAPOTS LTD./LEICESTER.

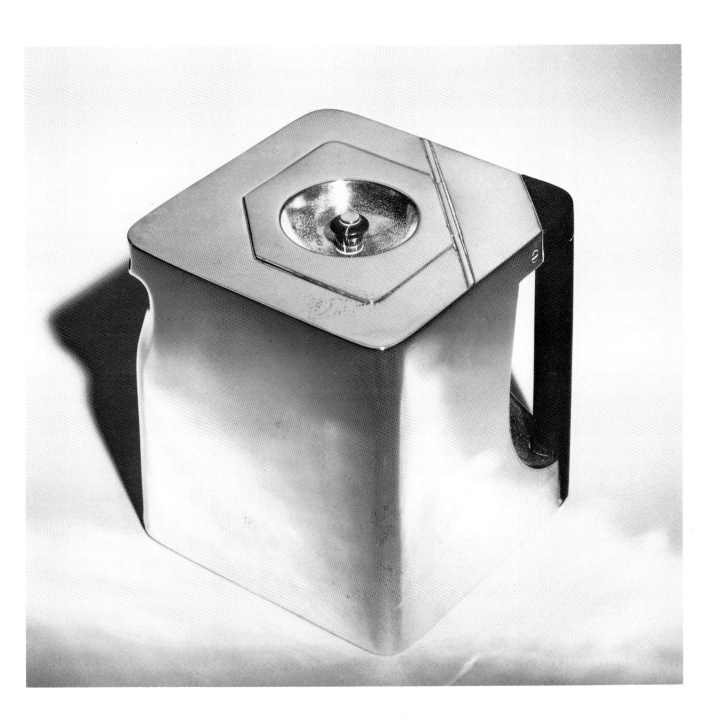

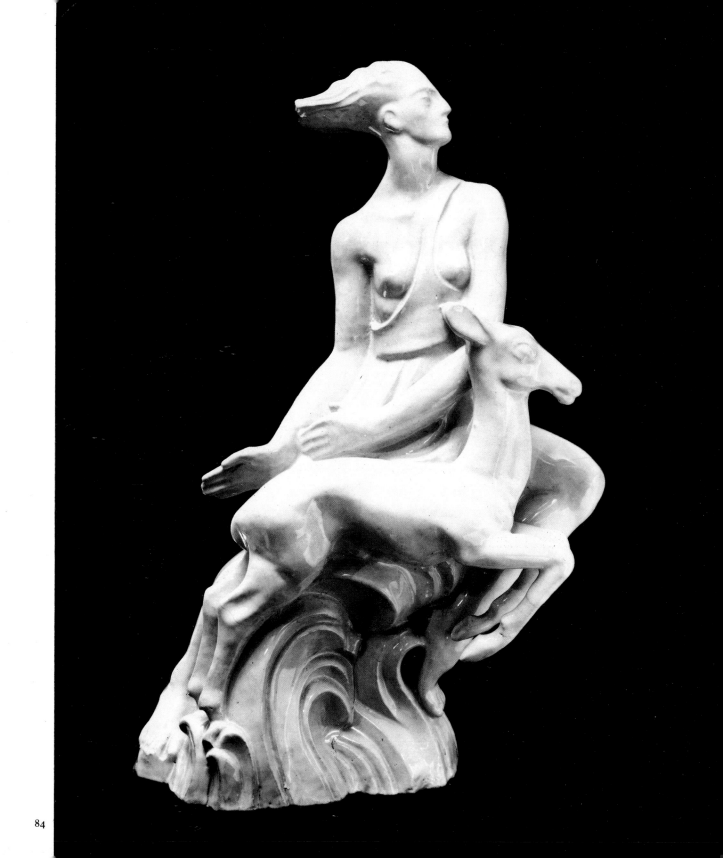

Diana Made by Adrian Paul Allinson (1890-1959)
London
Possibly 1922 or 1928
Mark: incised, the artist's rebus and an indistinct date
Cream coloured earthenware in the stylised form of the huntress Diana with foliage and a springing deer
H. 39.5 cm
Purchased by the Isidore Spielmann Memorial Fund for the British Institute of Industrial Art and acquired by the Museum on the closure of the B.I.I.A. in 1934
C. 538-1934

Adrian Allinson was primarily a painter, having trained at the Slade School of Art, but brought his particularly decorative style to a number of related arts such as stage design, for which he had his first professional commission, poster design and, as in this case, pottery sculpture.

A figure entitled 'Diana' was shown by Allinson in the Arts and Crafts Exhibition Society, Royal Academy, 1928, no. 137A, and may be this or a closely related figure. He was a regular exhibitor at the Royal Academy as a painter, the Royal Society of British Artists, the New English Art Club and, above all, with the London Group.

Furnishing fabric F. W. Grafton & Co
1923
Roller printed cotton
Acquired by the Museum on the closure of the British Institute
of Industrial Art
T. 442-1934

The Calico Printers Association was formed in 1899 to rationalise the British textile printing and dyeing industry and to boost trade. The firm F. W. Grafton (Manchester) was part of the amalgamation and their *forte* was the printing of vibrantly coloured patterns. This particular design with its strong purples, green and orange with black outlines is typical of their output and reveals the influence of French design.

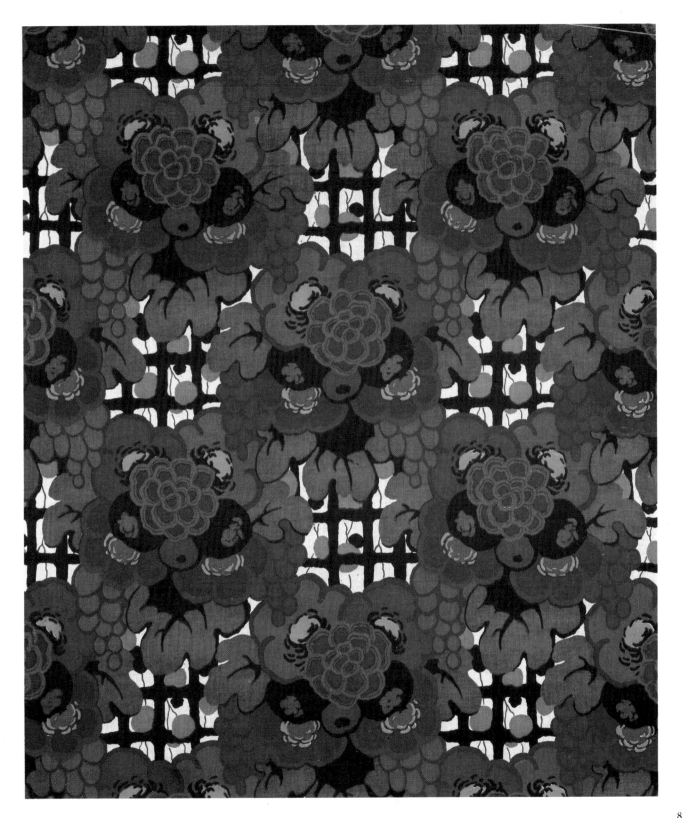

Dish Made by Bernard Howell Leach (1887-1979)
 St Ives Cornwall
 1923
 Mark: in coloured slip BL 1923
 Buff coloured earthenware, decorated in brown slip on a
 yellow ground with a Tree of Life
 Diam. 42.3 cm
 Bought from Bernard Leach in 1923
 Circ. 1278-1923

In 1920 Leach returned from Japan and his travels in the Far East
accompanied by Hamada Shoji. Hamada was then a young potter
with mainly scientific experience from the Ceramic Testing Institute
of Kyoto. Together, they settled at St Ives in Cornwall, finding in the
West Country the surviving traditions of English pottery-making.
They built a three-chambered kiln of a traditional Japanese type and
only a year later, propelled as much by natural enthusiasm as the
need to support a wife and five children, Leach's first one-man show
was held at the Artificers' Guild.

Slip-ware was one of Leach's chief interests, the reason for his return
to England and the reason for searching out an area where such
earthenware was still made in a tradition which was just traceable
back to the mediaeval.

This handsome dish is of prime importance not only for its con-
fident, decorative flourish but for its early date.

Nude Girl Frank Dobson (1888-1963)
1923
Bronze
H. 123 cm
Given by Dr Neville Goodman, CB
A. 32-1971

Frank Dobson was the son of a Christmas card illustrator and studied painting at the City and Guilds College, Kennington. He took up sculpture after completing war service in 1918 and was the only sculptor to exhibit in the group X exhibition of 1920. Although best known for his sculpture, he also designed and printed his own textiles including batiks and lino blocks. Another example of his sculpture is to be seen in the tiles he designed for Goodhart-Rendel's Hays Wharf, on the Embankment.

Bookbinding Madeleine Kohn (1892-1940)
1924
Reddish-brown morocco with green onlays, gold and blind-
tooling
Paste-downs and fly-leaves of gold-sprinkled green paper
On *Tendres Stocks,* by P. Morand
L. 3518-1958

Madeleine Kohn is accounted one of the most interesting English
binders working as an amateur between the wars. She worked both
in Paris, with Dumont and Maurice La Haye, as well as in London,
from 1931 onwards with the McLeish family. The Broxbourne Library
holds no less than ten of her bindings together with a book of rubbings
from a succession of her designs.

Four examples, including the item illustrated here, were shown in
the British Government Pavilion at the International Exhibition of
Modern Decorative and Industrial Arts, Paris, 1925. C. H. St John
Hornby wrote afterwards in the Official Report (1927), 'the British
exhibit of binding . . . was quite the best in the Exhibition . . . It was
entirely free from the riotous extravagances and meretricious orna-
mentation of much of the foreign binding . . . [Foreign] bindings were
the best where they most nearly approximated to our English
standard of taste, which is on the whole restrained and dignified, and
follows without slavish imitation the best traditions of the craftsmen
of the past, English, French, and Italian'.

Desk Designed by Sir Edward Maufe (1883-1974)
Made by W. Rowcliffe
1924-25
Mahogany, camphor, ebony gessoed and gilded with white gold
Given by Prudence, Lady Maufe
Circ. 898-1968

This desk was designed and made for the Paris Exhibition of 1925. Maufe retained the desk as part of the furnishings of his house at Shepherds Hill, Sussex. This was one of the few British pieces at the Paris Exhibition which bore serious comparison with the French exhibits. Most British firms had sent pieces in the Arts and Crafts survival style or reproductions of Georgian pieces. These looked rather sad by comparison with the latest French and German furniture. Maufe, though primarily known as an architect, Guildford Cathedral being one of his most celebrated works, also designed furniture. This was perhaps partly under the influence of his wife who worked for Sir Ambrose Heal.

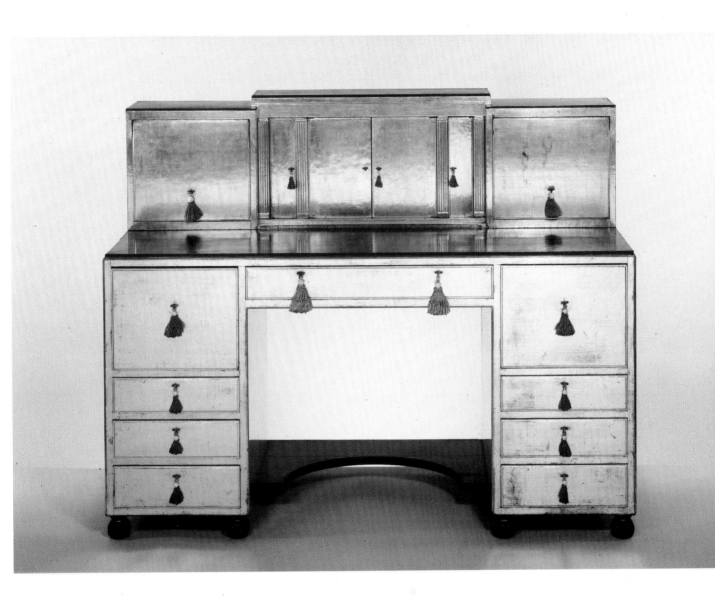

Addendum: A Fifteenth Century Carol (from A.E. Carols, ed. by E. Rickert, 1910.): Transcribed with two soft Reed, & Mended, by E.J., 11th, Dc: 1925. A.D.

This MS. was written in a hurry for a Village Show, & it being thereby spoilt, I determined to present it to Mr. Sidney Cockerell, one of my most valued guides who (tho' he never spoilt me) is able to appreciate good intentions. E.J. 23. xij. 25.

which is wrong & so this MS. is spoilt.

Adam lay ybounden,
Bounden in a bond;
Four thousand winter
Thought he not too long.
And all was for an apple,
An apple that he took,
As clerkës finden written
 In their book.
Nor had the apple taken been,
The apple taken been,
Then had never our Lady
A-been heaven's queen.
Blessed be the time
That apple taken was!
Therefore we may singen
 Deo gracias!

96

A Fifteenth Century Carol Edward Johnston (1872-1944)
1925
Manuscript, ink on laid paper
L. 4398-1959

The Carol is taken from 'A. E. Carols' edited by E. Ricketts, 1910. It
carries the note, in superscription, 'Transcribed with too soft a Reed,
& Mended*, by E.J. 11th Dec. 1925 A.D. *which is wrong, & so this
MS is "spoilt".' And the further note is added: 'This MS was written
in a hurry for a Village Show, & it being thereby spoilt, I determined
to present it to Mr. Sidney Cockerell, one of my most valued guides,
who (tho' he never spoilt me) is able to appreciate good intentions.'

Johnston studied manuscript writing in the British Museum, after
ill-health forced him to abandon an intended career as a doctor. In
1899 he was invited by W. R. Lethaby, Principal of the Central School,
to start the first writing-class there, and he later extended his teaching
to the Royal College of Art also. In 1906 he published *Writing &
Illuminating, & Lettering,* followed in 1909 by *Manuscript and Inscrip-
tion Letters.* These were to form the spring and the foundation for a
world-wide revival of interest in letter forms. From 1910 to 1930 he
designed calligraphic founts for Count Harry Kessler at the Cranach
Press, Weimar. But his most important commission came in 1916
when he was asked by Frank Pick to design the standard sans serif
alphabets for the exclusive use of London's Underground, which
remain in use today for official signs and notices throughout the
London Transport system.

Vase Designed and painted by Susan Vera (Susie) Cooper (b. 1902)
Decorated at A. E. Gray & Co Ltd (Gray's Pottery),
Mayer St., Hanley, under Albert Edward Gray (1871-1959)
1925-29
Mark: a printed ship with 'A. E. Gray and Co Ltd, Hanley,
England'; 'HAND PAINTED, DESIGNED BY SUSIE COOPER'; artist's
monogram
Earthenware, painted in enamel colours with three panels
showing respectively a deer, an ibex, and a ram
H. 34.5 cm
Given by A. E. Gray's daughter, Mrs Ronald Bailey
C. 193-1977

Susie Cooper trained at the Burslem School of Art where her talent
was recognised and encouraged by Gordon Forsyth (1879-1953). He
recommended that she take employment with a ceramic firm,
although she had originally hoped to enter the fashion world. Follow-
ing his suggestion, Susie Cooper began her distinguished career in
ceramic design at Gray's Pottery, a decorating concern supplied with
blank wares from pottery manufacturers. Her work was exhibited
in all the firm's displays including the International Exhibition at
Paris in 1925. She left her position as designer to found her own
pottery business in 1929.

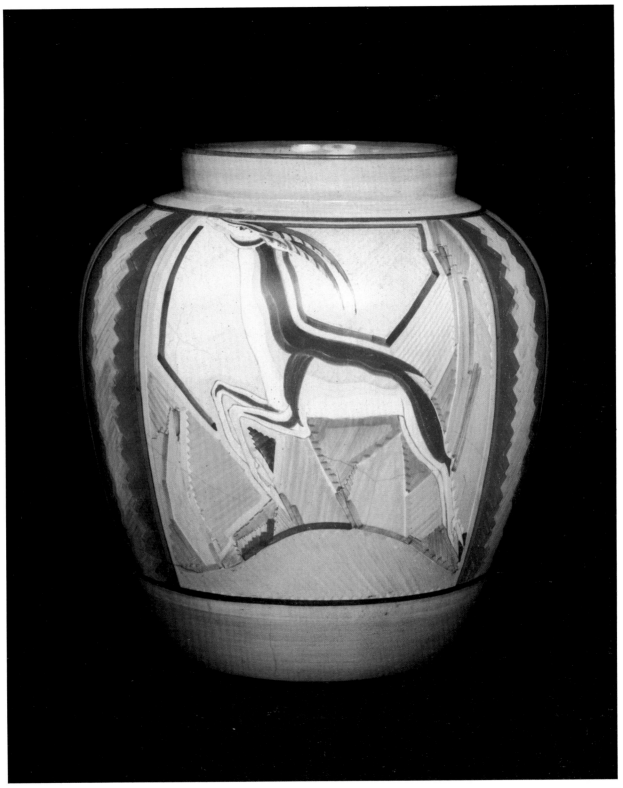

Print 'St Ippolyts' (2nd state)
By Frederick Landseer Maur Griggs, RA, RE (1876-1938)
1927
Signed with the artist's initials and dated *F.L.G. 1927* and
signed again in pencil *F.L.Griggs*
Etching
E. 285-1928

With the traditional role of printmaking as a means of multiplying an
image taken by photo-mechanical processes, the work of the print-
maker during the first quarter of the 20th century was greatly
influenced by a desire to establish printmaking as a form of art as
original, creative and respectable as, say, painting and sculpture. In
the past, etching had been the medium most favoured by painters and
used least merely as a means of reproduction. Inspired by the example
of Whistler and Seymour Haden, it was on this medium that British
printmakers concentrated. Griggs' work is typical of the romanticised
topographical subjects which proliferated. The subject of this print,
a church on a hill in the village of Ippollitts (near his birthplace,
Hitchin), and its treatment is reminiscent of the work of Samuel
Palmer whose plates Griggs helped to print before they were finally
cancelled at the time of the influential Palmer exhibition held at the
Victoria and Albert Museum in 1926.

Griggs lived much of his life in Campden, Gloucestershire, and
illustrated *Highways and Byways in the Cotswolds*. He was on the com-
mittee of the Council for the Preservation of Rural England and of the
Society for Protection of Ancient Buildings.

Tahitian Woman By Robert Gibbings (1889-1958)
c. 1927-31
Hopton Wood stone
A. 98-1980

Gibbings is best known as a book-illustrator and wood engraver and
only three other sculptures by him are known. None of these is dated,
but they may be assigned to between the years 1927 and 1931, when
Gibbings was in close contact with Eric Gill at the Golden Cockerel
Press. It was in these years that Gibbings became interested in
sculpture.

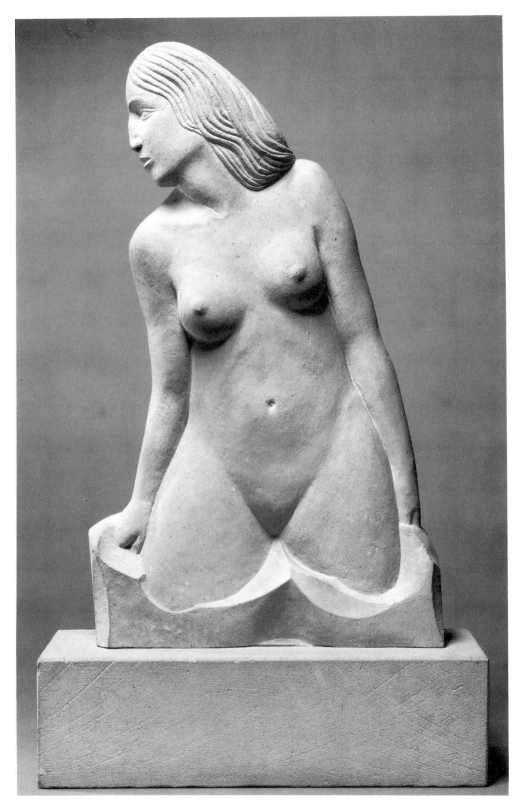

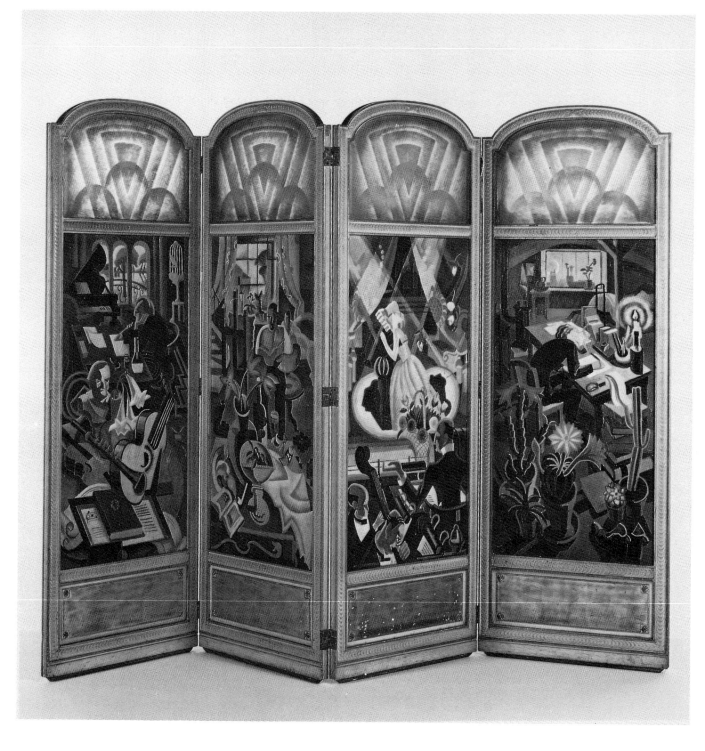

Screen Designed and painted by Adrian Paul Allinson (1890-1959)
1928
Glass with a wooden frame
Given by Peggy Mitchell-Smith in memory of her sister Mollie
W. 88-1982

Allinson was a stage designer, artist, caricaturist and potter. He made this screen for himself and it remained in his London studio until his death. The scenes represent an allegory of the arts. A ceramic by Allinson is also on display. The conventional frame of this screen, derived from late 18th century French models, is a piquant contrast to Allinson's jazzy patterns and mildly cubist scenes, and the general effect, though decorative, is decorous compared to the Vanessa Bell screen (*Page* 55).

Desk Designed by Sir Ambrose Heal (1872-1959) in 1928
Made by Heal and Son Ltd, London
1929
Oak
Circ. 609-1966

Inside the top drawer is a vellum label, signed by Sir Ambrose Heal and dated 1929, stating that this is one of the 'Signed Edition Series'. In its use of plain oak this desk reflects the Arts and Crafts survival style practised by Heal. But angular details betray the influence of the French 'Art Deco' style of the 1920s. This desk and a chair *en suite* were illustrated in *The Architectural Review* Vol. LXVIII, 1930 p. 37.

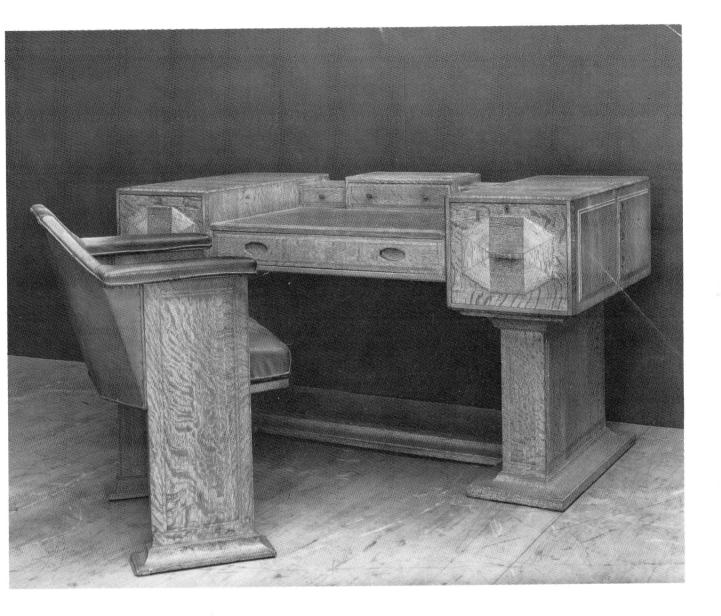

Rug Designed by Edward McKnight Kauffer, Hon RDI (1890-1954)
 Made by The Wilton Royal Carpet Factory Ltd
 1929
 Hand knotted woollen pile on a jute warp
 T. 440-1971

In the 1930s it was modish and 'modern' to have streamlined interiors
decorated throughout in neutral tones. Decorative relief came in the
form of rugs and carpets with bold designs. In Britain, The Wilton
Royal Carpet Factory and Edinburgh Weavers were the main pro-
ducers of these *avant-garde* hand knotted carpets. Edward McKnight
Kauffer and Marion Dorn set the pace and held an exhibition of their
rugs at Arthur Tooth & Son Ltd in 1929. Critics were not charitable
– in *Apollo,* Spring 1929, Herbert Furst wrote 'The carpets – really
rugs – have neither centres nor borders. If there are any associations
connected with these patterns they belong to the category of
mechanical designs. Actually, however, they are meaningless, ie
purely abstract'.

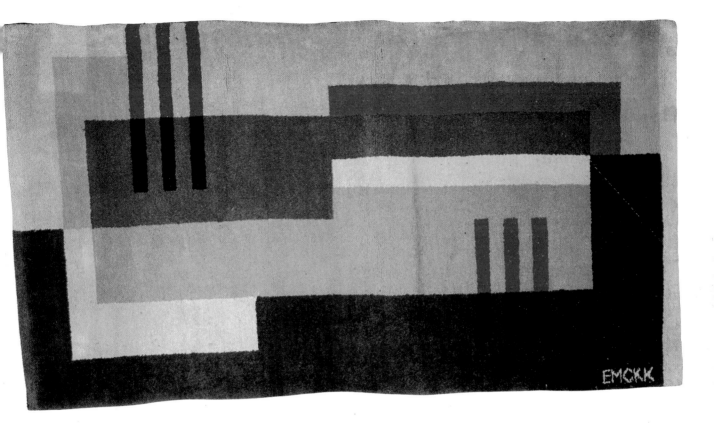

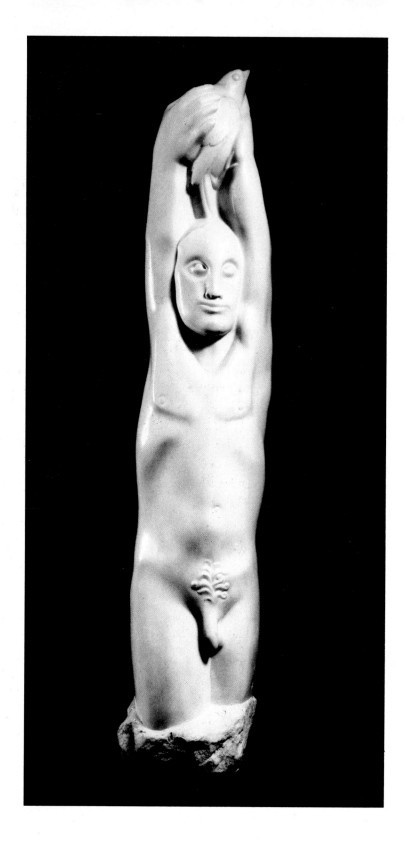

Man with a bird Maurice Lambert (1902-1964)
1929 (signed ML)
Marble
Given by Mr H. Daniel Conner
A. 35-1930

Maurice Lambert, the brother of the composer Constant Lambert, was born in Paris. Their father, George, himself a painter and sculptor, had been the first Australian artist to achieve an international reputation. Maurice received no formal art instruction but served a kind of apprenticeship as studio assistant to Derwent Wood, between 1918 and 1923, when Wood was Professor of Sculpture at the Royal College of Art.

In his interest in and use of materials which could take high polishes, such as marble, hard woods and bronze, he had points of contact with Brancusi, whose work had been shown at the Chenil Galleries, London, in the mid-1920s.

Man with a bird was bought by the donor from the artist's second one-man show held at Arthur Tooth's Gallery, London, in 1929.

Edmund Dulac wrote a piece on it in *Studio* at the time, in which he commented,

> Maurice Lambert's formal imagination is not static. He does not present you only with a pleasing pattern. Behind each sweep and kink of his lines there is some sort of throbbing force reluctantly imprisoned in marble, bronze, alabaster or iron . . .; it runs over the polished surface of the *Man with Bird*.

> It is that rare gift of vitality restrained that makes Lambert's work different from the work of most other modern sculptors . . . rich enough in imagination and power of invention not to have to borrow from any contemporary.

A later article, in June 1932 in the same magazine, observed 'The effect as a whole of his accumulated work is one which produces a twentieth century impression on the mind – the complicated life of today which forces us to demand simplification as an antidote.'

Designer's impression Interior of the foyer of the Cambridge Theatre, Seven Dials.
Perspective view showing box office facade, auditorium doors,
mirror, carpet and patterned flooring
By Serge Chermayeff (b. 1900)
1929-30
Preliminary pencil, gouache and metallic pigment
E. 85-1979

The Cambridge Theatre, designed by Wimperis, Simpson and
Guthrie with interiors designed by Chermayeff, was completed in
1930. Chermayeff was born in the Caucasus and came to England in
1910. From 1924 to 1927 he was chief designer for the decorating firm,
E. Williams Ltd, London, and from 1928 to 1931 he was Director of
Waring and Gillow's 'Modern Art Studio' which concentrated on
furniture and interior design. In 1931 he set up independently as an
architect. His career is typical of many *avant-garde* architects of the
period who came to 'modern' architecture through interior and
product design.
 A carpet with a similar motif and of the same date as the one
illustrated in this view is in the Department of Textiles (T.152-1978).

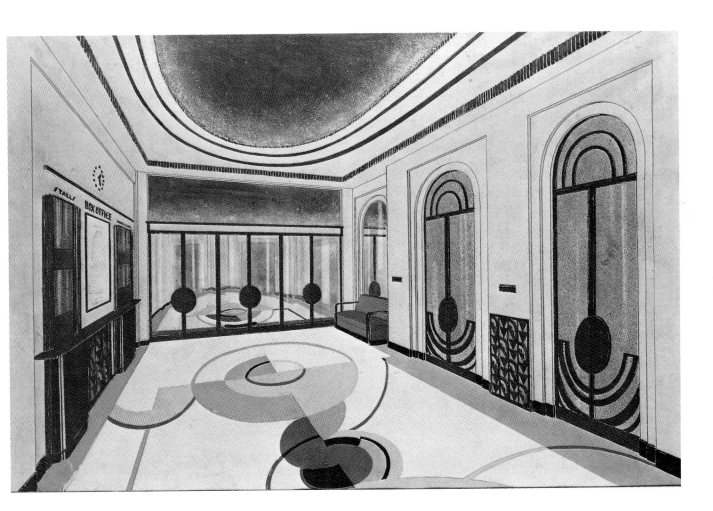

Tea Service Kettle, stand, teapot, sugar bowl, and milk jug
Designed and made by Harold Stabler (1872-1945)
1929-30
Mark: maker's mark of H. Stabler; London hallmarks for
1929-30
Silver and ivory
H. (kettle) 31 cm
Bequeathed by Frank Pick, Esq
Circ. 1, 2, 3, 4-1942

Frank Pick (1878-1941), as Vice Chairman of the London Passenger
Transport Board from 1933-40, was a noted patron of artists and
designers.

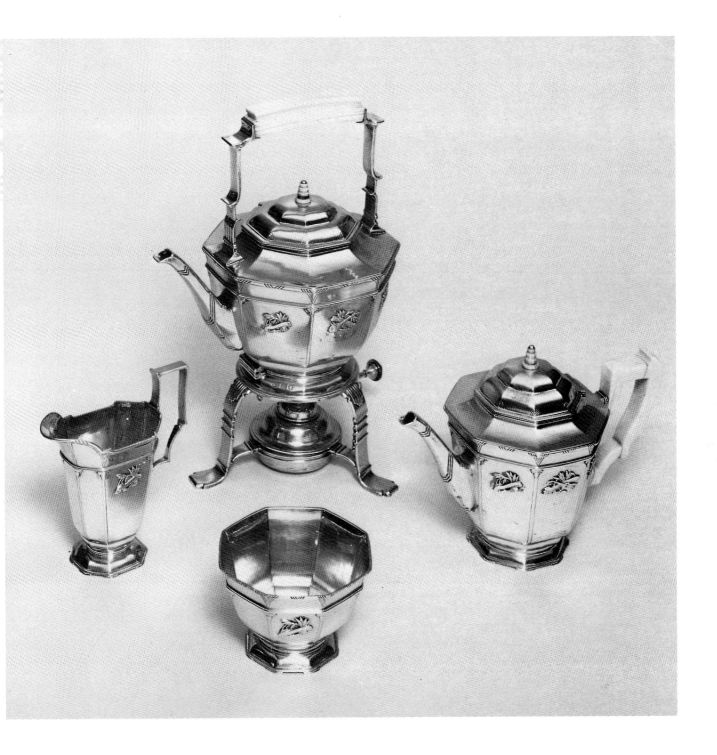

Vase 'Roc's Egg'
Made by Katherine Pleydell-Bouverie (b. 1895)
The Mill, Coleshill, Wiltshire
1929-30
Mark: impressed KPB in monogram
Stoneware with speckled grey-green and pale blue glaze
H. 25.5 cm
Bought from Katherine Pleydell-Bouverie in 1930
Circ. 236-1930

After a year working with Bernard Leach at St. Ives, Cornwall in 1924, Katherine Pleydell-Bouverie started her own pottery at Coleshill with the help of the Japanese potter, Tsurunoske Matsubayashi. From him she had already accumulated a quantity of technical information on glazing and firing. Over the next sixteen years she developed a unique range of glazes based on vegetable ashes which she created from the trees and plants on the estate at Coleshill, where she lived until 1946. The subtlety and richness of these colours is demonstrated in this vase with its speckled grey-green and pale blue colouring.

ACT V SCENE I
LINES 193-201

THE TRAGICALL HISTORIE OF

HAMLET PRINCE OF DENMARKE

ACT V SCENE I
LINES 202-210

son excellence et lustre, surpassa l'humaine capacité, se soit abaissé jusques à prendre pour femme, celle qui sortant d'une race servile, a beau avoir un Roy pour pere, veu que tousjours la vilité de son sang, luy fera monstrer quelles sont les vertus, et nobles se ancienne de sa race.

Les mariages se doivent mesurer à la vertu et race, et non à la beauté.

Est-ce à vous, Monsieur, à ignorer, que la liaison maritale ne doit estre mesuree par quelque folle opinion d'une beauté exterieure, mais plustost par le lustre de la vertu, et antiquité de race, honoree pour sa prudence, et qui jamais ne degenera de l'integrité de ses ancestres? Aussi la beauté exterieure n'est rien, où la perfection de l'esprit ne donne accomplissement, et orne ce qui aucorps se flestrit, et perd par un accident et occurence de peu d'effect: joinct que telles mignotises en ont deceu plusieurs, et les attrayans, comme gluantes amorces, les ont precipitez és abismes de leur ruine, desbonneur, et accablement. C'estoit à moy à qui cest advantage estoit deu, qui suis Royne, et telle qui me puis esgaler en noblesse, avec les plus grans de l'Europe, qui ne suis en rien moindre, soit en antiquité de sang, ou valeur des parens, et abondance de richesses.

La beauté a ruiné plusieurs.

Et ne suis seulement Royne, mais telle que recevant qui bon me semblera pour compaignon de ma couche, je peux luy faire porter tiltre de Roy et luy donner, avec mes embrassemens, la jouissance d'un beau Royaume et grand' Province. Advisez, Monsieur, combien j'estime vostre alliance, qui ayant de coustume de poursuivre, avec le glaive, ceux qui s'osoyent enhardir de pourchasser mon accointance, c'est à vous seul à qui je fais present, et de mes baisers, et accolade, et de mon sceptre, et couronne. Qui est l'homme, s'il n'est de marbre, qui refusast un gage si precieux, que Hermetrude avec le Royaume d'Escosse? Acceptez gentil Roy, acceptez ceste Royne, qui avec une si grande amitié vous pourchasse tant de bien, et peut vous donner plus d'aise en un jour, que jamais l'Angloise ne sçauroit vous apprester

Clowne. A whorson mad fellowes it was, whose doe you think it was?

Ham. Nay I know not.

Clowne. A pestilence on him for a madde rogue, a pour'd a flagon of Renish on my head once; this same skull sir, was sir, Yoricks skull, the Kings Jester.

Ham. This?

Clowne. E'en that.

The Dane arriving in her court, desired she to see the old king of Englands letters and mocking at his fond appetites, whose blood as then was half congealed, cast her eies upon the yong and pleasant Adonis of the North, esteeming herselfe happy to have such a pray fallen into her hands wherof she made her ful account to have the possession, and to conclude she that never had been overcome by the grace, courtesie, valor or riches of anie prince nor Lord whatsoever, was as then vanquished with the onelie report of the subtilties of the Dane who knowing that he was already financed to the daughter of the king of England, spake unto him and said, I never looked for so great a blisse, neither from the Gods, nor yet from fortune, as to behold in my countries, the most compleate prince in the north, and he that hath made himselfe famous and renowned through all the nations of the world, as well neighbours as strangers, for the only respect of his vertue wisdom and good fortune, serving him much in the pursuite and effect of divers thinges by him undertaken, & thinke myselfe much beholding to the king of England (although his malice seeketh neither my advancement nor the good of you my Lord) to doe me so much honor as to send me so excellent a man to intreate of a marriage (he being olde & a mortal enemy to me & mine) with mee that am such a one as every man seeth, is not desirous to couple with a man of so base quality as he, whom you have said to be the son of a slave, but on the other side I marvel that the son of Horvendile, and grand-child to king Rotherick be that by his foolish wisedom, & fained madnesse surmounted the forces, & subtilties

Ham. Let me see. Alas poore Yoricke, I knew him Horatio, a fellow of infinite jest, of most excellent fancie, hee hath borne me on his backe a thousand times, and now how abhorred in my imagination it is: my gorge rises at it. Heere hung those lyppes that I have kist I know not howe oft, where be your gibes now? your gamboles, your songs, your flashes of merriment, that were wont to set the table on a roare, not

of Fengon, and obtained the kingdom of his adversary, should so much imbase himselfe, (having otherwise bin very wise and wel advised, in al his actions) touching his bedfellow, and bee that for his excellency & valor surpasseth humane capacity, should stoope so lowe as to take to

Woodcut illustrations Edward Gordon Craig (1872-1966)
Printed at the Cranach Press, Weimar
1930
L. 2768-1930

This special edition of *The Tragedie of Hamlet Prince of Denmark,* by
William Shakespeare, was planned and printed by Count Harry
Kessler at his Cranach Press. It followed the text of the Second Quarto
of 1604-05, and printed, parallel with this, the Hamlet stories from
Saxo Grammaticus and Belleforest, with English translations there-
from. Gordon Craig designed and cut the illustrations himself direct
on wood. Eric Gill cut the title. The type was specially designed by
Edward Johnston after a Mainz Psalter of 1457. The paper was
specially made, of pure hemp fibre and linen, by a process developed
by Kessler in research with the French sculptor Aristide Maillol. The
paper carries the watermark of his press, and the book was printed
on hand-presses in a standard edition limited to 300 copies.

Craig's life and career in the international theatre were of the most
romantic. The son of E. W. Godwin and Ellen Terry, his links with
Germany went back to school-days, for a time, in Heidelberg.
Kessler invited him to Weimar, and Berlin, in 1904, to show his
drawings, and he soon achieved a reputation across Europe. The
magazine he edited, *The Mask,* was published in Florence from 1908,
and its first issue took his ideas to Constantin Stanislavsky in Moscow.
The result from this was a production of Hamlet, directed by
Stanislavsky and designed by Craig in the Moscow Art Theatre at the
beginning of 1912, which enjoyed a quite sensational success. Kessler's
plan for an edition of the play to be illustrated by Craig was
enthusiastically taken up immediately afterwards, but was not to
reach fruition until 1930.

Fireback Designed and made by Eric Gill (1882-1940)
c. 1930
Cast iron
H. 74.5 cm
M. 3-1983

This cast iron fireback is the only known example of a piece of ironwork designed by Eric Gill. It was cast at a small iron foundry in the village of Loosley Row near Gill's house, Pigotts at Speen in Buckinghamshire, where he had been living since 1928. According to Gill's daughter, the fireback was for his personal use and hence only one was made.

Eric Gill was a sculptor, engraver, typographer and writer. He became interested in lettering while he was articled to the architect W. D. Caroë in London between 1900 to 1903 and went to the Central School of Arts and Crafts where he studied under Edward Johnston. He was later to collaborate with Johnston and Hilary Pepler in the productions of the St Dominic's Press, started by Pepler in 1916. In the '20s Gill started his work for the Golden Cockerel Press and was commissioned by Stanley Morrison to design typefaces for the Monotype Corporation.

His sculpture includes commissions for Broadcasting House, London, the League of Nations Building, Geneva, and a series of panels for the new museum in Jerusalem. He was appointed RDI in 1936 and elected an ARA in 1937.

121

Drawing 'Café Scene'
 By Edward Burra (1905-1976)
 c. 1930
 Pen and ink
 Circ. 305-1958

Edward Burra is coming to be seen as one of the most widely repre-
sentative of the artists who continued to work during the mid-20th
century in a basically figurative mode. Here the inspiration is from
George Grosz and provides a mordant misanthropic view of human
society. In his Vorticist and Surrealist veins there is more of the
optimism of the century, its enjoyment of the mechanical and of the
bright imagery of a commercial pop culture.

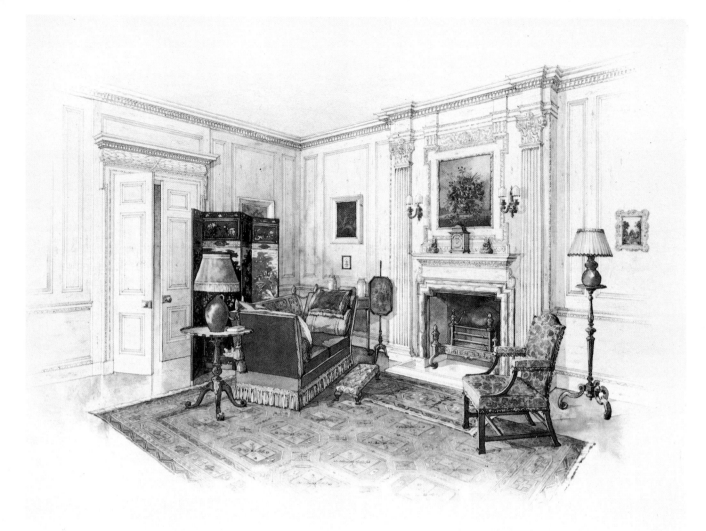

124

Designer's impression A drawing room
Designed by William Henry Haynes & Co
c. 1930
Watercolour and pencil on board
E. 6-1977

Haynes and Co., operated as antique dealers, upholsterers (dealing mainly in chintz), and as interior decorators.

This mixture of old and new furniture (but in the antique style) in a setting of stripped panelling is still the norm for a certain type of interior. The custom of stripping paint off wood never intended to be seen has now spread to other parts of the house and to many types of furniture.

Table Designed by Denham MacLaren (b. 1903)
1931
Glass, painted wood and chromium plated metal
W. 24-1979

This original and inventive table is one of the few pieces of British
1930s furniture which is able to stand direct comparison with the best
Continental designs, which makes MacLaren's small output and
limited influence a matter for regret.

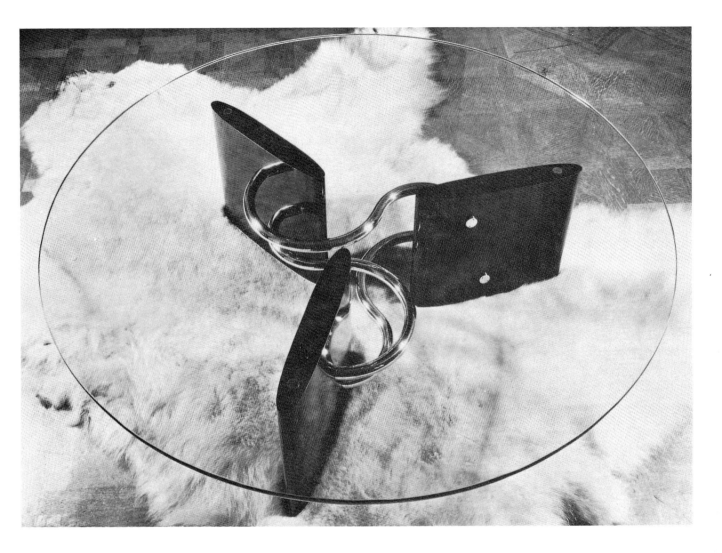

Arm-chair Designed by Denham MacLaren (b. 1903)
1931
Glass and zebra skin
W. 26-1979

This armchair was designed by MacLaren for his own use. The use of zebra-skin strikes a surrealistic note, in contrast to the glass, a fully accredited Modern Movement material.

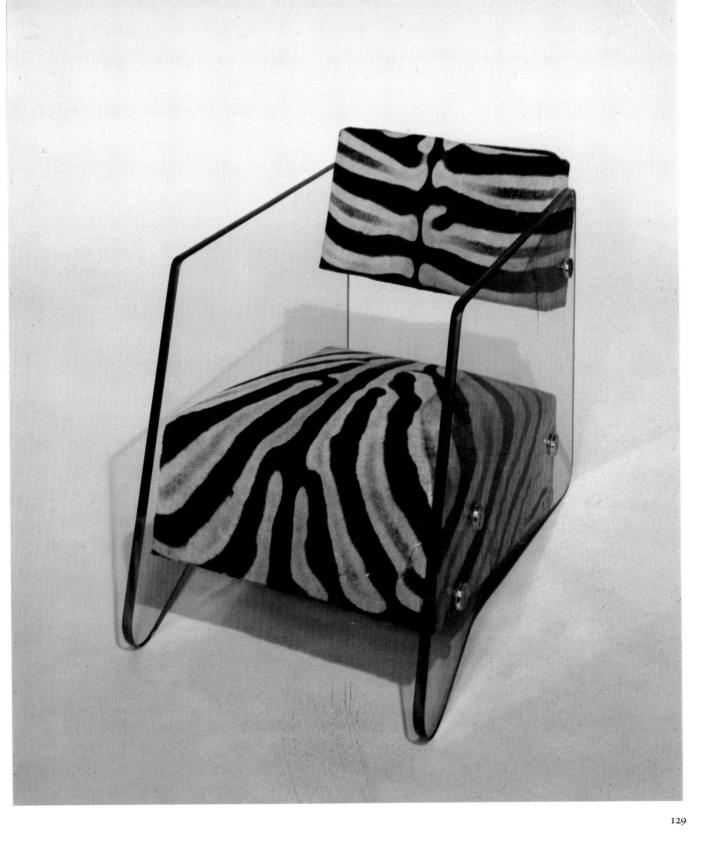

Engraved decorations Eric Gill (1882-1940)
The Four Gospels
Printed at the Golden Cockerel Press
1931
L. 212-1933

The Four Gospels of the Lord Jesus Christ according to the author-
ised version of King James I were printed and published in this
edition by the Golden Cockerel Press, at Waltham St Lawrence,
under the direction of Robert and Moira Gibbings. It contains
upwards of sixty engravings by Gill with magnificent initial letters
and monograms. It was the first book printed in the 18pt size of the
then new Golden Cockerel Face, and used a paper specially made,
with the watermark of the Press, by Joseph Batchelor & Sons. The
edition was limited to 500 copies, bound by hand by Messrs San-
gorski and Sutcliffe in ¼-white pigskin. The *London Mercury* said at the
time 'The Golden Cockerel Press is now producing books which will
stand comparison with any book printed in the whole history of
mankind; lovely, solid, firmly printed, soundly decorated things
which it is an abiding pleasure to possess'.

IN THE BEGINNING WAS THE WORD, AND THE WORD WAS WITH GOD, AND THE WORD WAS GOD. THE

SAME WAS IN THE BEGINNING WITH GOD. ALL
THINGS WERE MADE BY HIM; AND WITHOUT HIM
WAS NOT ANY THING MADE THAT WAS MADE. IN
HIM WAS LIFE; AND THE LIFE WAS THE LIGHT OF
MEN. AND THE LIGHT SHINETH IN DARKNESS;
AND THE DARKNESS COMPREHENDED IT NOT.

Knocker Designed and made by Gertrude Hermes (1901-1983)
1932
Brass
Diam. 40 cm
M. 36-1974

This is the first of a series of door knockers and letter boxes which Gertrude Hermes executed for several of her friends after she had completed a commission which included door furniture for the Shakespeare Memorial Theatre, Stratford-upon-Avon in 1932. This example was made for Gilbert Mitchison (1880-1970) later Lord Mitchison, for his house in Hammersmith Mall, while he was a practising barrister of the Inner Temple. This prototype had to be rejected because the aperture was not sufficiently large to receive solicitors' briefs. The version eventually installed was modified to do so.

Gertrude Hermes was primarily a wood engraver and sculptress but nonetheless executed an appreciable amount of architectural decorative work, particularly before the Second World War. In 1925 she was one of the finalists in engraving for the Prix de Rome. She was a prominent illustrator, and in 1939 was one of the seven wood engravers to represent Britain at the Venice International Exhibition. During the Second World War, she took her young family to Canada where she worked as a tracer and precision draughtsman in the drawing offices of aircraft and shipbuilding practices. After the war, she returned to England and concentrated more on sculpture. She was elected an associate of the Royal Academy in 1963 for her engraving, she was the first woman engraver to be elected, and she became a Royal Academician in 1971.

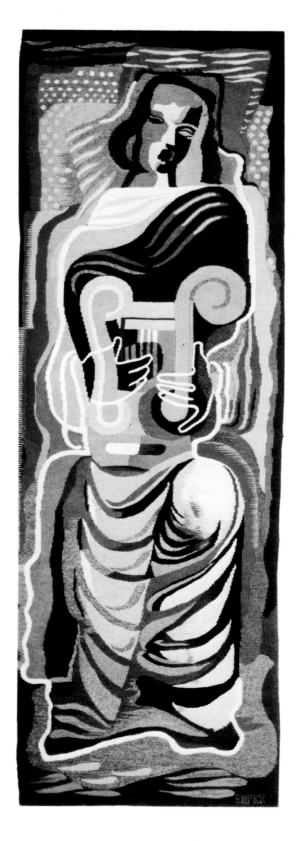

134

Tapestry Designed by Edward McKnight Kauffer, Hon RDI (1890-1954)
Probably made by Mrs Jean Orage
1932
Tapestry woven wool on a cotton warp
T. 368-1982

The Museum has three rugs designed by Edward McKnight Kauffer but until the end of 1982 lacked one of these rarer tapestries. This particular panel was shown at the 1932 exhibition of 'modern decorations and designs for walls, panels and screens' held at Messrs Keebles, Carlisle House, Soho and was featured in the *Architectural Review*.

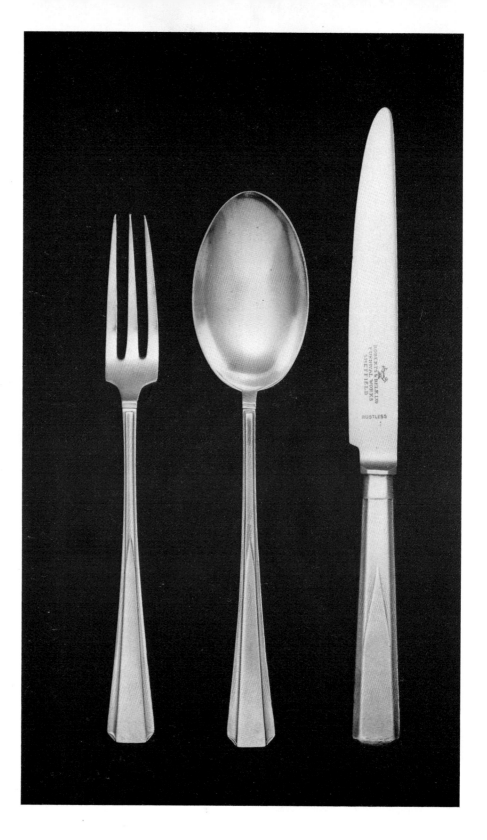

'Plain Pine' Dessert knife, fork and spoon
Designed by Walter Patrick Belk (1872-1963)
Made by Roberts & Belk Ltd, Sheffield
1932-36
Electroplate, the knife with a steel blade
L. (knife) 21 cm
Made for the first class dining room of the Queen Mary, which
was panelled in pine
Circ. 122, a, b-1937

The design of the cutlery proved so popular that it was re-used for
the Queen Elizabeth.
A set was lent by the Mappin Art Gallery, Sheffield, to: *Thirties,
British art and design before the war,* Hayward Gallery, 1979-80 (cat.
no. 3.40).
W. P. Belk, architect, designer and silversmith, did much to en-
courage modern design.

Desk Designed by Wells Coates (1895-1958)
Made by PEL (Practical Equipment Ltd)
1933
Ebonised wood, chromium plated metal
W. 35-1983

This desk is closely based upon one designed by Marcel Breuer and manufactured by Thonet from 1929. In 1935 PEL also made tubular steel furniture for Wells Coates to use in his Embassy Court Flats, Brighton. This desk was purchased from PEL by its original owner along with a Breuer designed chair (*Page* 148). It may be that in selling these two pieces together PEL were aware of the debt which Coates owed to Breuer in the design of the desk.

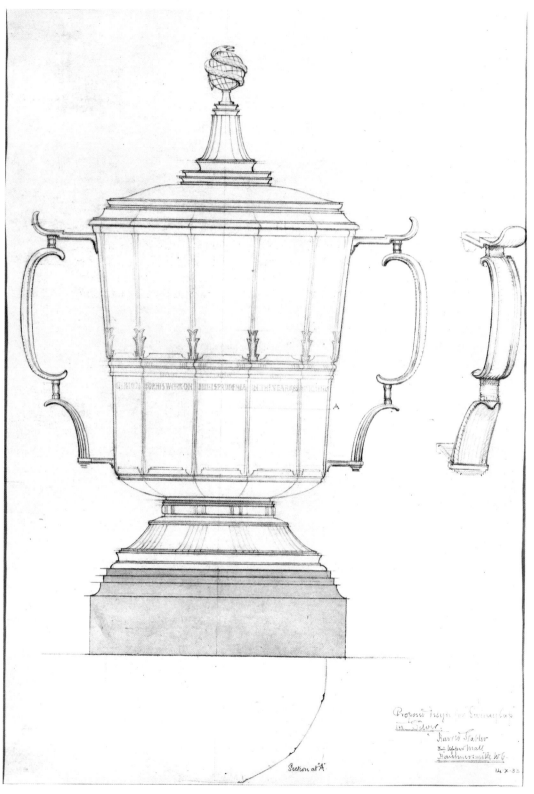

Proposed design for Surrey Club
in Silver.
Harold Stabler
34 Upper Mall
Hammersmith W.6.

Section at "A"

14·X·38

Design Prize cup
 Probably designed by Harold Stabler (1872-1945)
 1933
 Pencil and wash
 Given by Mr J. E. Stapley
 E. 411-1976

A design for the Swiney Prize for Jurisprudence, awarded by the Society of Arts. At its presentation the silver cup was stated to have been made by Stabler but designed by Sir Edwin Lutyens, then Vice-President of the Society. Lutyens' responsibility for the design remains uncertain as the cup is characteristic of Stabler's style during this period.

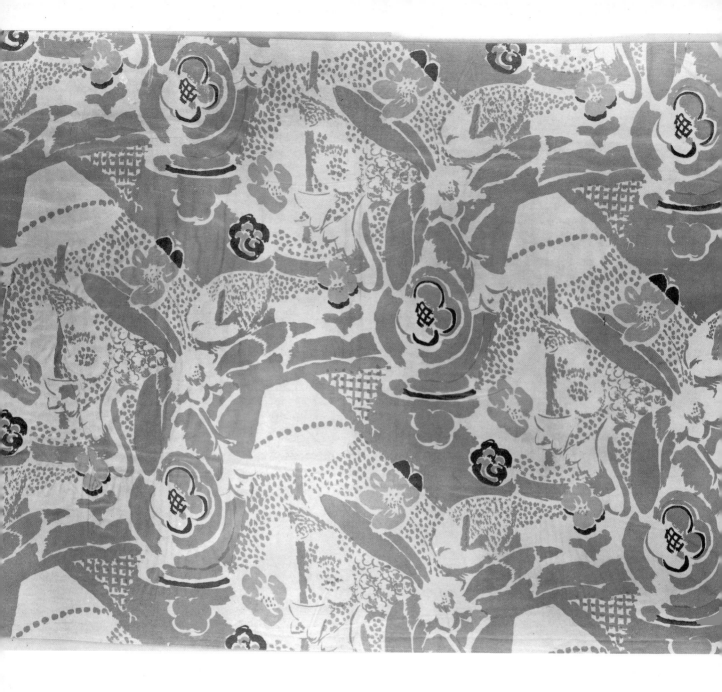

Furnishing fabric Designed by Vanessa Bell (1879-1961)
Made by Allan Walton Textiles
1934-6
Screen printed cotton and rayon (satin finish)
Circ. 88-1937

Allan Walton (1891-1948) was a painter, designer and decorator as well as one of the most enterprising textile producers of the 1930s. From about 1929 he commissioned a wide range of designs from leading professional designers as well as artists including H. J. Bull, T. Bradley, Margaret Simeon, Cedric Morris and Frank Dobson. His liaison with Vanessa Bell and Duncan Grant was particularly fruitful. Their free flowing painterly patterns were ideal for the fabric he used so often – a satin faced mixture of rayon and cotton which intensified colours and reflected light. The outbreak of World War II halted this successful alliance between art and industry and in 1948 saw Allan Walton's untimely death.

Tea Service Teapot, hot water jug, sugar basin, and cream jug
Designed by Harold Stabler (1872-1945)
Made by Adie Brothers Ltd, Birmingham
1935
Mark: maker's mark of Adie Brothers Ltd; Birmingham hall-marks for 1935-36; underside stamped 'Stabler' and 'REG. APPLIED FOR'
Silver with ivory and wood
L. (teapot and coffee pot, with handle and spout) 19.8 cm
M. 291, a, b, c-1976

One of Stabler's designs for mass-production. The square pieces originally fitted on to an oblong tray. An electroplated version of the design, dating to 1936 and bearing the Registered Design no. 810663, was shown in *Birmingham Gold and Silver,* an exhibition celebrating the Bicentenary of the Assay Office, 1973 (cat. no. H. 105).

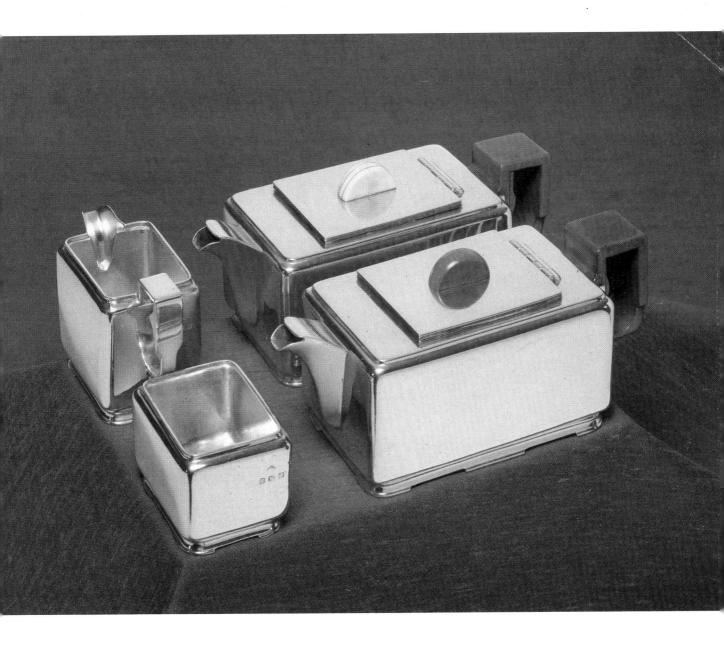

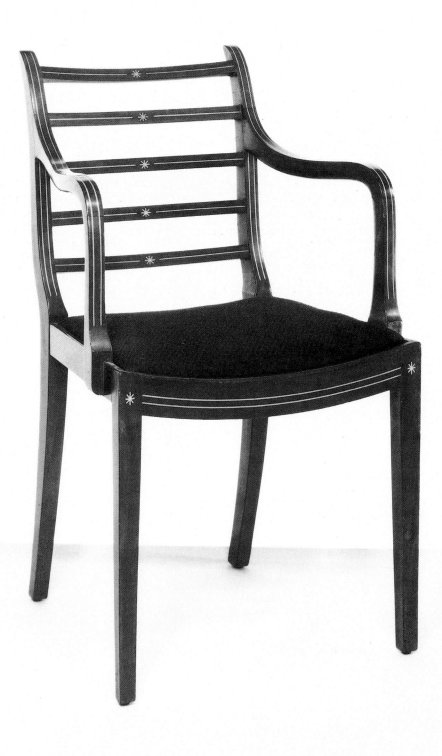

Arm-chair Designed by Eric William Ravilious (1903-1942)
Made by H. Harris for Dunbar Hay Ltd
1936
Mahogany inlaid with box
Circ. 265-1948

In 1936 Ravilious was commissioned by Lady Sempill of Dunbar Hay and Company to design a table, two arm-chairs and two single chairs for a client. Several of these Regency Revival suites were made, but Ravilious designed no other furniture. The Neo-Georgian and other revivals are at present under-represented in the V&A's collection.

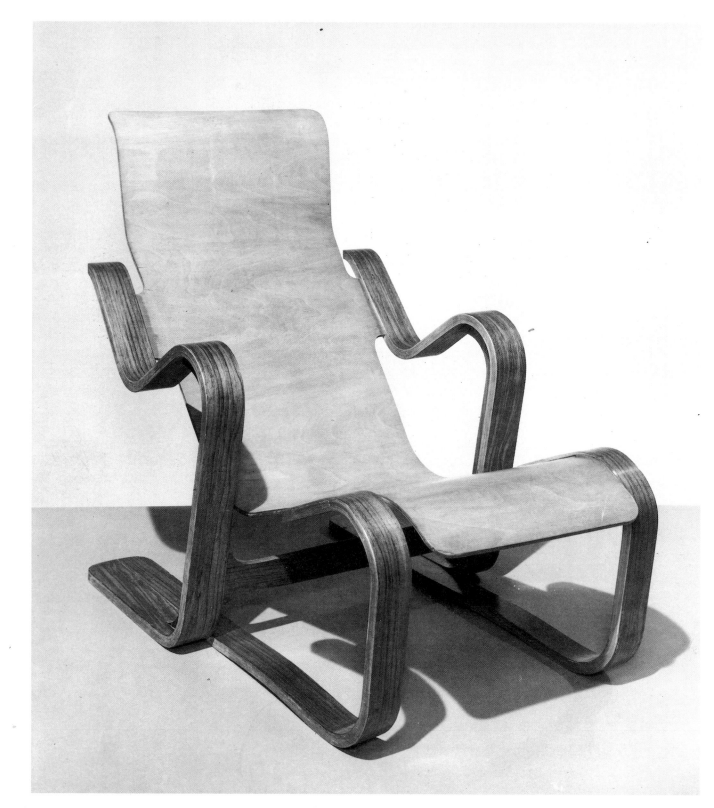

Chair Designed by Marcel Breuer (1902-1981)
 Made by Isokon Furniture Company, London
 1936
 Laminated plywood with 'zebrano' veneer finish
 Given by Mr and Mrs Dennis Young
 Circ. 80-1975

This is the shorter version of Breuer's celebrated 'long chair', an example of which is also in the Museum's collection. Breuer spent 1935-1937 in London in partnership with F. R. S. Yorke and as consultant to Isokon. This chair was originally sold with a long cushion, the full length of the seat, no longer extant. Though interesting experiments in the use of plywood in furniture took place in England none of the furniture produced approaches this piece in quality of design or elegance.

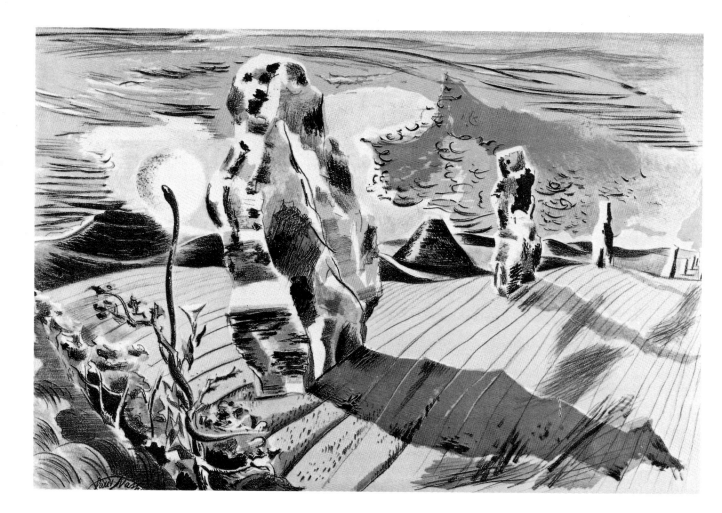

Print 'Landscape of the Megaliths'
By Paul Nash (1889-1946)
Published by Contemporary Lithographs Ltd, London
1937
Signed *Paul Nash* and lettered with details of publication
Colour lithograph
Given by Mrs Margaret Nash, widow of the artist

E. 4800-1960

A watercolour of the same subject, dated 1937, is in the Albright
Knox Art Gallery, Buffalo, U.S.A.

Contemporary Lithographs Ltd., which published two series of
prints in 1937 and 1938, was directed by John Piper and Robert
Wellington. Their intention was to make the work of contemporary
British artists accessible to a much wider public than had hitherto
been possible. They included lithographs intended particularly for
children for display in schools and nurseries. The prints were warmly
welcomed at the time of publication: 'The production of these ten
lithographs in colour is easily one of the most significant happenings
in English Education since the War' claimed Henry Morris, Director
of Education in Cambridgeshire, and Marian Richardson, L.C.C.
Inspector of Art, considered 'These delightful lithographs are the
best collection of pictures for schools that I have seen'.

Furnishing fabric 'Horizontal'
Designed by Ben Nicholson (1894-1982)
Made by Edinburgh Weavers
1937
One of the constructivist fabrics designed by Ben Nicholson and
Barbara Hepworth
Circ. 172-1938

The experimental off-shoot of Morton Sundour fabrics, Edinburgh
Weavers, under the admirable leadership of Alastair Morton pro-
duced exciting modern printed and woven furnishing fabrics designed
by free-lance designers and artists. Friendship with Ben Nicholson
culminated in the impressive range of Constructivist Fabrics issued
in 1937. At the private view Alastair Morton said that they had not
been 'brought out as just another stunt, but as a conscious attempt to
build a contemporary style in decoration in keeping with modern
architecture and present day culture generally . . . We wanted to
think out the real principles of modern design and bring out some-
thing that was lasting . . . based on the beauty of pure shapes and
colours'.

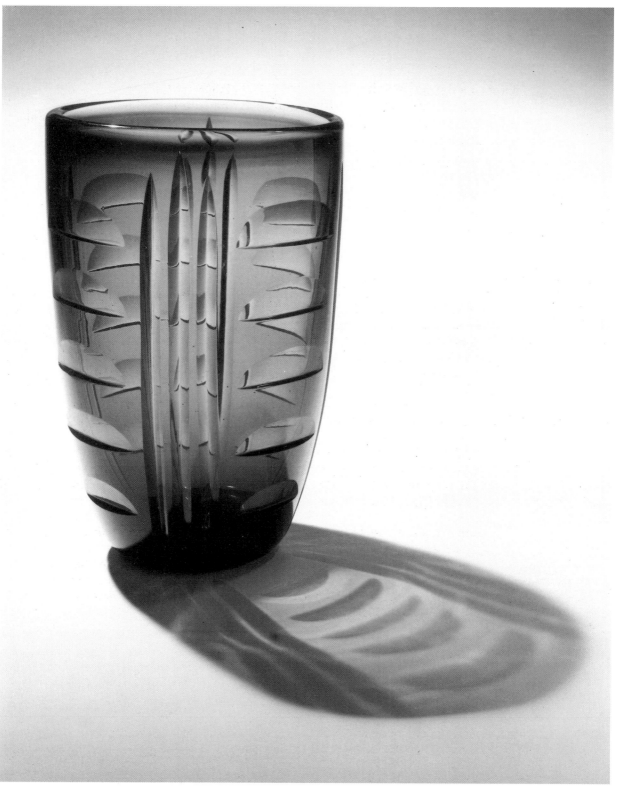

Vase Designed by Keith Day Pearce Murray (1892-1981)
Made by Stevens & Williams, Brierley Hill, Stourbridge
1937
Unmarked
Green glass, wheel cut with a series of vertical and horizontal
grooves
H. 28 cm
Given by Stevens & Williams in 1938
Circ. 16-1938

This vase is unusual in being unmarked, unlike the majority of Keith
Murray's designs for Stevens & Williams. It was shown in and,
presumably, made especially for the international exhibition held in
Paris, 1937, thus by-passing the stage at which the usual etched
signature was added. It appears in the Stevens & Williams pattern
books in about 1937 as drawing no. 591A. After the exhibition it was
acquired by the Museum through negotiations with the Council for
Art and Industry. Under the Chairmanship of Frank Pick, the C.A.I.
was concerned with the selection for the British section of the exhibi-
tion and subsequently initiated many of the Museum's acquisitions of
exhibited pieces.

 Keith Murray, an architect and collector of glass, began designing
glass under the influence of the Scandinavian sections, which he saw
in the international exhibition at Paris in 1925 and the Swedish
exhibition held in London in 1931. His designs reflect his frequently
expressed admiration for the Scandinavian flat cutting, using both
polished and unpolished surfaces and, in many cases, provide a direct
comparison with Swedish examples as may be seen in the Museum's
study collections. Simultaneously, he demonstrated a respect for
early 19th century glass cutting styles. His chief anathema was the
type of cutting once described by John Gloag as a 'death of a thousand
cuts' (*Architectural Review,* Feb., 1933, p. 85).

Furnishing fabric 'Aircraft'
Designed by Marion Dorn (1899-1964)
Made by Old Bleach Linen Company Ltd
1938
Screen printed linen and rayon
Circ. 241-1939

The 1930s saw the rapid development of screen-printing techniques applied to textiles. Costs were kept low by the use of undyed grounds and complicated designs were avoided in favour of simple, well spaced patterns such as 'Aircraft'. Marion Dorn's printed textiles reveal her initial training in the graphic arts. She preferred bold, large scale repeating patterns which suited the needs of numerous interior designers and architects who frequently specified her fabrics. This soft furnishing was used for the curtains in the first class lounge on the liner Orcades.

Bowl 'Boat Race'
Designed by Eric William Ravilious (1903-1942)
Made by Josiah Wedgwood & Sons, Etruria
1938
Mark: printed WEDGWOOD MADE IN ENGLAND DESIGNED BY ERIC
RAVILIOUS painted CLH 1263C
Cream coloured earthenware transfer printed in black, over
printed in colours with a design based on the annual Oxford
and Cambridge boat race
Diam. 31 cm
Bought from Josiah Wedgwood & Sons in 1939
Circ. 379-1939

Eric Ravilious was firstly and primarily a wood engraver and painter.
However, after some limited industrial design experience with glass,
in about 1935 he was introduced to Tom Wedgwood by Cecilia
Dunbar Kilburn (Lady Sempill) of Dunbar Hay Ltd. As a result,
Ravilious was responsible for some of Wedgwood's most prestigious
and successful printed designs of the 1930s. Several of his designs were
also produced in the 1950s and after his disappearance while on a
flying mission during the war as a War Artist.
*The Thirties, Progressive Design in Ceramics, Glass, Textiles and Wall-
papers,* V&A travelling exhibition, 1975.
Thirties, British art and design before the war, Hayward Gallery, 1979-
1980, 4.86.

Cigarette box Designed and made by H. G. Murphy (1884-1939)
1938
Mark: maker's mark of H. G. Murphy and the bird symbol of
his Falcon Workshop; London hallmarks for 1938
Silver, with turned ivory finial
H. 13.8 cm
Circ. 228 & a-1938

A reissue of a design first produced in 1931, of which the Goldsmiths'
Company has an example. The V&A box was purchased from the
Goldsmiths' Hall exhibition, Modern Silverwork, 1938. Murphy
studied at the Central School of Arts and Crafts, worked for Henry
Wilson, went to Germany to study with Emil Lettré and became
Principal of the Central School in the late 1930s.

Poster Dig for Victory. Issued by the Ministry of Agriculture to aid the
 war effort in the Second World War
 By an anonymous artist
 Produced by Charles F. Higham & Co Ltd for the Ministry of
 Information
 Printed for H M Stationery Office by J. Wiener Ltd, London
 WC1
 1941
 Numbered 51-8374
 Colour offset
 Given by Ogilvy Benson & Mather Ltd
 E. 136-1973

Vast developments in technology, particularly in communications,
transport and military weapons by the time of the Second World War,
led civilians to be involved to a far greater degree than in the First.
'There was no need to whip up patriotic interest or display recruiting
posters, everyone was immediately fully committed' (H. Hutchison
The Poster 1969). Posters concentrated on themes of domestic behav-
iour: 'Careless talk costs lives'; personal cleanliness and hygiene;
care and frugality in the factory and at home; appeals for blood
donors and for home grown food. Images were often domestic rather
than of battlefields, soldiers, Uncle Sams, Russian Bears or groups of
frightened women and children, but as this example aptly demon-
strates no less powerful. The foot which digs is also about to crush the
enemy.

Study for sculpture 'Counterpoise'
By Barbara Hepworth, DBE (1903-1975)
1946
Pencil and gouache on prepared board
Circ. 57-1958

This drawing is typical of the work of the artist in the early 1940s.
She made various sculptures of intricate convoluted forms, using
painted carved wood and stretched strings, reminiscent of musical
instruments and shells.

Furnishing fabric 'Sutherland Rose'
 Designed by Graham Sutherland (1903-1980)
 For Helios Ltd
 1946
 Screen printed cotton
 Circ. 71-1947

When the textile industry revived after World War II Graham
Sutherland designed a number of floral patterns for both dress and
furnishing fabrics. Flowers have long been the main motifs for
decorative fabric design. In this case the tradition was refreshed by
the vigorous drawing of the pair of bold, fully blown roses which
form the repeat. This fabric was originally printed by Helios Ltd., but
after 1950 it was produced by Warner & Sons Ltd., who own the
design. It was selected by various authors to illustrate the new
approach to flower patterns and appears in *Textile Design* by Anthony
Hunt (Studio, new edition 1951) and in *Fabrics in the Home* by Roger
Smithells (Herbert Jenkins, 1950). It was shown at the Council of
Industrial Design's exhibition *Britain Can Make It* held at the V&A in
1946.

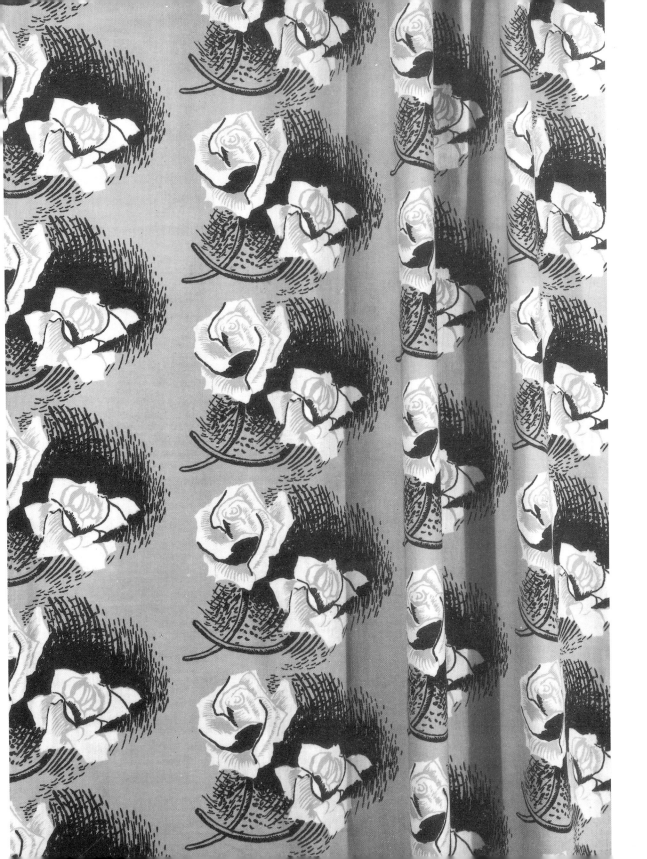

Furnishing fabric 'Mexican Market'
Designed by Jane Edgar
For Heal and Son Ltd
1947
Screen printed linen
Given by Heal and Son Ltd
Circ. 215-1947

Between 1939 and 1945, when energies were devoted to the war effort no advances in textile design were possible. After 1946 industries gradually recovered and a new, abstract style emerged which became widespread in the 1950s. Jane Edgar was responsible for many innovative textile designs throughout the 1940s and 1950s. 'Mexican Market' reveals the post-war fondness for line drawings of domestic objects contained within square or rectangular frames.

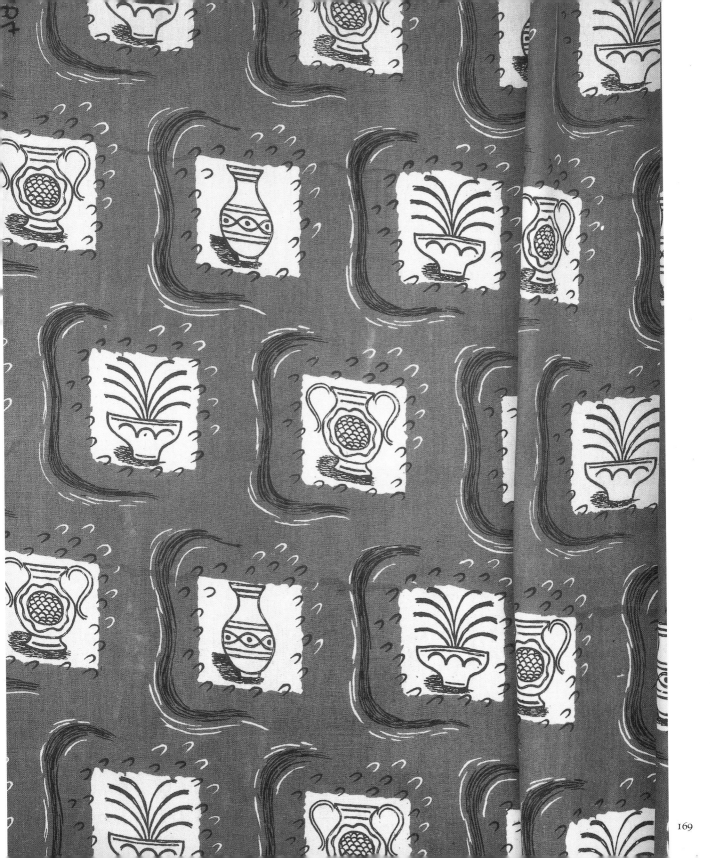

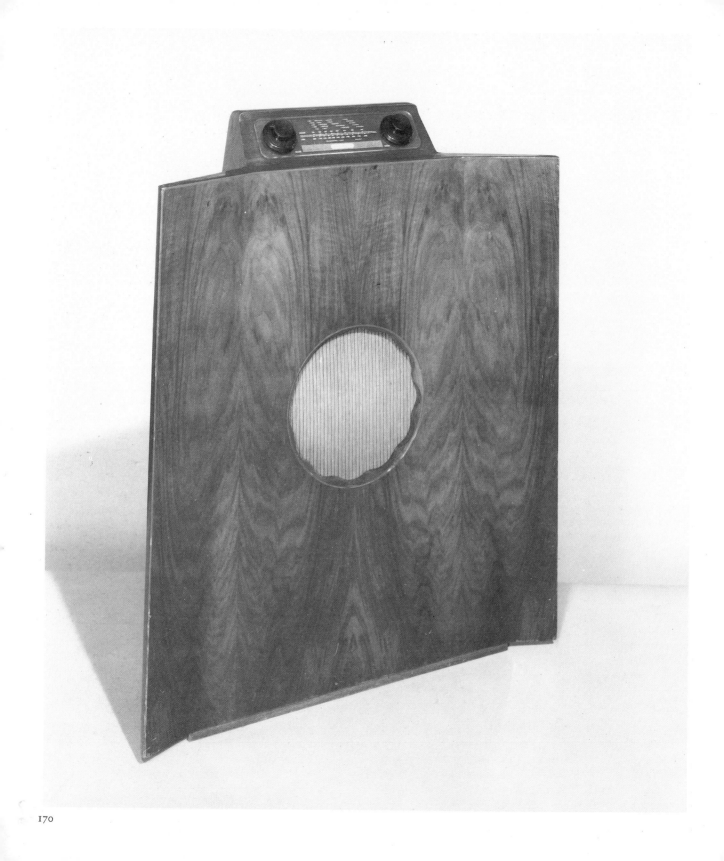

Wireless 'A146CM' Designed by Professor R. D. Russell (1903-1981)
Made by Murphy Radio Ltd, Welwyn Garden City
Hertfordshire
1948
Veneered wood
Circ. 411-1975

This wireless is made on the 'baffle board' principle, the edges being bent forward at a 15 degree angle. The residual 'rose window' chamfered around the loudspeaker is an amusing instance of Arts & Crafts survival in an otherwise Modern design.

Furnishing fabric Designed by Hans Tisdall (b. 1910)
Made by Edinburgh Weavers
1949
Screen printed cotton
Circ. 39-1950

The painter and designer Hans Tisdall was born in Germany and
studied at the Academy of Fine Art, Munich before moving to
London (after a stay in Paris) in 1930. His inventive textiles betray the
fact that he is primarily a painter with a bold and sure approach to
decorative patterning. He uses the textile surface as a canvas but at
the same time is careful to observe the laws of repeating design which
are essential to a pattern's success. The Museum has a representative
collection of his work for firms such as Morton & Sundour, and
Turnbull & Stockdale Ltd., dating from the late 1930s to the 1960s.

Tapestry 'Farming'
Designed by Edward Bawden (b. 1903)
Made by The Edinburgh Tapestry Company Ltd at Dovecot
Studios
1950
Tapestry woven wool on a cotton warp
T. 273-1978

Edward Bawden's bold animal design proved ideal for interpretation
by the Dovecot weavers. Better known as a painter, graphic artist and
illustrator his familiar placid cows and sturdy farmyard fowls succeed
just as well on this larger woolly scale. Subtle colour changes are
achieved by skilled use of hatching. The excellent catalogue *Master
Weavers, Tapestry from the Dovecot Studios 1912-1980* (The Scottish
Arts Council, 1980) outlines the production of this and similar tapes-
tries – 'Before 1947 practically all the tapestries had been very finely
woven and of a vast size but the cost of producing them had become
prohibitive in the changed economic situation. As a result, a serious
attempt was made to find a market for these smaller tapestries and to
keep prices as low as seemed feasible.'

Bowl Made by Lucie Rie (b. 1902)
 London
 1950
 Marks: impressed, the potter's monogram
 Stoneware with incised decoration
 Diam. 15 cm
 Circ. 1-1951

Lucie Rie moved to Britain from Vienna in 1938. After a difficult period recovering her confidence and establishing herself, together with Hans Coper she began making the forms which were to become so great an influence on studio pottery in this country.

Her practice is to raw-glaze her work. 'The advantage of raw-glazing to Lucie Rie is the intimate fusion of all parts of the pot during the single firing. The surface is the product of the interaction between body, slips and glaze during firing, with the oxides which she adds to body and to slips percolating to the surface and helping to mark the depth and degree of melting and fusion . . . In the late 1940s she added a finely drawn graffito to her technical armoury . . .' (John Houston, *Lucie Rie,* V&A, 1982).

Zodiac Bull Designed by Arnold Machin (b. 1911) 1940-1945
Made by Josiah Wedgwood & Sons, Barlaston
1950
Mark: printed WEDGWOOD BARLASTON ENGLAND
Cream coloured earthenware decorated with transfer printed
motifs based on the signs of the zodiac
L. 39 cm
Bought from Josiah Wedgwood & Sons in 1951
Circ. 276-1951

In April 1979 Arnold Machin wrote to the Museum:
'I designed . . . a Zodiac Bull which I think is the most interesting
piece of that period. It was made during the war and at that time
Wedgwood were manufacturing mainly army mugs and utility ware
which could be produced by semi-skilled labour. Even the moulding
seams were part of the design and the forms were simplified so that
the workers who finished the mugs with a sponge were able to use
the same process on the bull without any extra care or skill. The
decoration of the zodiac signs were drawn by myself on the litho-
graphic plates and all the decoration including eyes, nostrils etc., were
mechanically achieved thus eliminating the necessity of any special
skills and yet preserving the original quality'.
 Machin worked at Minton and Royal Crown Derby before settling
at Wedgwood in 1940 as a full-time modeller.

Illustration Henry Moore, CH, OM (b. 1898)
Prométhée by Goethe, translated by Andre Gide, and
published by Henri Jonquières
1950
Lithograph
L. 1784-1951

If the image is the work of a British artist, the publication is entirely
French. The play was newly translated for the edition which was
printed at the Imprimerie Nationale, Paris. The typeface used was
Grandjean Romain du Roi, originally cut in 1692, and the lithographs
were pulled in the studios of Mourlot Frères. Moore had reached the
front rank of modern British sculpture during the 1930s, but his
international reputation began to soar only after the war, and
particularly after he won the Grand Prize at the Venice Biennale in
1948. This work was commissioned shortly after. He had always had
the habit of making drawings, from life and from natural objects, as
a way of exploring three-dimensional form. But his work as an
official War Artist from 1940 to 1942, when he made a memorable
series of studies both in the coal-mines and the improvised air-raid
shelters of the London Underground, greatly developed his pictorial
range at a time when conditions made it difficult to pursue his carving.

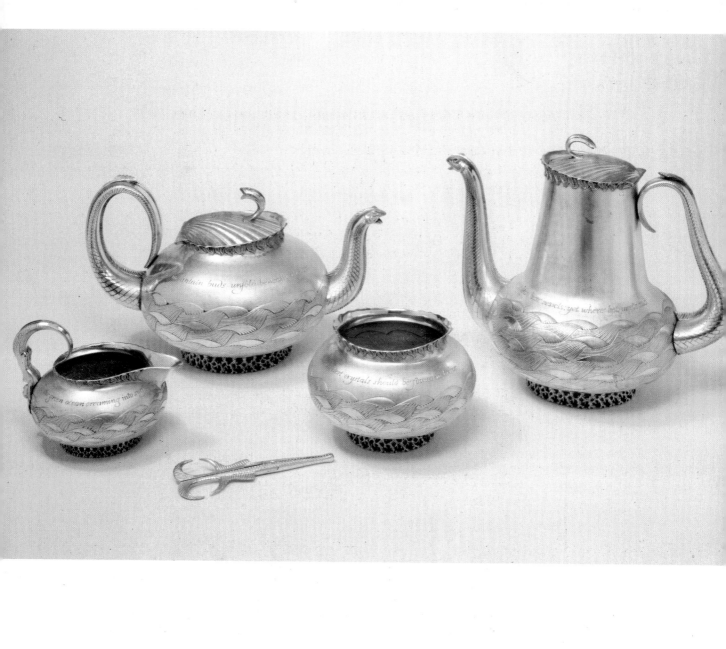

Tea Service Teapot, hot water jug, sugar bowl, milk jug and tongs
Designed by Robert Goodden, CBE, RDI (b. 1909), for the
Lion and Unicorn Pavilion at the Festival of Britain
Made by Leslie Durbin, MVO, LL.D (b. 1913)
1950-51 (The tongs, 1982, recast from the original moulds by
Leslie Durbin)
Mark: maker's mark of Leslie Durbin; London hallmarks for
1950-51; special mark of the Festival of Britain
Inscribed: (the hot water jug) 'WATERS BEAR VESSELS; YET WHERE
HOT MEETS COLD; ONE VESSEL HAS BOTH WATERS IN ITS HOLD'; (the
teapot) 'WHEN MOUNTAIN BUDS UNFOLD BENEATH THE SEA/THIRST-
ING AND QUENCHING SHALL EACH OTHER BE'; (the sugar bowl)
'UNNATURAL NATURE; IF BY YOUR DESIGN/THE SWEETEST CRYSTALS
SHOULD BE FOUND IN BRINE'; (the cream jug) 'WHITE FROM THE
GREEN, PEARLS FROM THE EMERALD TURF/AND THE GREEN OCEAN
CREAMING INTO SURF'
The couplets were composed by the designer
Silver, parcel-gilt, with cast, embossed and chased decoration
on a marine theme
H. (hot water jug) 25.7 cm
The service was used by King George VI and Queen Elizabeth
at the opening of the Festival in May 1951
The sugar tongs given by Leslie Durbin
M. 176, a, b, c-1976; M. 80-1982

Robert Goodden, Professor of Silversmithing at the Royal College of
Art, 1948-74, was trained as an architect but began to design silver-
work while still a student at the Architectural Association. He
designed the Lion and Unicorn Pavilion at the Festival of Britain.
Leslie Durbin, a distinguished silversmith, made the Stalingrad
Sword and much plate for the City Livery Companies, Universities
and other official bodies.

Sideboard Designed by David Booth (fl. 1925-1951) and Judith Ledeboer
Made by Gordon Russell Ltd, Broadway, Gloucestershire
1951
Mahogany with Bombay rosewood veneer cut to reveal white
birch
Given by Mr and Mrs Ian Short
W. 43-1978

This sideboard was bought from Liberty's in 1951 by the donors. A
version was shown in the 'Homes & Gardens Building' at the Festival
of Britain in 1951. This plain, worthy, but unexciting piece, beautifully
made, is typical of much British furniture of the 1950s.

186

Wallpaper 'Insulin 8.25'
 Designed by Robert Sevant (fl. c. 1950)
 Made by John Line & Sons Ltd
 1951
 Screen print
 E. 888-1978

This pattern, derived from the crystalline structures of insulin, is one
of a series of designs known as the Festival Pattern Group, based on
the molecular formations of natural objects revealed by micro-photo-
graphy. Dr Helen Megaw, crystallographer of Girton College,
Cambridge, first perceived that the diagrams recording the arrange-
ment of atoms could be used as a basis for textile design, and the idea
was developed by Mark Hartland Thomas, head of the Council of
Industrial Design's Industrial Division. Manufacturers from a range
of industries, including textiles, cutlery, ceramics, plastics, paper and
glass were commissioned to produce designs based on the crystal
structure of matter as varied as haemoglobin, nylon, afwillite, sugar
and china clay. Other designs for wallpapers in the Festival Group are
by William Odell, Head Designer for John Line & Sons Ltd.

Furnishing fabric 'Calyx'
Designed by Lucienne Day, RDI (b. 1917)
For Heal and Son Ltd
1951
Screen printed linen
Circ. 190-1954

The Festival of Britain set the seal on abstract textile design although it exhibited numerous other types of patterns ranging from strictly traditional tartans to glazed cottons with naturalistic florals. 'Calyx' was included in the exhibition and is the textile which most effectively sums up the prevailing trend for non-representational patterns and reveals fashionable '50s colours. Its irregular 'calyxes' linked by a network of delicate 'stems' were far removed from their appearance in nature – these motifs were much copied and were soon to become a widespread decorative cliché. 'Calyx' has appeared in many texts and exhibitions concerned with the decorative arts. Terence Conran used it in *Printed Textile Design* (The Studio Limited, 1957) alongside an interview with Lucienne and Robin Day. It was awarded a Gold Medal at the 1951 Milan Triennale and the International Award of the American Institute of the American Institute of Decorators for the best textile design of the year.

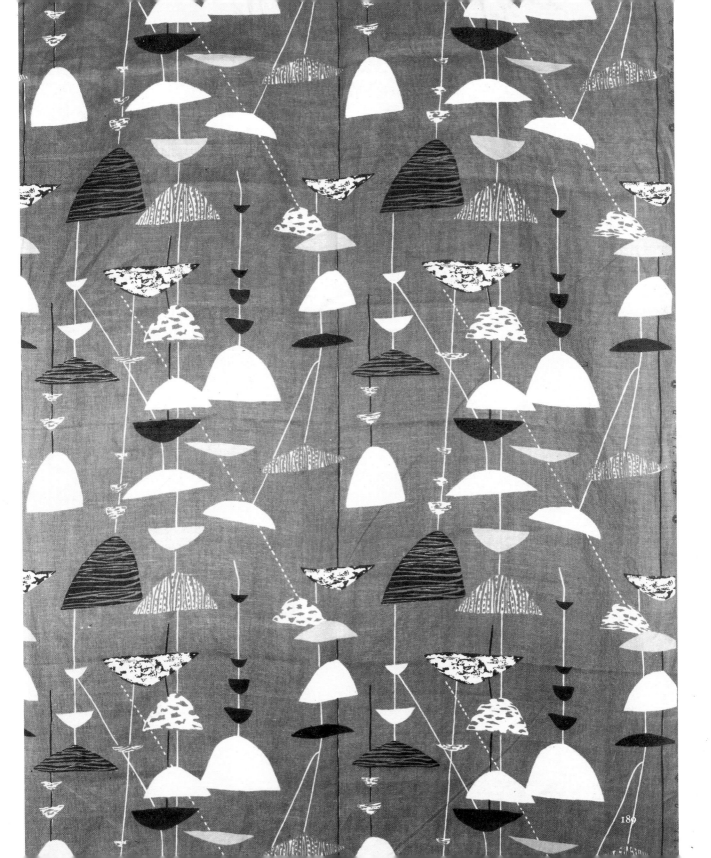

189

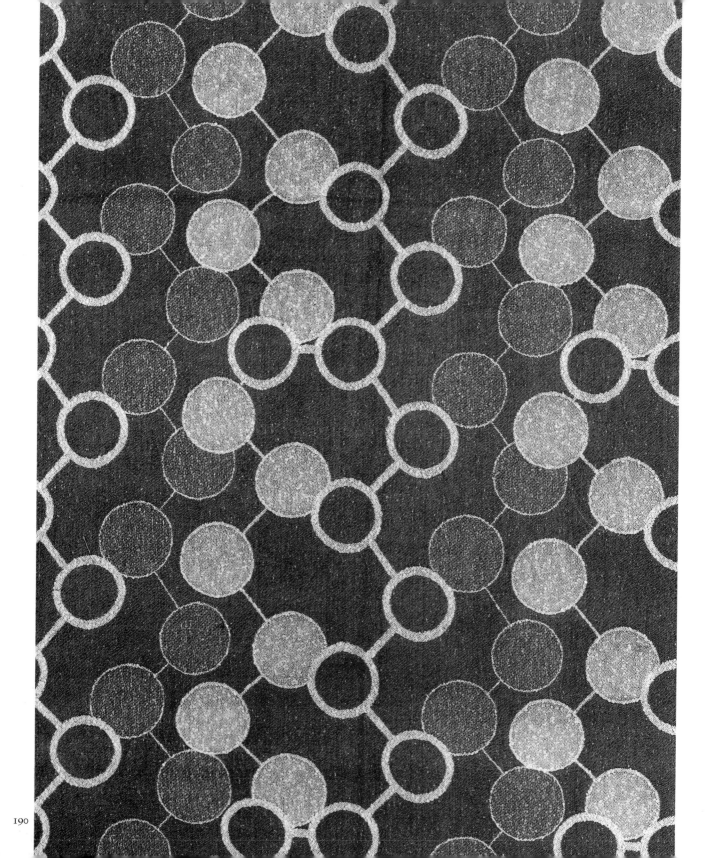

Furnishing fabric 'Helmsley'
Designed by Marianne Straub (b. 1909)
For Warner & Sons Ltd
1951
Jacquard woven cotton
Given by Warner & Sons Ltd
Circ. 308A-1951

The title-page of a Festival of Britain textile sample book (T.446f-1977) explains the crystal structure venture 'FESTIVAL PATTERN GROUP DECORATION TAKEN FROM SCIENTIFIC DIAGRAMS Crystal structure diagrams – the maps that a scientist draws to record the arrangement of atoms in particular materials – have been adapted by a group of leading British manufacturers to the decoration of different kinds of products. DRESS MATERIALS FURNISHING FABRICS POTTERY GLASS CUTLERY AND FLATWARE FLOOR COVERINGS PANELLING WALLPAPER PRINTING AND PACKAGING FURNITURE AND FITTINGS The Festival Pattern Group has met under the auspices of the Council of Industrial Design to develop this new system of decoration for the Festival of Britain'. In *A Choice of Design 1850-1980 Fabrics by Warner & Sons Limited* Hester Bury lists the three crystal structure fabrics by Marianne Straub and Alec Hunter – 'Harwell', 'Surrey', and 'Helmsley', which were used for curtains in the Regatta Restaurant.

Inscription 'Dum Medium . . .'
David Jones (1895-1970)
1952
Opaque watercolour on an under-painting of Chinese white
L. 1262-1982

The text 'for while all things were in quiet silence and the night was in the midst of her course, thy almighty Word came down from Heaven from thy royal throne' is from the Mass of the Sunday after Christmas (taken from the Book of Wisdom), and is echoed by the phrase round the edge from the carol 'I sing of a maiden'.

A retrospective exhibition of the artist's work was held at the Tate Gallery in 1981 when he was described as belonging to that line of British poet-painters, so exceptional to our culture, of which Blake and Rossetti are the great exemplars. One has also to say that, most notably, he was Celt (thus heir of bards) and Catholic convert. His conversion, at the moment of leaving art school, dated from 1921 when he joined a craft guild, the Ditchling Guild of St. Joseph and St. Dominic, founded a couple of years before by Eric Gill and Hilary Pepler. It was 'a religious fraternity for those who make things with their hands', and Jones not merely joined the Gill household but became engaged, for a time, to one of his daughters. He followed Gill moreover in 1924 when he moved with his small community to Capel-y-ffin near Abergavenny.

It is inescapable that Jones learned an instinctive care of letters from these early links with Gill, but his feeling for them was utterly different, private, emotive, and incantational. The series of inscriptions which he began to make in the 1940s, after the publication of his book *In Parenthesis,* are an important part of his work, not just a side-line, and are to be ranked with his painting and his writing that express a connecting link between the two.

Gill's supreme inspiration had been the capital letters bearing the imperial proclamation from the foot of Trajan's column, of which a life-size cast has stood in the V&A from the last century. Jones fed rather on the much cruder tablets left behind in further Britain, with their ghosts, by the common soldiers of Imperial Rome.

his mother was : like dew in April

there still so came al he

DVM · MEDIVM ·
SILENTIVM ·
TENERENT·OMNIA ·
ET · NOX · IN·SVO·CVRSV ·
MEDIVM·ITER·HABERET ·
OMNI POTENS·SERMO ·
TVVS · DNE · DE · CÆLIS ·
A · REGALIBVS ·
SEDIBVS·VENit ·
IN·FESTO · NATIVITATIS·DOMINI · MCMLII

193

Bookbinding Sydney Morris Cockerell (b. 1906)
1954
Purple leather, gold tooled, with marbled paper doublures
On *The Order of the Administration of the Lord's Supper Or Holy Communion,* an illuminated manuscript transcribed and gilded on vellum by W. Graily Hewitt
Commissioned by the Museum

L. 838-1953

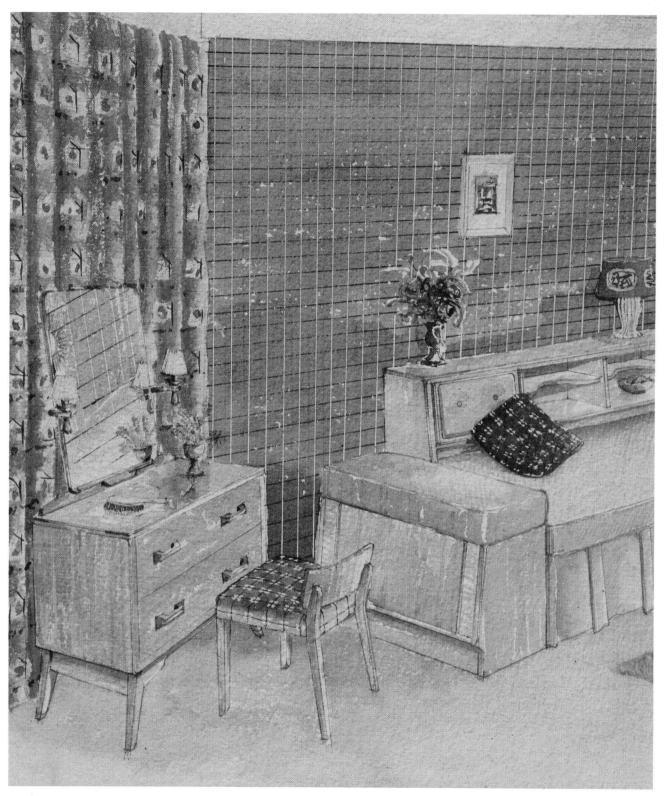

Designer's impression A bed-sitting room furnished with 'G-Plan'
By Leslie Dandy (b. 1923)
For E. Gomme and Sons Ltd, High Wycombe
c. 1954-55
Pencil, water- and bodycolour
Given by E. Gomme and Sons Ltd through the designer
E. 334-1978

With the easing of restrictions after the War on the type and quality of materials permitted in the construction of furniture, the aims of manufacturers diverged: some reacted against the austerity of Utility by producing ornamented 'period' furniture; others were determined to continue the standards of rational design which had been set during the War. The first major commercial attempt in Britain to mass-produce well-designed and modern furniture was made by E. Gomme & Sons Ltd., with its original range of G-Plan furniture launched in 1953. Its simple lines echoed the standards of Utility ranges and rejected fussy ornamentation. It provided a new approach to home furnishing with interchangeable pieces of matching furniture which made it possible to build up a unified interior gradually.

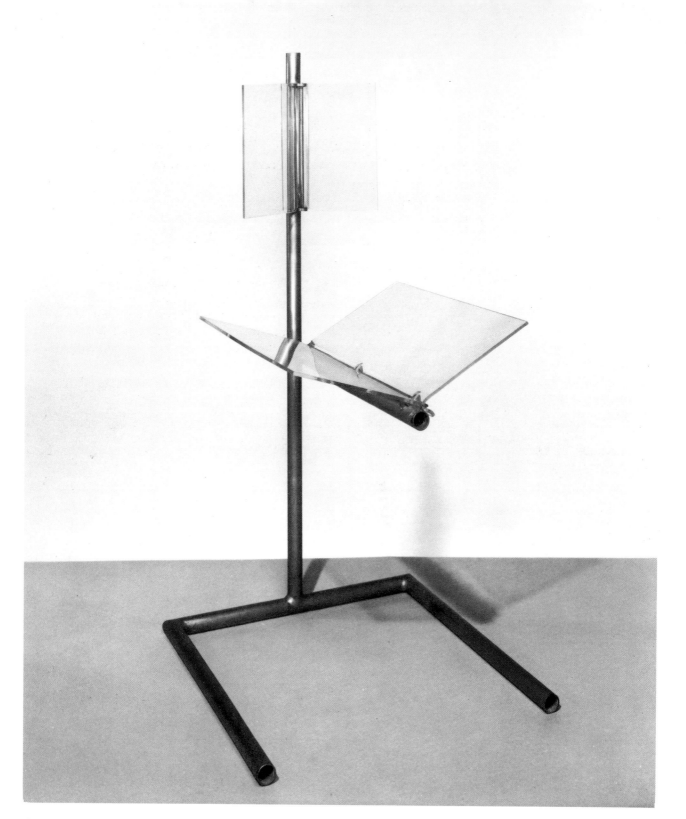

Chair 'Pogo'
Designed by Peter (b. 1923) and Alison (b. 1928) Smithson
The frame made by V. E. Edwards, Ilford, Essex, the perspex
parts by Thermo Plastics Ltd, Dunstable, Bedfordshire
1956
Steel and perspex
Circ. 81-1975

Designed for 'The House of the Future' exhibit at the Ideal Home
Exhibition of 1956. The original drawings are in the Prints & Draw-
ings Department. Interesting though this design must have seemed
in 1956 it seems to have had no direct influence on the development
of British furniture. Indeed in the 1960s the hard machine aesthetic
it represents was to fall very much out of fashion.

Design Wall in the House of the Future
Designed by Peter (b. 1923) and Alison (b. 1928) Smithson
1956
Inscribed with descriptions and measurements
Pen and indian ink on tracing paper
E. 663-1978

The wall of a dressing room in the 'House of the Future', commissioned for the Ideal Home Exhibition, 1956. This scheme was one of the first examples of Pop architecture, constructed with a double plastic shell designed to be mass-produced in the same way as a car body. Some other outstanding features of the House were the folding and stacking Pogo chairs, a table which rose from the floor by switch control, and a self-rinsing thermostatically-controlled bath which filled from the bottom upwards.

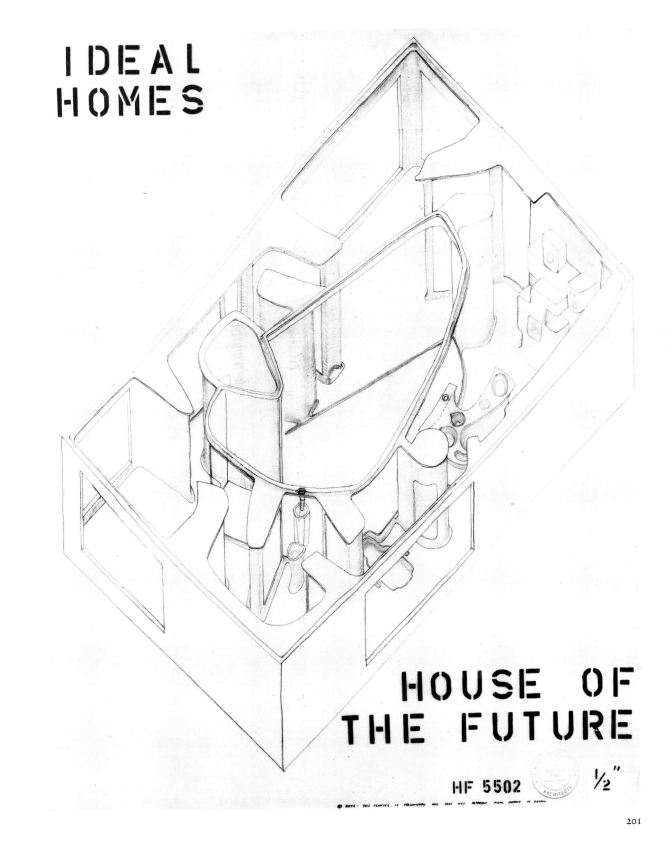

IDEAL
HOMES

HOUSE OF
THE FUTURE

HF 5502 ½"

● NOTE - THIS DRAWING IS PRELIMINARY AND DOES NOT REPRESENT FINAL SCHEME IN DETAIL

Furnishing fabric Designed by Louis le Brocquy
For David Whitehead Ltd
1956
Screen printed cotton
Given by David Whitehead Ltd
Circ. 644-1956

David Whitehead Ltd. was one of the top textile manufacturers
producing *avant-garde* designs in the 1950s which were featured
regularly in journals and exhibitions. Louis le Brocquy provided the
firm with a group of advanced designs in 1956 and 1957. This stark
black and white screen print with sickle motifs anticipates the
optical designs of the 1960s.

Jar and screw stopper Made by Michael Cardew (1901-1983)
Abuja, Northern Nigeria
c. 1957
Mark: impressed ABUJA, in arabic and the potter's monogram
Stoneware with incised decoration
H. 40 cm
Circ. 112 & A-1958

In 1950 Cardew returned to Africa, after two previous stays, and, settling at Abuja in Northern Nigeria, he opened a Pottery Training Centre in 1953. He remained until his contract expired in 1965. Work of this period reflects his close and sympathetic affinity with his African students and their culture. His most outstanding pupil was Ladi Kwali and the Museum bought an example of her work (in the study collections) and this jar from one of the several exhibitions of Abuja pottery which Cardew arranged in London.

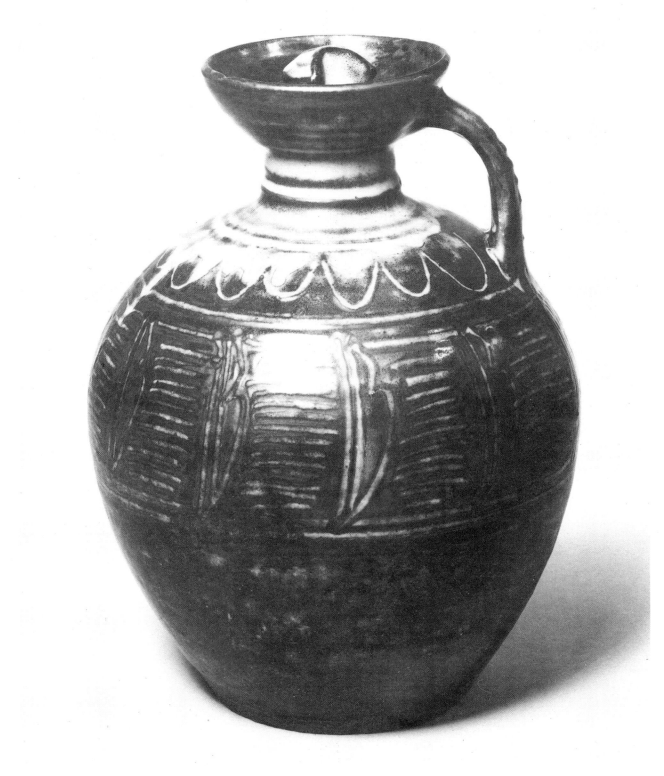

Martini jug and six tankards

Designed by Gerald Benney, RDI (b. 1930)
Made by Messrs Viners Ltd, Sheffield
c. 1958
Pewter
H. (jug) 26 cm
Circ. 27, 28, 29, 30, 31, 32, 33-1959

Viners of Sheffield were one of the first British firms to introduce modern designs in pewter after the War. They appointed Gerald Benney after consulting the Council of Industrial Design's Record of Designers. They were employing a consultant designer for the first time and were seeking somebody who had sympathy for the material and a knowledge of the problems and techniques involved in working it.

Pewter was a traditional material for the company but had in recent years been losing popularity with the public. Viners, in this new departure, sought to revitalise the medium. Pewter was particularly suitable for experimentation since it was cheaper than either silver or stainless steel.

After the prototypes had been approved, Benney was given a free hand to supervise their production which involved both craft and machine methods. The textured decoration, for example, was rolled on by a semi-industrialised process. Benney designed the sales leaflets and packaging for the new range which also included an ashtray, sauceboat and cigarette box.

Gerald Benney was trained in silversmithing at the Royal College of Art and before his appointment to Viners had carried out a number of important commissions for local authorities and civic bodies, such as the ceremonial maces for Leicester and London Universities. In 1964 he was appointed a Liveryman of the Goldsmiths' Company and in 1974 granted a Royal Warrant. He was Professor of Silversmithing at the Royal College of Art, 1974 to 1983.

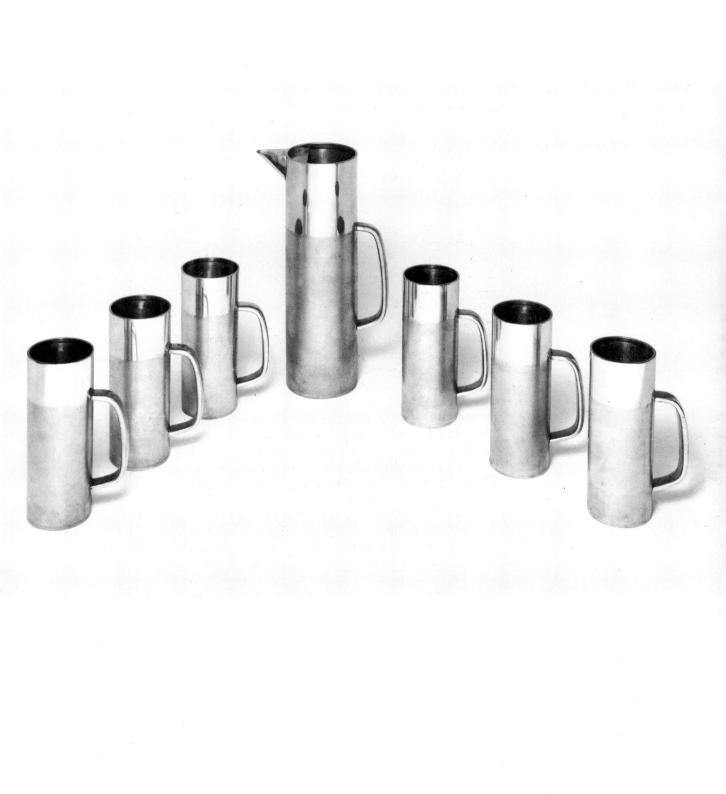

MAY 1958

Collage 'Mask with motor car'
Eduardo Paolozzi (b. 1924)
1958
Signed in blue biro and dated in ink *Eduardo Paolozzi 1958*
Gouache and collage on paper (an unused shipping chart)
P. 31-1977

In the 1950s Paolozzi, with a small group of other artists, was concerned with establishing the significance of anonymous commercial and industrial draughtsmanship and photography, an interest linked with Surrealism, Dada and the more recent abstract-expressionist movement 'Art-Brut'. Here he picks a few examples of such material, throwing them together to suggest the apparently random way in which we commit information to memory. The style of the work is moving toward the more organised agglomeration of spatially independent images which formed the basis of his early Pop screen prints of the 1960s.

Furnishing fabric 'Adam'
Designed by Keith Vaughan (1919-1977)
For Edinburgh Weavers
1958
Woven cotton and rayon
Given by the Design Centre
Circ. 466-1963

The design for this fabric (which won a Design Centre Award for the best woven textile of 1958) was commissioned by Alastair Morton. In his standard work on the firm *Three Generations in a Family Textile Firm* (Routledge & Kegan Paul, 1971) Jocelyn Morton explains – 'Alastair, when faced with an artist's work which he wished to translate into a textile would contemplate it for weeks, sometimes months, before he was satisfied with the right weaves, the right yarns, the best printing techniques, the necessary blends of coloured yarns to give a true interpretation'. 'Adam' was conceived on a large scale by Keith Vaughan and was best suited for use by architects in lofty interiors.

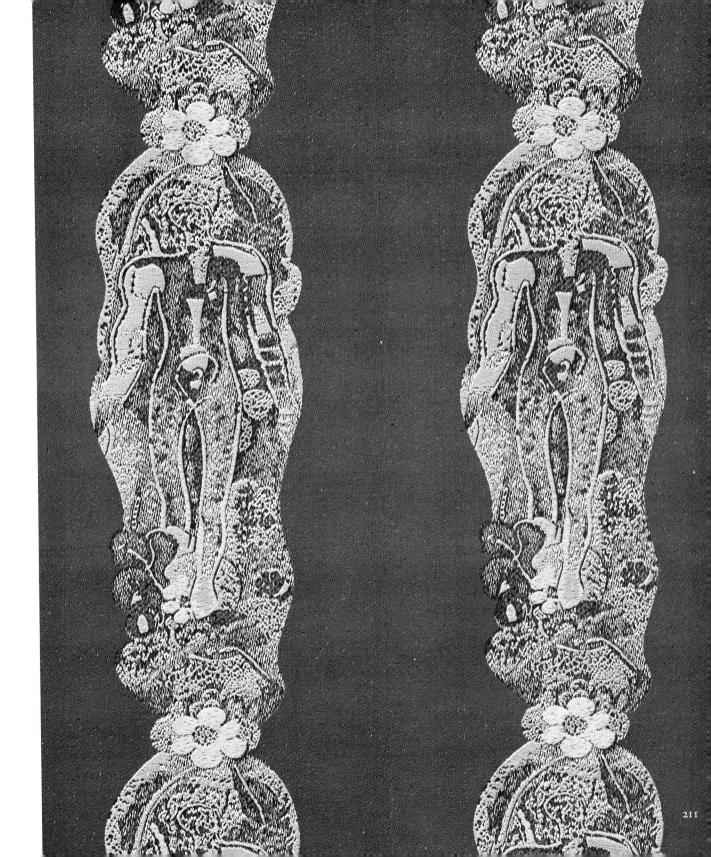

211

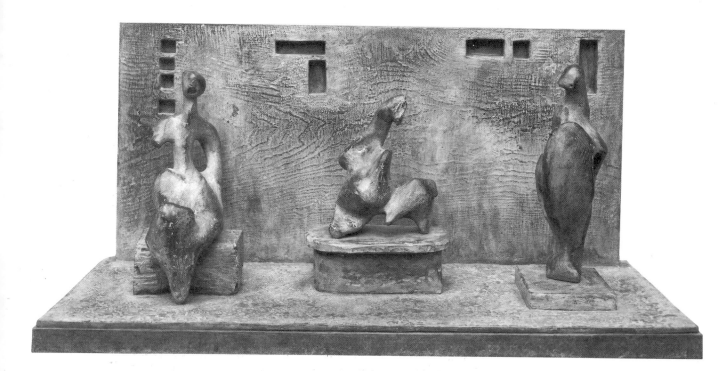

Three motifs against Henry Moore, OM (b. 1898)
a wall 1958
Bronze
Circ. 234-1961

Two versions of this subject were made by the artist in 1958 and 1959, at identical scale, both in bronze, cast respectively in editions of twelve and ten. In the second, the three shapes stand in line and are wholly abstract, evoking perhaps the forms of bulging flints; but the first version, shown here, carries the clear suggestion of three anthropomorphic seated figures.

Moore's range of image themes, by verbal definitions narrow, has always cloven to archetypes of a profound order, quarried out of deep deliberation, and found in the ceaseless drawings of natural forms as well as the human body.

The idea of figures set in a relation to a schematically window-slotted wall appeared in sketchbook studies as early as the mid-1930s, and came to be repeated often over the next few years. He noted to himself in the margin of one of these that the wall evocation of an interior did not seem to suit reclining figures, and rather worked best with either sitting or standing ones. He did not, however, incorporate the idea into three-dimensional sculptures until the middle of the 1950s.

As his fame grew on the international scene, broadcast by the grand prizes in Venice (1948) and Sao Paulo (1953), he began to receive an increasing number of major public commissions, among which several, as it happened, had a wall connection – the facade e.g. for the Time-Life Building in London's Bond Street (1952-53), a brick mural relief for the Rotterdam Bouwcentrum (1954-55), and huge forecourt figure for the Paris Unesco Headquarters (1956-58). Each of these necessitated long series of experiments and maquettes, and may have helped to bring walls forward in his mind, which seems to have been especially preoccupied with seated figures through that decade. For whatever reason, however, he does not seem to have returned to an inbuilt wall-setting, after a single individual figure of 1960.

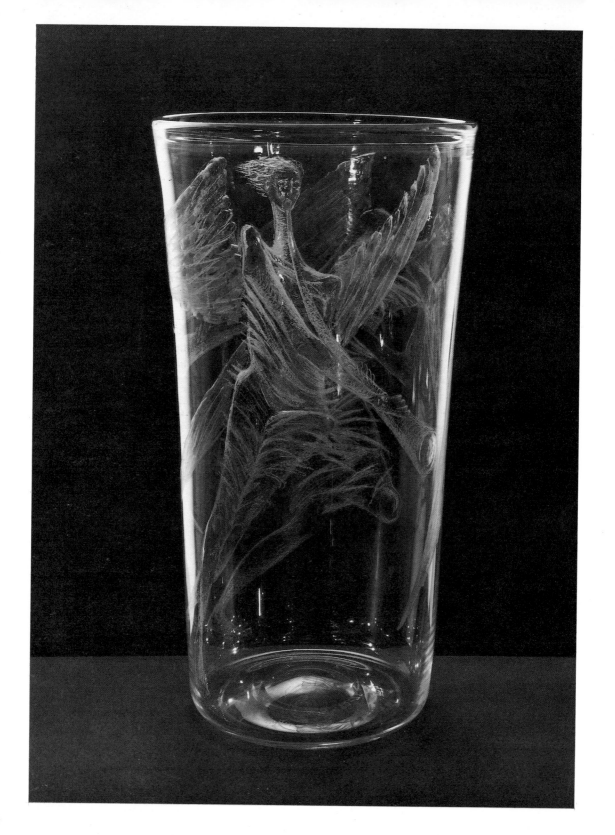

Vase Designed and decorated by John Hutton (1907-1978)
1958-1959
Mark: engraved No. 3 70-72
Clear colourless glass with engraved decoration of angels playing trumpets
H. 42.5 cm
C. 28-1975

This vase was engraved as part of a charitable scheme, no. 3 of a limited edition, and sold in July 1959.

John Hutton, a New Zealander, arrived in this country shortly after the War. He began as a mural painter and was then asked to do glass engraving for the War Graves Commission and for Guildford Cathedral. Dissatisfaction with commercial engraving drove him to teach himself the various techniques until he developed the free and almost painterly style evident in this vase and the contemporaneous and most famous example of his work, Coventry Cathedral.

His technique was based simply on the reversal of traditional methods. Instead of fixing the engraving wheel in a lathe and moving the glass, he held the glass in an easel and fitted his grindstones to a flexible drive, thus giving himself the unlimited mobility of a pencil or brush on paper. He himself called this technique 'flexible drive engraving'.

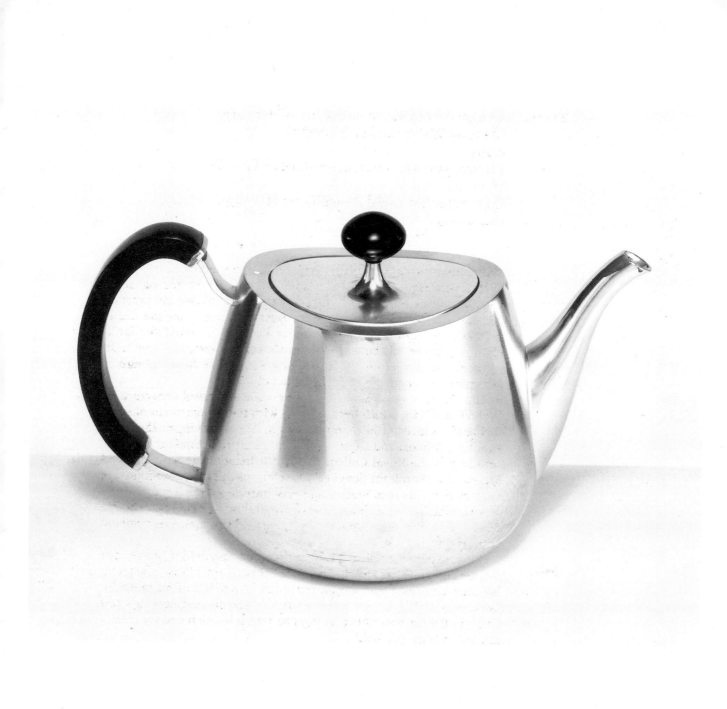

Teapot Designed by David Mellor, OBE, RDI (b. 1930)
 Made by Walker and Hall, Sheffield
 c. 1959
 Electroplate with black nylon finial and handle
 H. 13 cm
 Council for Industrial Design Award for 1959
 Circ. 293-1959

This teapot forms part of the 'Pride' tea service launched in 1959 by
Walker and Hall which included a hot-water jug, milk jug and sugar
basin. The C.O.I.D.'s panel of judges gave both aesthetic and practical
reasons for their award. They commented not only on the distin-
guished appearance of the tea service but also favoured the inter-
changeability of lids between the teapot and hot-water jug and heat-
resistant, hard-wearing, nylon handles which were large enough to
accommodate successfully the user's hand.

The 'Pride' service was part of a new and successful departure for
Walker and Hall, which began in 1956 with the appointment of Peter
Inchbald, as director in charge of design. After studying at the Royal
Academy Schools and subsequently, as a part-time student of silver-
smithing at the Royal College of Art, Mr Inchbald appointed David
Mellor as a consultant designer. The fruits of this collaboration were
soon evident. In 1956 Walker and Hall introduced the 'Pride' cutlery
service which won a design award the following year, and the tea
service, of which this teapot is a part, enjoyed similar success when it
appeared in 1959.

David Mellor studied silversmithing at Sheffield College, the
Royal College of Art and the British School in Rome. In 1954 he set up
his own workshop and design consultancy. As well as his work for
Walker and Hall, he was a consultant designer for engineering firms
and the British Post Office. In 1974 he set up his own cutlery factory
at Broom Hall, Sheffield.

Tableware 'Apollo'
Designed by Neal French (b. 1933) and David White (b. 1934)
Made by Copeland & Sons, Spode Works, Stoke-on-Trent
1960
Mark: printed SPODE BONE CHINA ENGLAND
Bone china
Design Council Award, 1960
Duke of Edinburgh's Prize for Elegant Design
H. (coffee pot) 23.8 cm
Given by Copeland & Sons via the Council for Industrial
Design
Circ. 398, 399 & a, 401 & a-1963

The Apollo range was designed when Neal French and David White
were still students at the Royal College of Art, for an exhibition
entitled *A Room of Our Own* at the Tea Centre, London, 1958. An
arrangement was made between the Royal College of Art and
Copelands, who at the time had no new post-war tableware shapes,
that manufacturers would supply the full range in time for the
exhibition if they approved the designs. French and White divided the
various shapes between them into dinner ware and tea ware respec-
tively although there was some overlap, and designed everything in
the round at the College. They showed two shape ranges, 'Elizabethan'
and this which was exhibited with a pattern, 'Golden Fern' designed
by Roger Young for Copeland. It was first marketed as 'Royal College
Shape' and then, after winning the Award in 1960 for its undecorated
form, it was titled 'Apollo'.
 Neal French left the Royal College in July 1958 and joined the
Worcester Royal Porcelain Co. He is now Head of the School of
Product Design at N. Middlesex Polytechnic. David White left in 1959
and went on to run his own firm, the Thanet Pottery, until 1964. In
1965 he opened the Broadstairs Pottery and he now teaches at the
Medway College of Design and works as a studio potter in porcelain.

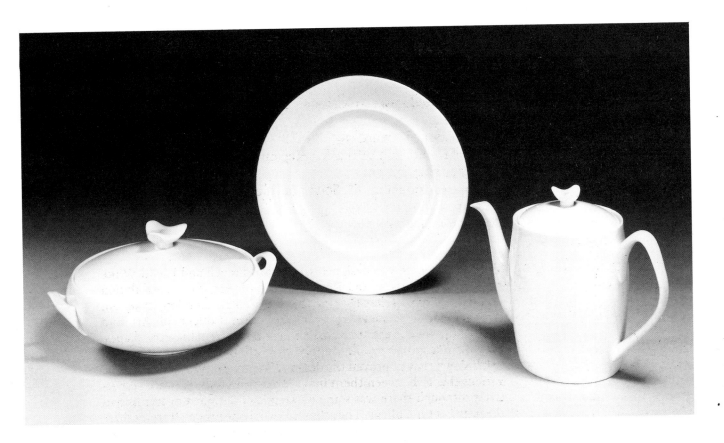

Oval casserole Designed by John (b. 1925) and Sylvia Reid
 Made by Izons and Co
 1960
 Enamelled cast iron
 L. 32 cm
 'Anniversary Ware', Design Centre Award for 1960
 Circ. 445 & a-1963

This casserole, part of a range of casseroles and entrée dishes issued under the title 'Anniversary Ware', satisfied the judges' criteria for several reasons. Its neat, clean appearance and unusual range of colours not normally seen on this type of product made it suitable for use on the dinner table. The machined base which distributed the heat evenly, without distorting the vessel, enabled it to be used on either gas or electric hobs. One of the judges expressed reservations about the ease of removing the lid without the traditional knob but it was felt that the advantage gained in saving oven space compensated.

Since 1951, John Reid and his wife Sylvia have practised as architects, interior and industrial designers. Their professional work covers a wide range of commissions from major clients such as British Rail, Thorn Electrical Industries, Boots and the City of London Corporation. They have been granted four Design Awards by the Council of Industrial Design and two Silver Medals as well as a Diploma di Collaborazione from the 10th, 12th and 13th Milan Internationale Triennales.